INSIDE CULTURE

David Halle

INSIDE CULTURE

Art and Class in the American Home

The University of Chicago Press
Chicago and London

The University of Chicago Press, Chicago 60637
The University of Chicago Press, Ltd., London
© 1993 by The University of Chicago
All rights reserved. Published 1993
Paperback edition 1996
Printed in the United States of America
02 01 00 99 98 97 96 2 3 4 5
ISBN: 0–226–31367-0 (cloth)
ISBN: 0–226–31368-9 (paperback)

Library of Congress Cataloging-in-Publication
Data

Halle, David.
 Inside culture : art and class in the American home / David
Halle.
 p. cm.
 Includes bibliographical references and index.
 1. Art and society—United States. 2. Art—Psychology.
I. Title.
N72.S6H32 1993 93-7335
306.4'7—dc20 CIP

To Louise

Contents

Illustrations

Tables

Acknowledgments

One evening, I knocked on the door of a Manhattan townhouse to which I had mailed my standard request for an interview. This house had been selected as part of a random sample, but I recognized it as belonging to the architect I. M. Pei. To my delight he opened the door himself, greeted my research assistant and me warmly, and offered us drinks. Only when I began the interview did it become clear that he had mistaken us for the dinner guests whom he had invited but never met. We were summarily evicted and rebuked for trying this kind of research. My main debt is thus to the many other residents of New York City and Long Island who, to my own surprise, did allow us full access to their houses. Their doing so testifies to the basic kindness and willingness to help intellectual inquiry that makes research a pleasure rather than a chore.

Jack Salzman, Director of the Center for American Culture Studies at Columbia University, provided an unfailingly supportive base from which I could interview the upper middle class. Richard Brilliant's encouragement and insights were invaluable to a sociologist straying across disciplinary boundaries into the realm of art history. Louise Mirrer read and criticized the

manuscript more times than I had a right to ask. Frank Romo combined statistical expertise with an enthusiasm for the subject matter.

Anyone needing artistic and design skills is fortunate to live in New York City. I received help from several talented people. Martha Cooper took all the photographs of residents' homes except those for figures 36, 69, 77, 79, 82, and 83, which are my own. Josh Brown made the maps. Frances Campani drew the architectural plans (figs. 6–23).

Elisabeth Tiso was a wonderful research assistant, who taught me much about the New York art scene. Kathy Nelson was of great help too, and suffered through such low moments as a Great Neck resident calling the police to arrest us for knocking at her door, and the Secretary General of the United Nations threatening to do the same if we ever reappeared on his doorstep.

I wish to thank many others who helped. At the State University of New York at Stony Brook, these include Said Arjomand, Diane Barthel, Michele Bogart, Rachel Carmean, Mark Granovetter, Ellen Hopkins, Hyman Korman, Donald Kuspit, Herman Lebovics, Jung-Kyu Lee, Anita Moskowitz, Tom Phelan, James Rule, Judy Tanur, Andrea Tyree, Richard Williams, and Robert Zussman; at the University of California at Los Angeles Jeffrey Alexander, Robert Emerson, Jack Katz, Jeffrey Praeger, Emanuel Schegloff, and Donald Treiman. Others I wish to thank include Paul Attewell, Elena Cielak, Jonathan Cole, Diana Crane, Peter de Janosi, Paul DiMaggio, Marcel Fournier, Herbert Gans, Naomi Gerstel, Andrée Hayum, Aldona Jonaitis, Suzanne Keller, Michèle Lamont, Robert Merton, Kristine Mirrer, Katherine Newman, Linda Nochlin, Elizabeth Parker, Rick Peterson, Neil Smelser, Fritz Stern, Gaye Tuchman, Eric Wanner, Janet Wolff, Eviatar Zerubavel, Vera Zolberg, and Sharon Zukin.

The National Endowment for the Humanities and the National Endowment for the Arts funded an earlier study of the exteriors of working-class houses ("Transformed Houses," with Camilo Vergara, Lisa Vergara, and Kenneth Jackson); doing this research suggested to me the idea of studying the interiors, too, and then of looking at the houses of the rich. The Russell Sage Foundation provided a highly stimulating year in residence, from 1990 to 1991.

Introduction

"Much writing about art now strikes me as history-less. Because the social matrix for art is not examined . . . art seems to beget art without the intervention of society."
—Robert Herbert, 1988

THE HOUSE AS THE MATERIAL CONTEXT OF ART AND CULTURE

For every period except the modern, we look at art in the context in which it was displayed and viewed. Who would think, for example, of medieval art without thinking also of the cathedral and the Church? Who would consider the art of ancient Egypt and China apart from the funeral tombs of the aristocracy? Who would study Roman art without looking, too, at the public monuments that celebrate political power? In all of these cases we consider art in the context in which it was seen at the time, and we link its meaning to the material environment in which it was located.

What about the context of modern Western art and culture? Since the waning of the Middle Ages that context has been, increasingly, the private house. Think, for instance, of paintings. Certainly in the last 150 years the majority of paintings have been originally purchased by individuals who wish to hang them in their homes. Yet there

1

are few studies of painting in this context.[1] Or consider "primitive" art. The meaning of "primitive" or "tribal" art for the societies that produce it has been amply studied. But in the twentieth century "tribal" artifacts have been increasingly displayed as art in a context far removed from that of their creators—in people's homes in the West. About the meaning of the artifacts in this context we know almost nothing.[2] Or think of religious artifacts and representations which, with often striking imagery, have long pervaded the homes of many members of the Roman Catholic and Russian Orthodox churches. Kandinsky, for instance, was deeply influenced by the vivid religious images he saw in Russian peasants' houses. There are, however, almost no studies of religious artifacts in Western homes.[3]

Some people will say that the museum, and not the house, is the main context for twentieth-century art and culture.[4] Certainly the museum cannot be ignored, for once items have found their way onto the museum walls, that does become their context. Further, museums do exert an independent impact, in several ways. Above all, the decisions by their staff concerning which items to purchase and display provide an important imprimatur on the works and on the artists. And museums do sometimes buy works directly from artists.

But most of the art and cultural items that have been produced in the last 150 years and that now hang in museums do so because they once hung in a private home. The French Impressionists, for instance, occupy lavish and well-attended sections of the Musée d'Orsay and Metropolitan Museum of Art because for many years people bought the paintings for their homes.[5] Likewise with "primitive" art: only after "tribal" objects were displayed as art in people's homes, especially in the homes of influential rich people and the studios of vanguard artists such as Matisse and Picasso, did they begin to be displayed as art in museums.[6]

The lack of studies of art and culture in the house leaves some of the central developments in the history of twentieth-century taste for art and culture inadequately explained. We do not fully understand why abstract art took hold, why the painted portrait declined, why "primitive" artifacts came to be displayed as art, why landscape depictions took a particular form, and so on.

In 1937, Meyer Schapiro, the art historian, complained that the dominant approach to explaining the origins of abstract art excluded as "irrelevant to its history the nature of the society in which it arose." Instead, the history of abstract art proceeded in terms of the history of great artists.[7]

Although art historians and others, including Schapiro, have done much since then to expand our understanding of the social forces that influenced the artists,[8] we know almost nothing about the crucial other half of the picture—namely the reasons why the works attained a certain popularity with the audience. Indeed, the actual meaning of abstract art to those who purchase and view it is one of those topics in modern culture that has provoked enormous amounts of speculation but little actual research.

Worse still, the "rise of abstract art," the causes of whose attractions for the audience are themselves scarcely understood, has then been used to "explain" other central developments in twentieth-century artistic and cultural taste. For example, the twentieth-century taste for "primitive" (or "tribal") art has been ascribed to the modern taste for "abstraction," on the grounds that "tribal" art and abstract art both operate on a "conceptual" level.[9]

This explanation omits much. For example, the largest category of "primitive" art displayed in the West is from Africa, and among African art it is depictions of the person, in the form of figures, faces, or masks, that predominate.[10] This raises a central question. Why do some white Americans, who usually live in segregated neighborhoods from which African Americans born in the United States are typically excluded, by economics or prejudice or both, display images of Africans in their homes in a place of honor? Strangely, not a line has been written on this question. Certainly notions of the modern affinity for "conceptual modes" of imagining do little to illuminate the question.

Analyses of modern art and culture that consider only the artists and critics and the forces that motivate them are inevitably incomplete. What is missing is the audience—a theory of what accounts for the popularity of certain styles with an audience, for in the end few artists work in a vacuum for themselves alone, without regard to the reception of their work, and even those that do (e.g., Van Gogh) only become famous because eventually—even if long after their death—their work finds favor with at least some members of the public. Almost twenty years ago, Leo Steinberg protested against this tendency to ignore the audience. He wrote: "May we not drop this useless, mythical distinction between—on one side—creative, forward-looking individuals whom we call artists, and—on the other side—a sullen, anonymous, uncomprehending mass, whom we call the public?"[11] Above all, what is lacking is an understanding of art and cultural items in the audience's own terrain, namely the social life, architecture, and surroundings of the house and neighborhood.

Sociologically minded historians of the origins of modern art, for ex-

ample T. J. Clarke and Robert Herbert, have recently stressed the role of nineteenth-century suburbanization in the development of Impressionism. For example, many of the Impressionists painted the leisure forms associated with suburbanization, exhibiting the attendant view that nature was an arena for bourgeois leisure.[12]

This focus on nineteenth-century suburbanization, which involved new forms of dwelling and new modes of transport to reach those dwellings, fits well with my claims here. Yet it raises some intriguing questions. For one, the pace of suburbanization quickened in the twentieth century, especially after World War II with the widespread possession of automobiles. Yet where is the influence of suburbanization on twentieth-century art, and in particular on abstract art, which has dominated the period? Thus the ideas raised by a focus on suburbanization in the nineteenth century seem hard to apply in the twentieth century. To do so, I argue, we need not only to focus on the suburban context of much modern life but also to enter the houses themselves, look at a range of trends in addition to suburbanization, and link the art and culture within to the social life of the house and its neighborhood context.

This involves a kind of "materialist" approach to the reception of art and culture. The material context is not, however, the famous mode of production, but the mode of dwelling.

Nor does this material approach entail the mechanical, and much criticized, model according to which ideas are just a reflection of the economic base. On the contrary, it facilitates analyses of symbols and meaning, for in studying the interplay between meaning and material context, it becomes possible to check one against the other. It is, for example, from observed discrepancies between what people say about art and culture and what they do (in particular, what they display) that some of the most interesting interpretations of symbolic meaning emerge.[13]

Sociologists interested in the meaning of art and culture for a modern audience have focused on areas in the public domain.[14] In particular, they have asked survey respondents about certain art-related activities, especially about how often they attend art galleries, museums, and other such institutions. They also have studied what people know and think about certain important artists and types of art. They have, for instance, asked survey respondents to rank, in order of preference, a list of famous artists ("Do you prefer Leonardo, Breughel, Kandinsky, Picasso, and so on?"), or to express their attitude toward general categories of painting such as abstract art or Impressionism.[15]

While these studies provide valuable information, their perspective, in general, allows the audience to present itself only vis-à-vis the public world of art institutions and famous artists. For example, the questions about which art and artists respondents prefer basically amount to asking respondents about the kinds of information and attitudes that would be acquired in a college introductory art history course. This leaves open the question of what art people have in their own homes. And it leaves open the question of the meaning of such art in people's lives. The absence of information on such questions has prompted Herbert Gans to write:

> The fact is we still know virtually nothing about people and tastes. . . . Surveys can usually afford only to ask people about their most frequent activities and their general likes and dislikes, therefore producing findings about general tendencies. . . . The ethnographic and life-history data that can identify fundamental patterns of cultural choice and that are needed prerequisites to surveys have not yet been produced.[16]

CLASS, CULTURE, AND POWER

The absence of an understanding of the meaning of art and cultural items in the audience's own terrain—the house and its surroundings—has led to a tendency to deduce the meanings that these items must have for the audience. Often these meanings are seen as created by specific outside forces—artists, large corporations, critics, the media—and then, more or less intact, passed along to, or even imposed upon, the audience. This implies an image of the audience as one-dimensional and anemic. I have already pointed to one example—the focus in much twentieth-century art history on the role of artists and critics (albeit placed in their social context). Artists produce works, some of which critics ratify. The audience supposedly does little more than respond to the process, "intelligently" or otherwise.

Sociologists and economists have stressed other outside forces that provide prepackaged meaning to a one-dimensionally conceived, even caricatured audience. Economists, for example, often point to the fact that much art is purchased as an investment, and suggest that art is, for the audience, about the drive to accumulate economic capital. Now, it is true that once particular categories of art are sought after by enough wealthy people, then others will seek them too, primarily and sometimes only for their investment prospects. But why is there a demand for particular categories of art—land-

scape art, "primitive" art, abstract art—making them, in the first place, a suitable investment? Here the economic explanation has little to contribute.

Sociologists have emphasized a different set of external forces—struggles for power, status, and control—as determining much of the meaning of art and culture for the audience. In particular, many sociologists believe that underlying modern art and culture is the drive for power and class domination. Such theories divide into three main types (summarized in table 1)[17]

Art as Status

The first of the theories that closely link culture and power contends that art is mainly a status symbol. Individuals and social classes are said to use art primarily in an attempt to distinguish themselves from, and display their superiority over, others.[18] Thus the meaning of the art for the audience relates, above all, to the dynamics of struggles with outside individuals and classes for social standing.

This theory must have intuitive appeal to explain its popularity, for it faces a serious problem of evidence. When surveyed, people rarely say that the main reason they adopted an artistic or cultural form was status—a desire to display their superiority over others and to have that claim accepted. Not one empirical study of the reasons that people select artistic or cultural items (or other, related items) finds respondents offering status as the main reason for their choice. Of course defenders of the theory may say that this is not a fatal objection. Perhaps status is an overriding consideration in artistic and cultural choices, yet one to which people do not want to admit. Perhaps. But how do we know? Unsystematic data? Our own longings? The risk of projecting the researcher's own status desires onto the topic is apparent. For so empirically minded a discipline as sociology, this weak support for a central theory is unsatisfactory, and perhaps even scandalous.

Art and Culture as Ideological Domination

A second approach that views art and culture from the perspective of power focuses on popular culture (usually then called "mass culture"). Mass culture is said to be a standardized commodity and an ideological tool with which large corporations and the advertising industry dominate and repress the public. This view, stated by Leavis and the "mass culture" school as early as the 1920s and 1930s, as well as by the Frankfurt school of sociology in the 1930s and later, is very much alive today. It seems, for example, to be

popular among Central European intellectuals as they gaze at, and fear dominance by, Western capitalist culture, especially the products of Hollywood.[19]

The notion of popular culture as ideological domination has the merit of stressing that much culture, in capitalist societies, is marketed for profit by corporations, who have an interest in imposing their products on "the public." But it has a major problem. It implies that art and culture for the audience have just one set of meanings (or one "basic" set of meanings) that are somehow attached to the commodified cultural products, and that people simply absorb these meanings. This is a simplistic and condescending model. Why should cultural products have just one set of (basic) meanings? Even if they do, where is the evidence that people more or less passively accept these meanings? Thus this approach, most evidently of all the theories of power and domination, suffers from the absence of a proper analysis of the actual meaning of art and culture for the audience. These criticisms of the notion of popular culture as ideological domination are not new.[20] That the theory keeps reappearing is surely due to its superficial plausibility—the huge financial stakes of certain corporations in their cultural products are evident, as are massive efforts via advertising to persuade the public to buy those products. It is also due to the paucity of in-depth studies of the actual impact and meaning of these products on the audience. Without such studies, it is easy to just assume that the efforts of corporations to manipulate and dominate popular consciousness are successful.

Art as Cultural Capital

The third theory that links culture to power, known as the theory of "cultural capital," also sees culture as a central mechanism in reproducing the class structure of dominant and dominated classes. But it focuses less on the way popular culture represses and mystifies dominated classes, and more on the way high culture—difficult to "appreciate" and understand—serves as a device for excluding subordinate classes from the circles of power and privilege.

This argument has been advanced by two important and innovative sociologists of culture, Pierre Bourdieu in France and Paul DiMaggio in the United States.[21] First, it is argued that appreciation of, and familiarity with, the high arts is a trained capacity.[22] This capacity, which constitutes "cultural capital," is taught above all in the educational system, especially higher education. It is also taught in the modern family, but primarily in the families of the upper-middle and upper classes. Thus the working class and the poor have little chance of acquiring the capacity to appreciate the high arts. Hence

the origin of the two fundamental tastes in modern society—the taste for high culture, which is associated with the dominant classes, and the taste for popular culture, which is associated with the dominated classes.[23]

It is then argued that "cultural capital" operates to preserve and reproduce the class structure since familiarity with high culture is used as a criterion for access to the dominant class. Thus those wishing to enter the dominant classes (obtain important jobs, acquire political and economic as well as social power) are well advised to become competent in understanding the high arts, for this is the cultural capital that will be so crucial for their mobility. Also, familiarity with and participation in high culture operates to build solidarity among the dominant classes. Attendance at common cultural events and discussion of common cultural phenomena, for instance, create class solidarity.

This argument contains important truths, yet is also problematic. On the one hand, it has an immediate plausibility. The apparent inaccessibility to an ordinary audience of much twentieth-century painting is widely known, and has been commented upon by many artists and critics, including Kandinsky, Ortega y Gasset, Clement Greenberg, and Leo Steinberg.[24] It looks as if this is a culture the understanding of which requires specialized training. Further, this is a culture for which the wealthy and powerful appear to have an affinity. Thus the clustering of certain rich families on the governing boards of elite cultural institutions, in the United States at least, is also well known. And works by established artists are typically too costly for all except the wealthy to purchase.

However, "high culture" is not nearly as widespread among the dominant classes, in the United States or France, as the theory implies. While it is true that the survey data we have show that dominant classes are more likely than subordinate classes to participate in high culture, items of high culture do not in fact appear of great interest to most of the dominant classes. On the contrary, high culture often appeals to only a minority of them. One survey conducted in the early 1970s of exposure to the arts in twelve major United States cities not only showed little interest among blue-collar workers in high culture (only 4% had been to a symphony concert in the past year, only 2% to the ballet, and only 1% to the opera) but also revealed that the managers and professionals surveyed were only somewhat more interested. Among managers only 14% had been to a symphony concert in the past year, 4% to the ballet, and 6% to the opera. Among professionals, only 18% had been to a symphony concert, 9% to the ballet, and 5% to the opera. These figures scarcely suggest that managers and professionals

as a group are avid consumers of high culture.[25] This raises serious doubts about the importance of high culture as a criterion for entry into, and continued membership among, the dominant class(es).

The same picture of the limited penetration of high culture among even the dominant classes emerges from a reexamination of Bourdieu's data in France. For example, to probe his hypothesized difference between the taste of the dominant classes and the "popular aesthetic" of the dominated classes, Bourdieu asked each group whether they thought a "beautiful" photograph could be made from an object that was socially designated as meaningless (such as a cabbage), or repulsive (such as a snake), or misshapen (such as a pregnant woman). The idea was to explore the ("legitimate") taste of the dominant classes, which, Bourdieu argues, stresses "formal" qualities of objects and so is more likely to hold that any object can in principle be "formally" presented as beautiful. (The taste of the "popular" or "dominated" classes by contrast, Bourdieu argues, stresses "function" over "form.") Bourdieu did find that only about 5% of the least educated section of the working class thought a cabbage would make a beautiful picture and only 8% thought a pregnant woman would. But the dominant classes were scarcely, as a group, convinced of the aesthetic potential of these subjects. Only 27% of even the most highly educated section of the dominant classes thought a cabbage would make a beautiful picture, and only 29.5% thought a pregnant woman would. This too implies a picture of the high arts as a minority taste even among the dominant classes.

Bourdieu is, of course, well aware of differences in the degree to which "fractions" of the "dominant" class possess cultural capital. He frequently points to an opposition, and antagonism, between the fraction of the dominant class that he views as "richest in cultural capital" ("higher education teachers and cultural producers") and the fraction of the dominant class he views as least rich in cultural capital ("commercial and industrial employers"), with managers, professionals and engineers possessing amounts of cultural capital midway between the two extremes.[26] But these differences underline the problems facing the theory. Bourdieu's own survey data suggest that a majority of even the fraction of the dominant class supposedly richest in "cultural capital" often fails to do, know, or like what Bourdieu claims they do, know, or like. Anyway, Bourdieu's theory is primarily interesting in that it implies that "cultural capital" is a requisite for entry into those sections of the dominant class that are central to the exercise of economic and political power. Yet his survey data fail to show this. The finding that "higher education teachers and cultural producers," groups scarcely at

the center of political and economic power, are rich in "cultural capital," is not striking.

If high culture in the United States and France appears to have penetrated only sections of the dominant classes, it is less clear to what extent that culture functions to reinforce the existing class structure.

So none of these theories that see power, status, or investment potential as a central determinant of interest in art are complete, though some make important points. Each needs to be considered alongside the analysis of art and culture in the material domain of the house.

Notice, too, that all these theories share the tendency in twentieth-century art history to assign a paramount role to artists and critics and a negligible role to the audience, in explaining the emergence and continuing success of new high-culture artistic genres. Thus the theories that high art is basically about the conferring of status or about economic investment see the upper-middle class as following the lead of avant-garde artists and critics in deciding which artistic genres to adopt. Theories of art as cultural capital likewise imply that it is the highly trained (in culture) critics and experts who guide the upper-middle class in the difficult task of "appreciating" ("decoding") new artistic genres. And theories that see a commodified popular culture that is imposed on ordinary people by elites—corporations and so

TABLE 1 Characteristics of theories that link art/culture with power

Name of Theory	Main Function Attributed to Art/Culture	Realm of Art/Culture Stressed (High or Popular)	Extent of Difference Posited between High and Popular Culture	Force Driving Acceptance of New Modes of High Art/ Culture
"Status striving"	Distribution of status	High	Either large or small	Artists and critics
"Frankfurt/ mass-society"	Ideological domination of ordinary people by corporations/ Madison Avenue	Popular	Large	Artists and critics
"Cultural capital theory"	Access to dominant class positions and strengthening solidarity within the dominant class	High	Large, based on education and on family socialization	Artists and critics

on—see high culture, by contrast, as the domain of an embattled intellectual elite struggling to uphold standards.

I do not suggest, in this study, that the audience "creates" new meaning in the way that an individual artist creates a new work. But I do suggest that many meanings emerge or crystalize in the context of the setting in which the audience views the works (house, neighborhood, and the family and social life woven therein); that the content of these meanings cannot, therefore, simply be deduced from the meanings assigned to the works by artists, critics, corporations, or others; and that these new meanings then have an impact on twentieth-century elite and popular cultural history via people's "demand" for certain kinds of art and cultural items that are suitable repositories of these meanings. It would be absurd to deny that, in this process, artists, critics, and others play an important role in influencing the public's tastes. However, it would be just as absurd to overlook the important role played by those aspects of the audience's taste that, emergent in house and neighborhood, have until now in fact been largely overlooked.

THE AREAS STUDIED

The study is based on a sample of houses and residents chosen from four areas in the New York region. The four areas provide, within the limits of a single study, a cross section of social classes and neighborhoods. Two of these neighborhoods are middle or upper-middle class—one in the city (the Upper East Side of Manhattan) and one in the suburbs (Manhasset and adjoining suburbs on Long Island). Two are working and lower-middle class—again, one in the city (Greenpoint, Brooklyn) and one in the suburbs (Medford, Long Island). Figure 1 gives an overview of these areas. The main analysis is based on research in 160 houses, forty from each area. (In order to further explore abstract and "primitive" art, examples of which are found mainly among the upper-middle class, I supplemented the households in Manhattan and Manhasset by interviewing an additional forty households, twenty from each neighborhood, concentrating on these topics.)

In addition to the four main areas studied, I conducted two smaller samples (twenty interviews in each sample), both on Long Island. First, the exclusive vacation houses in the Hamptons on Dune Road and Meadow Road. The Hamptons is the choice vacation spot for Manhattan's economic and cultural elite, and the section sampled, fronting onto the Ocean and to the rear looking over the Peconic Bay, is perhaps the choicest location of

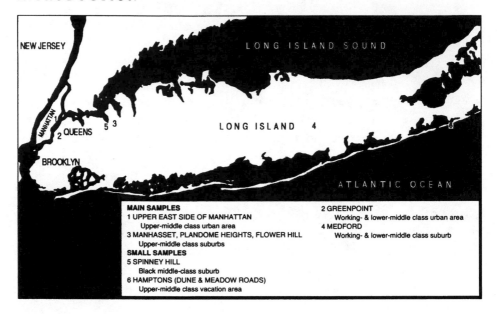

FIG. 1. The main areas sampled: New York City and Long Island.

all.[27] The second sample is a middle-class black suburb, Spinney Hill, which is part of Great Neck, Long Island.[28] I chose Spinney Hill in order to compare the attitudes of whites to "primitive" art with those of African Americans.

The sample size was determined by the aims of the research. Although larger samples, with at least several hundred respondents, make it possible to use more statistical techniques, they are inevitably limited in the amount of detail they can collect. For example, it would be hard to examine the *content* of the art that the respondents display, a fatal defect for this particular study. It was for such reasons that I chose a sample more modest in size.

Upper-Class Urban Area: Manhattan's Upper East Side

The upper-middle-class area consists of the expensive town house of Manhattan's Upper East Side, from Sixtieth to Eighty-sixth Streets and between Second and Park Avenues (fig. 2). While the other three main areas sampled were chosen to be somewhat representative of their type of social class and neighborhood, these Manhattan town houses were selected as an extreme case of the combination of money and culture in a city that, after World War II, replaced Paris as the dominant locus of modern art. Thus the Manhattan residents sampled are as wealthy and knowledgeable an audience for art as any residential group in the United States. Their occupations are of two main

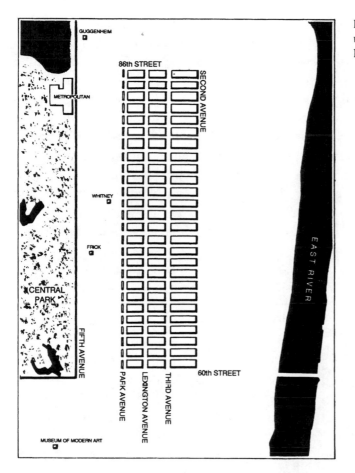

FIG. 2. Upper-middle-class urban area: the Upper East Side of Manhattan.

types—either the upper echelons of business, which offer the economic means to purchase art, or the creative arts themselves. Respondents in the creative arts include an Oscar-winning filmmaker, a well-known photographer, the director of an advertising agency, an architect, and a dealer in "primitive" art. Most of the respondents in business are also interested in art, attending galleries and museums at least from time to time, and some are closely involved with it.[29]

Among the original works in the town houses studied are pictures by Hiroshige, Monet, Vlaminck, Dufy, Sonia Delauney, Rivera, Bolotofsky, Stella, and Stanley; there are also valuable collections of African and pre-Columbian art. Bordering the area is a glitter of art museums: along Fifth Avenue, the Metropolitan and Guggenheim Museums and the Frick collection; on Madison Avenue, the Whitney Museum; and, a short distance southwest of the area, the Museum of Modern Art.

This section of Manhattan was developed in the second half of the nine-teenth century.[30] It was not, at that time, an affluent area. Most of the houses were occupied by middle-level white-collar people or by skilled blue-collar workers, many of whom serviced the wealthy residents of the Fifth Avenue mansions.[31] But through several developments these houses became among the most expensive in Manhattan. The mansions of the rich, located between Fifth Avenue and Madison Avenue, proved too large for twentieth-century urban life and were either replaced by apartment buildings or converted to other uses such as museums or government embassies. In the 1920s the railroad which had run above Park Avenue was routed underground, and Park Avenue started to become fashionable; later on, in 1955, the subway that had rattled along Third Avenue was dismantled and this section became fashionable too. When town-house life grew fashionable again among the well-to-do and middle class in the 1960s, this area became among the most desirable locations in Manhattan.

Working-Lower-Middle-Class Urban Area: Greenpoint

Just across the East River from Manhattan is an urban enclave, Greenpoint, Brooklyn.[32] The section sampled is a moderate-income area, many of whose occupants have blue-collar or lower white-collar jobs (fig. 3).[33] The resi-dences are modest—row houses or small, freestanding homes; most are wood frame. When built, around World War I, they had uniform, brown exteriors. But from the 1930s on, residents covered the wooden exterior boards with colored siding. Now a Greenpoint residential street is a cacoph-ony of colors—greens, pinks, yellows, and blues—to the disgust of many historic preservationists who, having "discovered" these neighborhoods in the late 1960s, treasure the rare wood frame house in Greenpoint that re-tains its original façade.

In fact, hiring a contractor to encase the wood frame houses in siding was the only affordable method of preserving the house as habitable, for the wooden boards, often dating from the 1900s, were warping and rotting. Res-idents were not expressing a distinct "working-class aesthetic" or "working-class taste." If anything, they were trying to make their older, urban houses resemble, even just slightly, the newer, fashionable suburban houses (them-selves often encased in a colored aluminum siding) to which many middle- and working-class Americans were then moving. Indeed, most Greenpoint residents, when asked why they had encased their houses in siding, said they had done so to "modernize" them, to rejuvenate the framework and give it a new look. The occasional houses that still have the original, wood frame

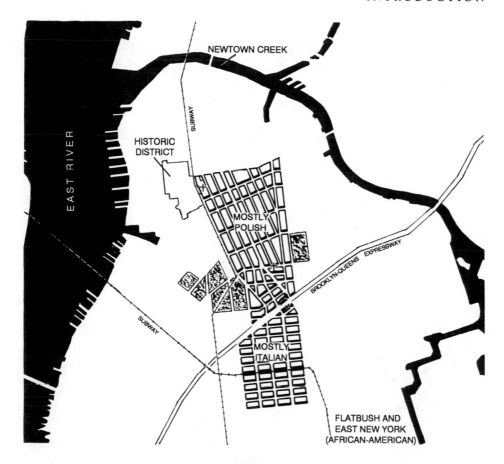

FIG. 3. Working- and lower-middle-class urban enclave: Greenpoint, Brooklyn.

exterior unencased in siding usually do so because they were inhabited by old people who could not afford the aluminum siding with which to cover the draughty and rotting sides and make the house properly habitable.

My research in this area focused on two adjacent sections, one mostly Polish, the other mostly Italian. The Brooklyn-Queens Expressway separates, roughly, these two sections.[34] Greenpoint is a white enclave, bordered on three sides by water (the north, west, and east boarder the East River and Newtown Creek); to the south the Italian section divides white Greenpoint from one of the largest black ghettos in America, Flatbush and East New York.

Greenpoint is viewed in some circles as an area undergoing rapid gentrification by the middle class. This is misleading.[35] Most such gentrification is

limited to a small section north of Greenpoint Avenue which contains many brownstone homes. A few blocks of this brownstone area were recently declared a historic district with a mission to save Greenpoint houses from the desecrations wrought by ethnic and working-class residents who put colored aluminum siding on their modest wood frame houses.[36]

Upper-Middle-Class Suburbs: Manhasset, Plandome, Plandome Heights, and Flower Hill

This group of suburbs is on Long Island's North Shore, about twenty miles to the east of Manhattan (fig. 4). For convenience, I will usually refer to them simply as "Manhasset." They were mostly formed from the subdivided estates of wealthy Protestants who dominated large sections of Long Island before World War II.[37]

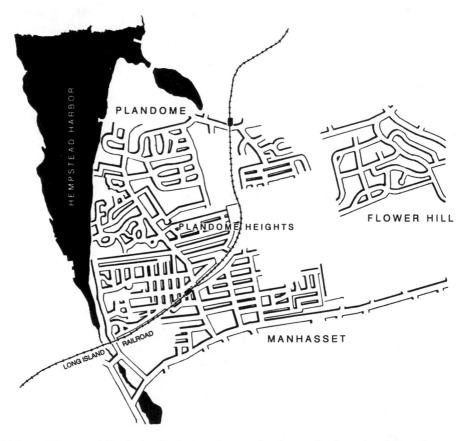

FIG. 4. Upper-middle-class suburbs: Manhasset, Plandome, Plandome Heights, and Flower Hill on Long Island.

Much of Manhasset, Plandome, and Plandome Heights was developed in the period between the two world wars. The styles of the houses thus reflect the prevailing taste for nostalgic and European, especially English, motifs— Tudor houses, large and smaller Gothic cottages, and Gothic romantic houses with turrets and even a tower. In a large section of Manhasset developed by Abraham Levitt in the 1930s, the houses contain many Colonial styles, in addition to the Tudors and Gothics. By contrast, other parts of these suburbs and most of Flower Hill were developed after World War II; the houses there are mostly large ranches or split-levels (although scattered around are some very large, custom-built houses, mini-mansions, five of which appear in the sample).

Despite the variety of housing styles, these areas have much in common. They constitute, in many ways, quintessential American upper-middle-class suburban life—the large, detached house; one- or two-car garage; manicured front lawn; and daily drive to work. They are also exclusive, for they have attempted to keep out, with varying degrees of success, blacks, Jews, and apartment dwellers.[38] Their residents are a mixture of Catholics and Protestants, with a small number of Jews and almost no blacks. (By contrast, next door Great Neck has a large number of Jews and a middle-class black section: Spinney Hill.)

Working-Lower-Middle-Class Suburb: Medford

Just off Exit 65 of the Expressway, in the less fashionable center of Long Island, is the suburb of Medford (fig. 5). Most of the inhabitants are working- or lower-middle-class people. Medford was built by developers in stages in the late 1950s and 1960s and was intended to be inexpensive. The builder laid out the streets in economical grid fashion, like the city, not bothering with the "winding" streets that purport to give more expensive developments in the suburbs a "country" look.[39] The original price of a house was $8,000 (not much higher than the famously inexpensive Levittown houses built a decade earlier). The Medford houses are modest in size—most are simple ranches, a few are split-level. A number of the first residents worked in the plants owned by Grumman, at Calverton (about fifteen miles east of Medford) or Bethpage (about twenty-five miles west).[40]

The houses in the first section built were sold almost entirely to white people. The completion of later sections coincided with a recession in the housing market. That, and a reputation Medford acquired for having many unruly teenagers, led to an exodus of some of the earlier residents. Several of the houses were then sold or rented to blacks, so that Medford now con-

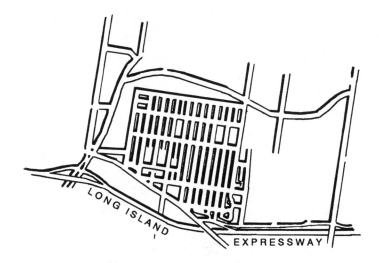

FIG. 5. Working- and lower-middle-class suburb: Medford, Long Island.

tains a minority of black residents, concentrated toward the periphery of the area sampled.[41]

Table 18 and tables A-1 to A-5 (see appendix) present data on the occupations, age, gender, religion, and ownership status of the head(s) of household sampled in each of the four neighborhoods.

METHOD OF STUDY

From each of the four main areas I chose a random sample of houses. Then, with an assistant, I interviewed residents in their homes. I also took a full set of photographs of the interior of most dwellings and drew a floor plan. The sample was drawn from a list, prepared by touring each area, of all the houses. However for ease of comparison I tried to focus on residents who owned their homes, so I excluded those houses with mailboxes indicating that they were subdivided into several apartments.[42]

On starting the project, I was unsure if residents would allow strangers access to their homes. In fact, the response rate was surprisingly high for such a topic. Not counting the Italian section of Greenpoint or the black suburb of Spinney Hill, I obtained interviews in 62% of the houses selected for study. (In the Italian section of Greenpoint the response rate was 39% and in Spinney Hill it was 47%).[43] A number of factors helped persuade residents to cooperate. I sent a letter to each house selected, explaining the

research. With the letter was a *New York Times* review of a previous project I had worked on (a study of the exteriors of working-class houses).[44] This, and Columbia University letterhead stationery, helped arouse the interest of several respondents among the upper-middle class. (Among working-class respondents, especially those on Long Island, the letterhead of the State University of New York at Stony Brook seemed a little more effective.) A few days after I sent the letter, we visited people's homes. When residents answered the door, we purposely avoided asking for an interview at once, since to do so gave people too little time to decide if we were the kind of strangers they could safely allow into their homes. Instead, we talked in a general way about our study. This was important, for it gave people time to assess us and gave us a chance to kindle their interest in the topic.[45] I went with a female assistant because this was, for some residents, more reassuring than a man alone. But in the end, people allowed us into their homes because they allow properly credentialed strangers (such as repair people, delivery people) into their homes all the time. We too presented our credentials.

In a full interview, people also gave us a tour of their house, and allowed a set of photographs to be taken—the latter was a crucial source of quantitative data. Often the house tour came early, proposed by the respondent after a few questions, for it was obvious that many of their answers would make more sense once the interviewer had seen the house. Full interviews were obtained in between 80% and 90% of the houses in Manhattan, Manhasset and Medford and in 70% of those in Greenpoint. Not all interviews were complete. Some people showed us just one or two rooms, and we had to rely on their descriptions for the rest. This we did with reluctance, for experience taught us that relying entirely on people's descriptions of what they had was risky.[46]

I interviewed most respondents twice, and sometimes more. This was because during the research new hypotheses suggested themselves. To explore these I needed to gather further data. In the end I had a list of topics to explore with every respondent, and I used this in further interviews, sometimes by telephone, to fill the gaps in my data. Requests for further interviews were rarely turned down.

DEFINITION OF ART AND CULTURAL ITEMS

Definitions of art and culture are fraught with controversy. For example, art might be defined narrowly to refer only to original items that are considered by experts to have aesthetic value and, often, are expensive. To select at the

outset this definition might close off, or presuppose, the answers to some of the central questions in this study. For example, this narrow definition would exclude almost all of the items in the houses of the working class in Greenpoint and Medford, as well as many of the items in the other houses. It would, therefore, be impossible to compare items that are considered art in this sense with other items such as those by unknown artists, those which are mass produced, and those which register religious devotion.

For this reason I will use the terms art and culture in three senses in this study. These senses range from the narrow to the broad and correspond to the variety of visual images in the houses studied.

First, there is the conventional, narrow sense of "art," which refers to items with the following qualities: they are original, one of a kind rather than mass produced.[47] They are the work of an individual artist, and they are considered to be of financial and artistic value. Items of art, in this sense, are confined to the East Side townhouses and to some of the upper-middle-class suburban houses. "Art" and "culture" in a second, broader sense also include inexpensive reproductions of works of art in the first sense, as well as works (mass produced or original) that experts would probably consider of little or no aesthetic merit. Examples would include a poster of a painting by a well-known artist such as Monet, as well as an inexpensive painting, either original or mass produced, by an unknown artist. Finally, in the broadest sense of all, art and culture refer to a broad range of visual representations, including, for instance, inexpensive religious statues and ordinary photographs.

Using art and culture in these three senses will provide a framework for the study which avoids prematurely determining the answer to questions that should be considered at the conclusion of the study, not presupposed in a preliminary definition.

One qualification at the start. It was impossible to discuss, in detail, the full range of artistic items in residents' homes. Thus I selected those topics that seemed most pertinent to the theories under consideration. For example, I have written about landscapes and family photographs because both are so pervasive. I have written about abstract art and "primitive" art among the upper middle class, and religious iconography among the Catholic working class, because there are class differences in the propensity to display such genres (although such differences should not be overstated), and because these are central topics in the history of art and culture; here then are three "critical" cases, in the sense that if certain theories about the relation of class, culture, and power are true then they should be supported by the findings

from these three genres. I did not write about such topics as the supposed tendency of the working class to cover their sofas with plastic, or to choose paintings made of black velvet, because less than ten percent of the working-class households in my sample did either. For the upper-middle-class households I did not write about Pop or Minimalist art, because it was far less common than abstract art, and I did not discuss Western "primitive" art (Grandma Moses and so on), because it was far less common than non-Western "primitive" art.

The House and Its Context

Certain themes dominate the texture of residential life in all four neighborhoods sampled, themes which can never be far from the consciousness of residents. How, then, could they fail also to dominate the content and meaning of the art and cultural items displayed in residents' homes?

The racially segregated context of these residential neighborhoods has already been described. Among the other themes to be stressed here is "suburbanization," with its attendant ideal of nature as scenic, depopulated, and unproductive—in sum, as the arena for leisure life. Also important is the unfolding of a notion of privacy that involves a shift from the front of the house to the back, the stress on private pleasure gardens, and the decline of "strangers" in the household (reflected in the decline of servants in the homes of the wealthy and the middle class and in the decline of boarders and lodgers in the households of the middle and working classes). The final motif is the primacy of the nuclear family in people's lives outside the workplace, yet the fragility of the relationship between the marital couple; this is reflected not only in the decline in the use of formal sections of the house, but also in the growing demand for an especially intimate space—the den or

family room—intended to counter the centrifugal forces that pull the family apart.

There are, of course, some visible differences in the way these themes manifest themselves in the homes of different social classes. But it will be apparent how much care needs to be taken to avoid mistaking trivial for important differences; even where important differences exist, much care needs to be taken before deciding that these are rooted in differences of education and family socialization which, hard to change, might then be said to underpin basic differences of taste between social classes, to serve as major barriers to class mobility, and to facilitate the cultural domination of one class over another.

In this chapter I lay out these major motifs that inform residential life. In the subsequent chapters I will locate in the context of these motifs many central meanings of the artistic and cultural items that residents display.

UPPER-CLASS URBAN AREA—MANHATTAN'S UPPER EAST SIDE
Layout in the 1880s and 1890s

In the Manhattan town houses of the well-to-do middle class in the 1880s and 1890s, the front was intended to impress, while the back was ignored.[1] A flight of brownstone or marble steps (the "stoop") led to an ornate front door, almost mandatory in American houses of the period (fig. 6). Indeed, it was a reflection of the importance then attached to the facade that many of the defining characteristics of new styles of nineteenth-century New York row houses, from Federal to Greek Revival to Italianate, involved changes in the front door and its immediate surroundings.[2] The backyard, by contrast, was neglected; rear yards were usually less than twenty-five feet deep, overrun by rodents, and within view of the servants working in the basement kitchen. When, by the 1890s, indoor plumbing had largely replaced the outdoor privy, the one reason for residents to visit the backyard was removed. As historian Kenneth Jackson has commented, "A social occasion there would have been unthinkable."[3]

Inside, the house was organized around the distinction between the formal, the informal, and the servants' sections. The formal sections of the house began with a hallway where guests waited to be announced by a servant. From the hallway, they were led to the front parlor (fig. 7, first floor). It was on the formal front parlor that the architect-builder lavished the most effort and expense, for the front parlor epitomized the family's social position—real or imagined.[4] Behind the parlor was the formal dining room,

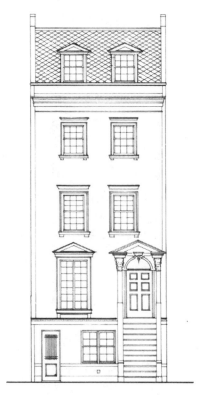

FIG. 6. Well-to-do Manhattan town house of the 1880s–1890s.

where the family and any guests were served meals prepared by a cook in the kitchen below. The family's informal life mostly took place on the second and third floors. The master bedroom ("master's bedroom" in the nineteenth century) was on the second floor and behind it would often be a library or family sitting room.[5]

The servants' domain was the top and bottom of the house. Servants played a central part in these households. A well-to-do middle-class family in New York at this time would have probably had at least three live-in servants—a cook, waiter, and maid, and perhaps a butler too. (A rich family would likely also have had a laundress, a coachman, and a second maid.)[6] These servants, as well as tradespeople, entered the house on the basement level, through a modest door. At the rear of the basement was the kitchen, where servants prepared the family meals;[7] this was linked to the formal dining room above by a dumbwaiter. The top floor contained several small bedrooms for the servants, and also often a nursery, next to a nanny's room.

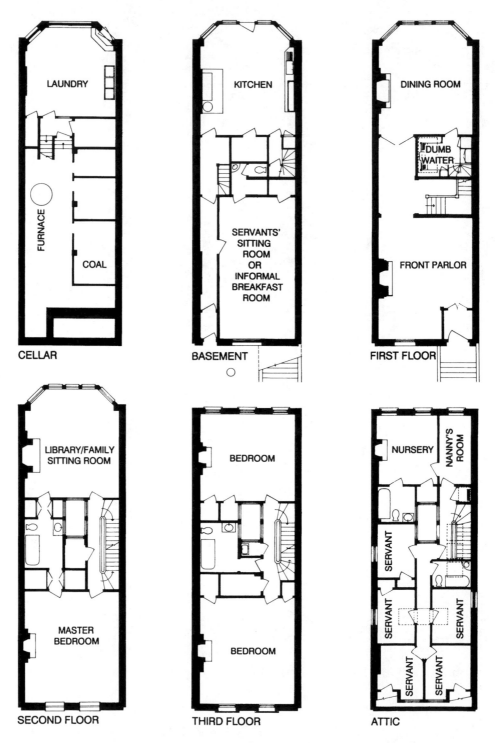

LAUNDRY

FURNACE

COAL

CELLAR

KITCHEN

SERVANTS'
SITTING
ROOM
OR
INFORMAL
BREAKFAST
ROOM

BASEMENT

DINING ROOM

DUMB
WAITER

FRONT PARLOR

FIRST FLOOR

LIBRARY/FAMILY
SITTING ROOM

MASTER
BEDROOM

SECOND FLOOR

BEDROOM

BEDROOM

THIRD FLOOR

NURSERY

NANNY'S
ROOM

SERVANT

SERVANT

SERVANT

SERVANT

SERVANT

ATTIC

FIG. 7. Well-to-do Manhattan town house, 1880s–1890s: cellar, basement, first, second, third, and attic floors.

Layout Nowadays

Exterior

Nowadays, the order of priority between front and back has been re-
versed. The front of these houses is relatively unimportant, while the rear is
prized.[8] The grand outside entryway up a flight of steps has declined. Most
residents prefer to go in through the modest basement door.[9] Indeed, in just
over a third of these houses the formal entryway and stoop have been en-
tirely removed (fig. 8).[10]

By contrast, every backyard in the houses studied is valued, for leisure
and for recreation. These yards are also highly private; each is enclosed with
fences and hedges, at least six feet high and often topped with barbed wire.[11]
Although security from intruders is the main reason for such fences, few
residents regret the loss of direct communication with their neighbors. A
private backyard is what most want, at least in the city. One described, with
scorn, how in the late 1960s a couple with "certain populist ideas" tried to

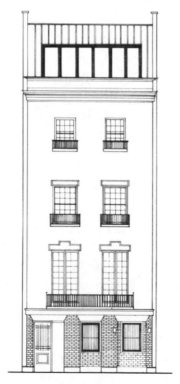

FIG. 8. Upper East Side (Manhattan) town house, nowadays.

persuade all the residents to remove their backyard fences: "They wanted to make it like the Hamptons, where people share a beach in their backyard. But the idea never caught on."

The backyards are of two main types: the contemplative garden and the child-dominated garden. The contemplative garden—a pleasure garden for adults—is the most common, accounting for 62 percent of all the gardens. This usually contains flowers and bushes, one or more trees, and a paved area with chairs and a table (fig. 9). Twelve of these contemplative gardens were designed by landscape architects. Many are in the Japanese style; others, more fanciful, include a garden of ancient Italy (with "Pompeian-style" columns) and an (Asian) Indian temple garden featuring a frieze of six sculpted goddesses.[12]

In households with young children, a child-dominated play garden tends to take priority over the contemplative garden. Here the major space is concreted over, and devoted to items such as swing sets.[13]

These backyards are not, however, ideal, for they are sandwiched between tall apartment buildings. As a result they lack privacy (sometimes children in the apartments above throw objects down to the garden below). Also, the apartments block much of the sunlight, and in summer their air conditioners drone noisily. As a result, just over a quarter of the residents have built roof gardens or sun rooms on the top floor (fig. 8 and fig. 10, fifth floor). With their increased privacy, these are seen as the perfect urban garden.

Productive kitchen gardens are almost entirely absent. In only five gardens is any space devoted to fruits or vegetables, and in all cases this space is tiny. However, a majority of these residents have summer homes, where many grow vegetables and fruits as a leisure pursuit.[14] Ironically, among all the social classes sampled, the "productive" kitchen garden is most thriving as a vacation activity for the wealthy.

In these yards and garden rooms of the wealthy can be seen one of the great themes of modern residential life—a "suburbanization" that has permeated urban life too. An image of life in the suburbs developed during the middle and later part of the nineteenth century that contrasted with the images of urban and rural life prevalent in the 1800s. Now the ideal house, to which one commuted daily from work, rested in the middle of a manicured lawn or picturesque garden. This new notion of suburban life was associated above all with the dominance of a particular attitude toward nature and the landscape. The "country" was increasingly prized, but as a set of scenic and aesthetic values associated with a pastoral and domesticated

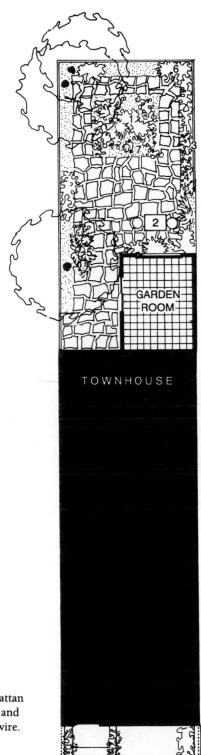

FIG. 9. Backyard (contemplative garden) of Manhattan town house, nowadays. 1. Japanese garden. 2. Table and chairs. 3. 16-foot picket fence, topped with barbed wire. 4. Azaleas. 5. Tubs with petunias. 6. Floodlights. 7. Stone frog.

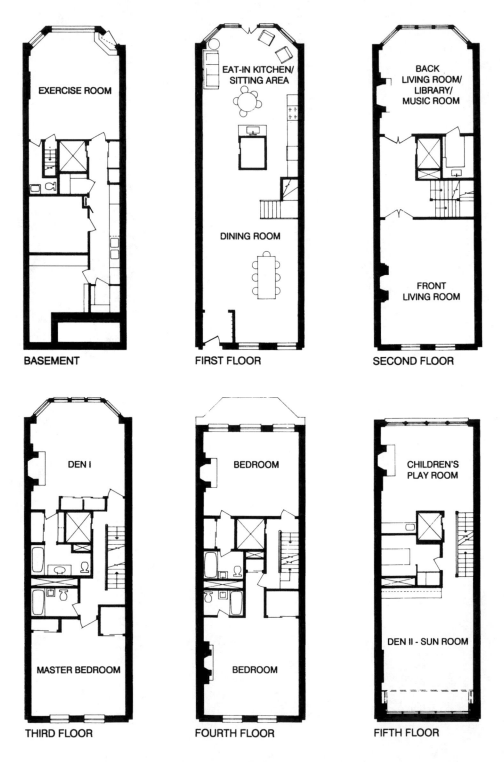

FIG. 10. Upper East Side (Manhattan) town house, nowadays: basement, first, second, third, fourth, and fifth (penthouse) floors.

landscape, and less and less as an agricultural milieu.[15] In these "suburban-ized" Manhattan yards, and in those of the working class in urban Green-point too, is evidence of the enormous power of this ideal.[16]

Interior[17]

DECLINE OF LIVE-IN SERVANTS. The decline of live-in servants in the house-holds of the twentieth-century rich, as compared with their nineteenth-century counterparts, is marked. Only twelve of the forty houses on the East Side currently have a live-in servant, and none has more than one. Further, the function of live-in servants is now mostly limited to looking after young children. In three-quarters of these households with a servant, the servant is a nanny. Thirteen more houses had a live-in servant at some time in the past; in ten of these cases the servant was also a nanny—when the children grew up, the need for a live-in servant was considered over. A second, less com-mon, task of live-in servants nowadays is to look after a sick adult. (There were no current cases in Manhattan, but two households once had a nurse for a sick adult.) Both these functions, as caretakers of children or of sick adults, imply that servants are temporary inhabitants of a house during a particular phase of the family life cycle. Only three houses have a live-in servant whose function is more permanent; in two cases this is a cook/housekeeper and in one case a housekeeper.

The number of servants in the homes of the wealthy and the middle class has been declining throughout the twentieth century. But the modern, es-pecially post–World War II, attitude toward live-in servants reveals a quali-tative change which revolves around a specific notion of privacy. In the early decades of the twentieth century, it was the declining *availability* of servants that was noticed and regretted. The well-to-do middle and upper class on the whole wanted live-in servants, but had problems finding "suitable" can-didates. Thus they complained about the difficulty of obtaining servants, and about the defects of the servants obtained—incompetence, dishonesty, un-reliability, insubordination, and surliness (the celebrated "servant prob-lem"). Already by 1914 most single women preferred to work in a factory, office, or department store, occupations that tended to offer shorter working hours, the companionship of numerous fellow employees, and higher social status than did lowly "domestic service."[18]

The dominant modern complaint in the houses sampled, by contrast, is that live-in servants intrude on the privacy of members of the household. The main issue here is not the availability of suitable servants, but their

undesirability from the point of view of privacy.[19] Mainly for this reason, 80 percent of East Side residents held that live-in servants were unwanted under any circumstances, or were wanted just so long as the children were young. Only a minority did not find the presence of a live-in servant an intrusion on the privacy of the nuclear family. These comments of East Side residents reflect this distinctly modern view:

> A woman in her fifties: "We had someone living in when my child was young. I was very glad to get rid of the help when the child grew up; I got my privacy back."

> A woman in her forties: "We had a nanny living in when the children were young. It was wonderful to have someone when the kids were very small. It's a large house and the kids were afraid, all the way on the top floor; so a nanny was reassuring. But I didn't like having another person in the house. The maid's bedroom was right over ours."

> A Manhattan man in his late forties: "My wife doesn't want anyone else in the house. We used to have an au pair girl. It was a pain in the butt. She's in between a maid and a member of the family. She's like a guest."

This concept of privacy, based on the primacy of the nuclear household, applies to kin as well as to servants. None of the married residents of Manhattan had parents or other kin living in their houses, and almost none wanted such kin living with them. In some cases residents had divided part of their brownstone into a separate apartment, which they rented to strangers, but in no cases did kin live in these apartments. Nor was there a case of a sick parent moving in (the closest was a household that had been considering, for a year, whether the husband's sick mother should come to stay). Half the households were explicitly opposed to this, whatever the circumstances. An architect vividly expressed the common view about having in the household live-in servants or kin who are not members of the nuclear family: "They are like guests, and guests are like fish—after three days they stink!" A woman explained that on the one occasion when her in-laws stayed for an extended visit (a month) she moved out to their summer house.

> A woman in her early sixties: "I wouldn't want anyone except ourselves and our children living here. Our parents could take care of themselves. They didn't have to move in. John's [her husband]

father was taken to Providence when he was ill; he lived in a nursing home."

A woman in her late thirties: "There's too many stairs for our parents to climb to the third floor [the guest room]. [Then would she and her husband vacate their second-floor bedroom?] No!"

ATROPHY OF FORMAL SECTIONS OF THE HOUSE. The formal sections of these Manhattan houses have drastically declined, the continuation of a long trend. Indeed, already by 1921 Le Corbusier, noting the fading usefulness of these sections, was heaping scorn on the many "large houses with so many rooms locked up."[20] This decline extends to each of the three central formal sections of the nineteenth-century town house—greeting hall, front parlor, and dining room.

With the dwindling number of live-in cooks and maids, the formal dining room, as a separate room where a maid serves the family meals that have been prepared in the kitchen, has almost atrophied. As a result the physical separation between kitchen and dining-room areas—a separation that was mandatory in middle-class houses for centuries—has collapsed or been much reduced.[21] In almost all houses the dining and kitchen areas have been merged or closely linked, usually by moving the dining area back down from the second floor to the kitchen on the first floor (the nineteenth-century basement). Typically the kitchen now itself contains such an eating area—the eat-in kitchen (fig. 10, first floor)—or opens directly to the moderate-sized dining area where the nuclear family eats. Thus the sharp physical separation between cook and diners, which reflects a difference between servant and family/guests, has disappeared. A living-room area is often part of this arrangement, resulting in the merged, or semi-merged, kitchen-dining-living arrangement which is also central in almost all the houses in this study (working class, middle class, and upper-middle class).[22]

The formal greeting hall and formal front parlor on the second floor are now rarely used.[23] We have already seen that residents themselves tend to avoid the second-floor entrance, if it still exists, preferring to enter straight into the heart of the house (kitchen-eating-living area) on the first floor. Generally, friends and other visitors are encouraged to enter this way too. Apart from other reasons for this, there is no maid/butler to open the door to them. The entire second floor (formerly called first floor) is typically now composed of seldom used formal rooms. The two main such rooms, the former front parlor and dining room, are now called, variously, "front" and

"back" living room, or "living room" and "library" (usually unrelated to the number of books there), or "living room" and "study," or (very formal) "library" and "music room." Most residents tend to "entertain" about once or twice a month, but on these occasions, though the event may start with an often perfunctory attempt to use one of these formal rooms, it usually soon moves to the informal dining-kitchen-living area downstairs, where it mostly remains.[24] The following example, from an exceptional house with a live-in cook, a maid hired for dinner parties, and an unusually large number of formal rooms, illustrates the heroic efforts often needed to use these spaces. The wife described a dinner party: "We'll start with drinks in the drawing room; then we move into the (formal) dining room; after dinner we move everyone to the study for coffee and liqueurs, and later we shift into the library."

THE INTIMATE ROOM/DEN. In most houses a room with a new name has appeared—the "den" or "family room." (This room is in some ways a distant descendant of the "back parlor.") Ironically, it is usually among the smallest rooms in the house, yet one of the most used. The room is deliberately small, in order to be cosy or intimate. Here the adult couple spend much of their leisure time, watching television or reading and so on; in some houses children gather in this room too. The name given this room varies with the pretensions of the residents. It may be called the "den," the "family room," the "sitting room," the "library," the "garden room" (if it adjoins the first-floor backyard) or the "sun room" (if it is on the top floor). But the function is constant: an intimate place where the adult couple, and perhaps their children, can gather. Common locations for this room are next to the master bedroom,[25] or on the first floor looking out onto the back garden, or on the top floor in the sun room. Given their wealth, it is no surprise to find that several residents have two such rooms designed to foster family intimacy in marginally different ways (one, for example, might be for evenings, another for the daytime). These comments are typical of the attitude toward the intimate room. One woman said of the glass-enclosed room on the top floor, "We just love it up here. It's completely relaxing and cosy. It's an inner sanctuary." A male resident, speaking about the room next to their bedroom: "We hang out in our 'sitting room'—it's like a little living room, but it's cosier and more manageable." Another woman said of her "garden room," adjoining the living room and a fraction its size: "Time-wise this is the most used room in the house. I can be here and watch TV while I'm knitting. Then in the evening we often sit in the den [a small room adjoining the bedroom]."

WORKING-/LOWER-MIDDLE-CLASS URBAN AREA: GREENPOINT
Layout before World War II

Until the 1950s, and even later, the front of the Greenpoint houses studied was part of an active social life. In the summer, for example, adults spent considerable time sitting in front of their houses.[26] Children typically played in the streets—stickball, punchball, hide-and-seek, and so on—and elsewhere, for example in and around the creek and in the park. A study of Greenpoint written in 1940 notes, disapprovingly, that the streets "swarm" with children most of the time after school hours and are "full of ball players at all hours."[27]

In keeping with the importance of the front, and like the East Side houses, every Greenpoint house studied was built originally (around 1900–20) with a front stoop leading to a decorated front door (fig. 11). (A modest ground-floor entrance led to the basement, where the coal and wood for heating were stored). By contrast with this front orientation, most backyards were either productive kitchen gardens, in the mostly Italian section, or were

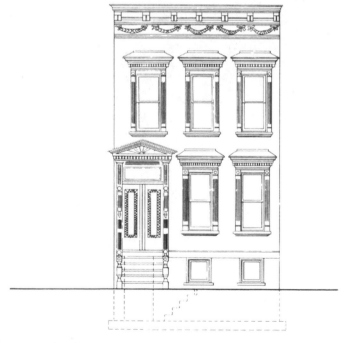

FIG. 11. Greenpoint row house, 1900s.

unused, in the mostly Polish section. The kitchen gardens were classic ur-
ban, working-class gardens, like those common in sections of European cit-
ies until World War II and even later. They were crammed with vegetables
and fruits, but contained few flowers, for these were seen as unproductive—
a luxury that represented a waste of valuable space.[28]

The houses sampled are of two main types—row houses and small, de-
tached houses.[29] The row houses consisted of two floors, and a basement,
and were intended for two families. The layout of each main floor was stan-
dard and almost identical (see fig. 12). The front door opened to a formal
entrance hall within. To the side of the front hall was the formal "parlor."
Andrew Jackson Downing, the nineteenth-century architect, held that a par-
lor was not an appropriate room for the houses of "working men," for they
lacked the resources to entertain (it was such views that earned for Downing
the epithet "snob and aesthete").[30] Nevertheless, and despite cramped living

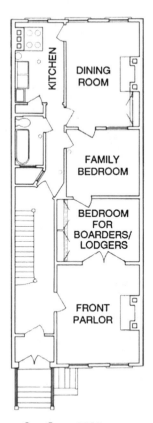

FIG. 12. Greenpoint row house, first floor, 1900s.

quarters, most of the families in these houses in Greenpoint in the 1910s and 1920s insisted on maintaining a parlor, for special occasions such as when guests came. Much of the time this room was indeed unused.[31] Behind the parlor three rooms extended in series to the back of the house. The first was a bedroom, often inhabited by the boarders or lodgers who were common in the households of the working and middle class in nineteenth-century America.[32] Thus "strangers," as well as newly immigrant relatives, were once common as residents of these Greenpoint households, as in the East Side houses. Behind this bedroom was another, where the family slept. In the rear was the dining room, where the boarders and the family ate meals, cooked and served by the women of the family in the adjoining kitchen.

Layout Nowadays

Exterior

Now much of the street life of which these houses were a part has declined, though it remains more vigorous than in any of the other areas studied. There are several causes for this decline. The spread of the automobile (many of the street games children played were clearly incompatible with a continuous flow of cars); the growth of notions of privacy; the increase in home comforts and appliances—radio, television, air conditioning, inexpensive swimming pools, barbecue equipment, and so on.

Just as in Manhattan the decorative door is almost extinct (see figure 13). It is now usually stripped of its ornamentation and covered with flat aluminum siding. Although this was the only economically viable way to preserve rotting structures, the absence of provision for an ornate front reflects the declining importance of the façade.[33] In over a third of the houses, the front stoop no longer exists either. In the houses where the formal stoop remains, about half of the residents usually ignore it, entering instead through the basement. One such house limits use of the formal front door to weddings and funerals: "Our two daughters married out of the front door. And when my husband's parents died, they were carried out through it. These are the only times we use it."

With the partial decline of street life has come the use of the backyard (just as in the Manhattan town houses) for recreation.[34] The unused backyard is now rare. The Greenpoint backyards sampled fall into three main types. There are "contemplative gardens" (for adults), child-dominated gardens, and productive kitchen gardens. The latter, however, are on the wane.

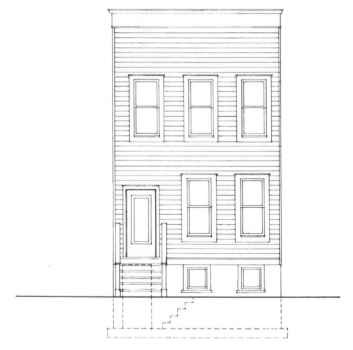

FIG. 13. Greenpoint row house, nowadays.

Child-dominated gardens, which constitute just under a third of all the gardens, are typically mostly paved over, both so children can run around without getting dirt on themselves and, often, to serve as the base for an above-ground swimming pool. Only one child-dominated garden did not have a pool. The move toward private pools gained impetus in the 1970s, after vandalism led to the closing of the large public pool in Greenpoint. The following is an example of such a garden (fig. 14). The husband, a mainte-nance man in a Manhattan apartment building, and his wife, who is disabled, live on the first floor of the house. A married daughter lives with her family on the second floor. A pool, installed for the grandchildren, takes up two thirds of the yard; it used to rest on grass, but the chlorine was killing the grass, so the husband cemented the area around the pool. In the remaining soil on one side are tomato plants, which the son-in-law looks after ("It's his hobby"). The husband has no interest in growing vegetables. "If I want veg-etables, I'll go to the food store." But he enjoys flowers. In a strip of earth at the back he has rosebushes, marigolds, some purple flowers, two plastic fawns, plastic bunnies, plastic daisies, and a pine tree.

A second main type of garden is the "contemplative garden," accounting

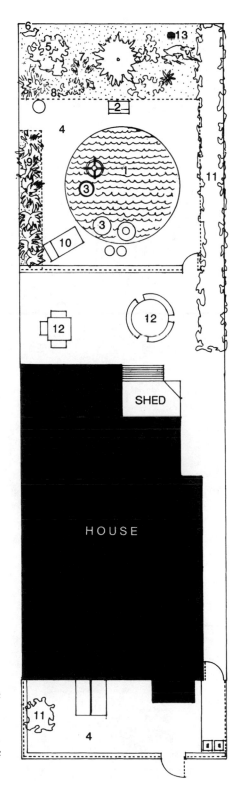

FIG. 14. Play garden for children, Greenpoint. 1. Above-ground pool. 2. Barbecue equipment. 3. Pool toys. 4. Concrete. 5. Rose bushes. 6. Plastic duck. 7. Toy rabbits. 8. Purple flowers. 9. Tomatoes. 10. Beach chair. 11. Bushes. 12. Table and chairs. 13. Telephone pole.

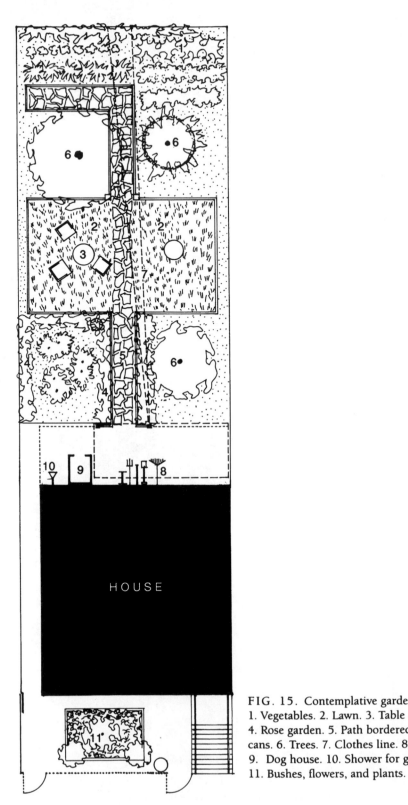

FIG. 15. Contemplative garden, Greenpoint.
1. Vegetables. 2. Lawn. 3. Table and chairs.
4. Rose garden. 5. Path bordered with beer
cans. 6. Trees. 7. Clothes line. 8. Tool area.
9. Dog house. 10. Shower for grandchildren.
11. Bushes, flowers, and plants.

for just over a third of the Greenpoint gardens. Here residents relax. Flowers are the central contents. Consider an example (fig. 15). The husband, a Puerto Rican, works as a doorman in an apartment building in New York City; his wife, from the Dominican Republic, stays home. Both spend a great deal of time in the garden during the summer, much of it relaxing and, in the husband's case, drinking beer. There is a flower section, which the wife takes care of, that covers about 40 percent of the yard. The husband takes care of the remaining sections. These include a decorative rock and shrub section, which looks like a Japanese garden, though the husband says it is not; he just got the idea from looking at gardens he liked. There is a small lawn area in the middle, with a table and chairs, surrounded by a border of decorative beer cans half buried in the soil. A concrete area near the house contains an outdoor shower/sprinkler for the grandchildren to play under, as well as a tool shed and dog kennel. Finally, there is a modest vegetable section.

The backyards in a fifth of the houses sampled in Greenpoint resemble the classic, urban working-class kitchen garden, where produce is grown mainly for economic reasons.[35] Yet the position of the kitchen garden is precarious, usually under pressure to give way to the child-dominated garden (for children and then grandchildren) or the "contemplative garden."[36] The following is a case study of a kitchen garden (figure 16). The husband, a science teacher in the New York City public schools, grows vegetables to save money ("We eat the vegetables; you can't eat flowers"), but the kitchen garden is scarcely central to the household economy. Indeed, this yard has not always been a kitchen garden. When the wife (a secretary) moved in twenty years ago, she planted flowers and aimed at a contemplative garden. She feels that flowers bring a touch of "the country to the city." Soon after her little boy was born, she converted the garden to a child-dominated yard, putting down a large section of concrete in the backyard so that he could play easily with other boys from the neighborhood, safe from the auto traffic in the front. When the child grew up and the woman's first husband died, her second husband converted the backyard to a kitchen garden. The wife would still prefer a contemplative, flower garden, but so far defers to her husband. Along each side of this garden, in two long strips, grow asparagus, horseradish, zucchini, tomatoes, rhubarb, and snow peas. Near one strip is a mesh frame, which protects the vegetables within from cats, birds, and squirrels. At the back is a shed for the husband's tools. A central section, covered in concrete, contains a workbench, a table and chairs, and various potted plants, most of which were given to his wife as presents on occasions

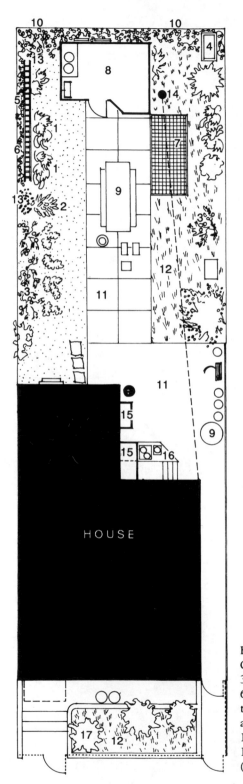

FIG. 16. Productive kitchen garden, Greenpoint. 1. Zucchini. 2. Cucumbers. 3. Tomatoes. 4. Rhubarb. 5. Horseradish. 6. Asparagus. 7. Mesh, covering zucchini, tomatoes, and cucumbers. 8. Toolshed. 9. Table and bench. 10. Ivy. 11. Concrete. 12. Grass. 13. Blueflowers (weeds). 14. Telephone pole. 15. Small sheds. 16. Xmas plant and poinsettia (in pots). 17. Bushes.

such as Mother's Day. In front of the house are two large shrubs, some grass, and a window box with pink petunias.

Scattered around the neighborhood are "wild" yards, of two kinds. One type is uncultivated (overgrown). The other kind is seen as dangerous, usually because of the presence of a ferocious dog. These wild yards are not common—none of the houses sampled had one. Where they exist they usually arouse the ire of neighbors, thus underlining the dominant expectation that yards and gardens be cultivated and tame.

Internal Layout

The earlier practice of having boarders or lodgers sharing living and eating facilities with the family is defunct. There are no boarders or lodgers in the Greenpoint houses sampled. To have strangers living in the household is now, in Greenpoint as in Manhattan, an infringement on the privacy of the family. The dominant preference among Greenpoint households is for the household unit to consist only of the nuclear family—husband, wife, and children not yet grown up.[37] A number of households rent sections of their house to strangers, but these sections are always self-contained, separate apartments.

Where Greenpoint differs from Manhattan is that close relatives (and their nuclear families) often live in the same house, which is, however, divided into physically distinct apartments.[38] In these cases each household will usually occupy one floor of the house. Almost one in three houses in the Greenpoint sample fall into this category.[39] Thus the dominant preference in Greenpoint is for the household, if not the house, to be nuclear. However, Greenpoint residents are more likely than those in Manhattan to make an exception for a sick relative, especially a parent, to live in their household.

The formal section of the house has declined, as in Manhattan. At some point it was no longer obligatory to have a formal entryway leading to a formal hall in which guests were greeted and then entertained in a formal front room (the "parlor"). The parlor was replaced by a less formal "living room" (which older residents often still call "the parlor"). But the living room could no longer be at the opposite end of the house from the kitchen and dining room. Above all, the idea that the women of the house should cook for the other residents, including boarders, in a kitchen some distance from where the social life of the house occurred lost its attraction. Thus the living room was relocated next to the dining room or was merged with it, producing the linked kitchen-dining-living space that is the center of the

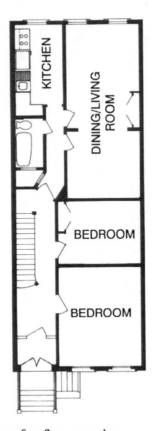

FIG. 17. Greenpoint row house, first floor, nowadays.

modern home of all the social classes studied. The front room, freed from doing duty as a parlor next to the front door, became a bedroom (see fig. 17). This has happened in almost all the row houses studied in Greenpoint. The hall still exists, but only in a few houses does it appear formal; indeed, sections of the hall are now often used for storage.

UPPER-MIDDLE-CLASS SUBURBS: MANHASSET, PLANDOME, PLANDOME HEIGHTS, AND FLOWER HILL

Exterior

These upper-middle-class suburbs represent, in extreme form, the decline of street life. Almost no one passes by on foot; even automobiles pass only intermittently. The main sound in summer and autumn is the droning of the hired gardeners' lawnmowers, like speedboats on an empty ocean.

There is little reason for residents to spend time in the front, for there is no one to greet on the street and nothing special to look at. Further, there is a common view that sitting in the front of the house is socially inappropriate behavior which may take place in urban working- and lower-class neighborhoods but not in the suburbs of the upper-middle class. A woman in Plandome expressed the dominant view: "I ignore the front yard; you wouldn't sit there. People would think you were strange sitting out there. It just isn't done." Older people who grew up in urban neighborhoods when some social life still occurred in front and around the street are more likely than younger people to sit in the front. But they know they are unusual.[40] The front door is typically less used than a side or back door or an internal door connected to a garage. In three-quarters of the households adult residents usually enter through the side, the back, or the garage. As in Manhattan, and increasingly in Greenpoint, external social life has shifted firmly to the backyard (despite a ban, in some of these communities, on fences that separate front from back—a now purely symbolic gesture rooted in the builder's desire to preserve an older idea of community).

Most of the gardens in Manhasset and Flower Hill are large enough to host both of the two main types: the garden for adults (mostly contemplative, but with some opportunities for active leisure, represented especially by the pool) and the play garden for children. Seventy-five percent of the gardens fall into this category. However, except in the very largest houses, there is still some tendency for gardens to stress either the adult or the child orientation.

The kitchen garden is of minor importance. Only a quarter of these gardens have serious kitchen sections. The rest have little or no kitchen produce. One woman described her vegetable section as "pitiful." Another sometimes plants vegetables and sometimes doesn't "get around to it." A third grows a few vegetables—tomatoes, lettuce, herbs—but flowers are her passion and she is loath to devote space to vegetables. "I'd like it [the yard] to look like a garden rather than a vegetable patch."

Figure 18 shows a typical frontyard and backyard, in Plandome. When the children were young, the backyard was child-dominated, with a swing set and jungle gym; attached to the garage at the rear is a basketball hoop. When the children became teenagers, the wife started planting flowers and has continued to do so. A few years ago they replaced the tiny stone patio in the rear with a large, wooden deck, where the husband loves to read. They are planning to add a Japanese garden next to the deck (the husband is a dealer in Japanese art who works in Manhattan). Some strawberries grow in

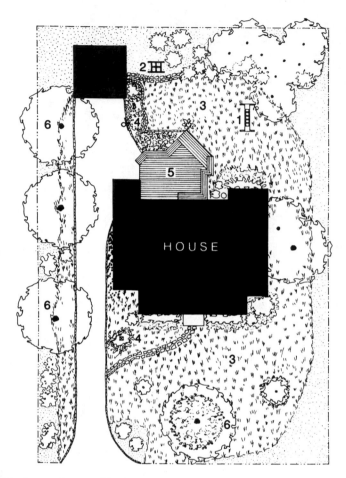

FIG. 18. Manhasset front and backyards. 1. Swing set. 2. Jungle gym. 3. Grass.
4. Flowerbed (petunias, roses). 5. Deck. 6. Trees.

a small section of one of the rear flower beds; this bed once contained more
vegetables—tomatoes, lettuce, and peppers, but the couple stopped growing
vegetables because they now spend most of the summer in a large family
vacation home, further out on Long Island, where a gardener provides fresh
vegetables for dinner.

The following garden, designed by a landscape architect, is in one of the
small number (five) of mini-mansions in this sample (fig. 19). It is interest-
ing because the activities it contains are similar to those in gardens in
working-class Greenpoint and in the more usual type of Manhasset house,
just grander in scale and with room for all functions to coexist. A section of
the rear is set aside for the residents' small children. Also in the rear is a

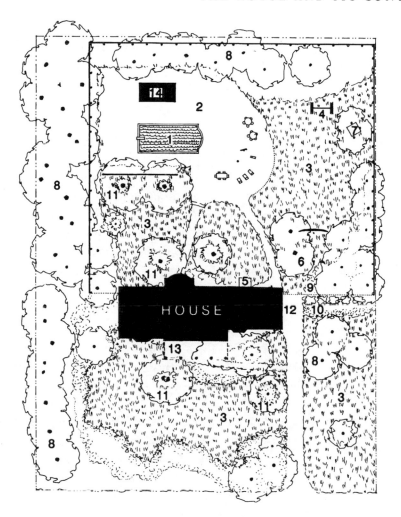

FIG. 19. Grounds, Flower Hill mini-mansion (1 3/4 acres). 1. In-ground pool (40 × 17 ft.). 2. Tiled floor/path. 3. Lawn. 4. Volleyball net. 5. Patio and barbecue equipment. 6. Tree house for children. 7. Swing set. 8. Trees. 9. Vegetable patch for children. 10. Rose bushes. 11. Petunias. 12. Garage and regular entry into house, via kitchen. 13. Formal (seldom used) front door. 14. Cabana.

large in-ground pool (about forty feet by eighteen feet) and a cabana; around the pool, on a red tile floor, are tables and chairs; the family often has social gatherings here. Attached to the back of the house is a small patio, where the wife's mother, who lives with the family, often sits; nearby is a barbecue. To the side of the lawn is a small patch for vegetables, which the wife keeps to "give my seven year old something to do." The rest of the back, and most

of the front garden, consists of expansive lawn, broken up by large trees, each surrounded by a flower bed. A front driveway brings residents to the garage on one side of the house, from where they enter to the kitchen. Off the driveway a small red tile path leads to the seldom-used front door.

Internal Layout

As in Manhattan and Greenpoint, there is a distinct preference for the residential unit to consist solely of the nuclear household. Married residents of Manhasset rarely live in the same house as their parents or other kin except in the case of illness, particularly the illness of a parent. Five households are sheltering or have sheltered a seriously ill parent, sometimes grudgingly, sometimes not. In two of these cases the parent remained in the household until or almost until death; in another case the parent eventually moved to a nursing home; in a fourth case the parent moves in when sick and then returns home to live alone when better. At present only one sick parent lives permanently in the same house with a married child.

The live-in servant is no longer a standard presence in an upper-middle-class home. Only 40 percent of the houses sampled have, or once had, a live-in servant. And, as in Manhattan, the live-in servant is associated with temporary phases in the family life cycle—mainly with the care of young children; in some cases the care of sick adults. In only one house is there a live-in servant whose main duties are cooking and housekeeping. As in Manhattan, privacy is the main reason given for this decline.

The changing role of servants can be traced in the architecture of the houses sampled. The five mini-mansions in the sample were each originally built with a separate servants' wing upstairs that could accommodate two or three people, and with a backstairs leading from the servants' rooms to the kitchen. Three of these houses still have a live-in servant, but there have been several changes (in addition to the main function of full-time live-in servants being now limited to looking after young children or a sick adult). For one, there is only one servant in each household. For another, the system of buzzers used to summon servants has fallen into decline and is seen as depicting a form of relationship inappropriate to the modern home. One woman (who has a live-in housekeeper) commented, "When we moved in there were buzzers in the living room and dining room; we took them out. That's a decadent idea. Would you like someone to ring for you? It reminds me of Pavlov's dogs." Another woman said, "The previous owner was rich—she had lots of servants. She never ate in the kitchen; she just buzzed for the servants."

Some of the less-grand houses built in Manhasset and Plandome in the late 1930s, 1940s, and 1950s were still designed with servants' rooms, usually next to the kitchen (rather than a full servants' wing). Residents of many of these houses nowadays, not wanting a live-in servant, have enlarged the kitchen by opening it into the former servant's room. In other such houses residents, discovering the need for a temporary live-in servant but finding that a servant's room next to the family-used kitchen intrudes on their privacy, have put the servant's room elsewhere, often in a specially constructed room off the living room (perhaps a former office or an enclosed side porch).

But most of the Manhasset and Plandome houses built in the 1930s or the next two decades, including those built by Levitt, had no servant's room, although the full implications of removing the servants from the middle-class home had yet to be recognized. Thus in many ways the internal layout of these Manhasset/Plandome houses constituted scaled-down versions of larger middle-class homes, with the servants' sections simply removed. The servant's room next to the kitchen disappeared, as did the servants' room(s) upstairs with a backstairs link to the kitchen. In contrast, the spatial separation between kitchen and dining room on the one hand and living room on the other—a separation that implied some need to distinguish those who cooked the meals from those who socialized together—remained. Indeed the internal layout of the houses built in the 1930s and 1940s was remarkably constant (despite a cacophony of external styles, including Tudor, neo-Gothic, and Colonial). Off an entry foyer was, on one side, a living room. On the other side of the foyer was a dining room. Separate from the dining room but adjoining it was the kitchen (fig. 20). (Upstairs were the bedrooms.) This basic layout was so common that several residents who were young adults at that time satirized it. As one woman put it: "You went into the foyer, 'march march' to the left was the living room, 'march march' to the right was the dining room, 'march march.'"

It was only with houses built in the late 1950s and 1960s that the architectural and social consequences of middle-class houses without servants were fully acknowledged. First, since food was now cooked and placed on the table by family members, the kitchen and dining areas were merged (eat-in kitchen or kitchen opening onto dining room). Second, because the person cooking was now likely to be participating in the social life of the house, the "living room" had to be closer to the kitchen/eating spaces, which led to the merged living-dining-kitchen that is the heart of the modern ranch house.

The ranch houses built in Flower Hill in the 1950s and 1960s and later

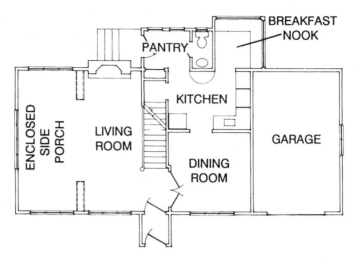

FIG. 20. Manhasset house, first floor.

exemplify this new layout (see fig. 21). They contain, in the same house, two versions of the merged cooking-eating-living arrangement, which differ in terms of the number of people they can accommodate and in their degree of "formality." One version, for the nuclear family, combines all these functions in a large eat-in kitchen. The second version, for a larger gathering, has a kitchen that flows into a dining room which flows into a living room which in turn flows back into the kitchen.

The Flower Hill ranch houses also exemplify the emergence of the "den" or "family room"—a cosy room in a large house. Thus the typical den is, in these houses as in Manhattan town houses, a small room near one of the central sections of the house (usually just off the kitchen or the master bedroom). A female resident: "The den is the room we use most often. It's near the kitchen and it's cosy." Another female resident: "The den is the family collapsing room. You don't have to be formal there. It's for my husband and me." A male resident: "We spend most of our spare time in the den, watching TV and so on. We feel comfortable there."

The dynamics of the modern den/family room are underlined by the demise of its historical predecessor in suburban homes—the finished basement with bar. The finished basement that featured a bar as its central attraction was an innovation in many of these Manhasset houses in the 1940s, 1950s, and 1960s. Most of the suburban houses that date from this period have such a basement. In its heyday, the finished basement had at least two functions, both of which in retrospect can be seen as transitional for adults

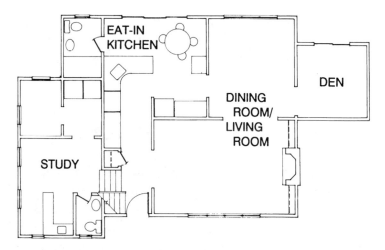

FIG. 21. Flower Hill split-level ranch, lower level.

and children from a public social life to a social life anchored more in house and family. For adult males, the finished basement represented a transition from social drinking (in male clubs, for the upper-middle class, and in taverns for the working class) to drinking at home, often with the wife. It was also a place where children could play away from the street. Nowadays the finished basement is often barely used, though in some houses it remains as a recreation room, coexisting with the den/family room upstairs that has largely supplanted it. There is a clear feeling among most adults, especially among the women, that the finished basement room is too far, too distant from the center of the home. It was all right in the days when most mothers were just housewives, but it lacks intimacy for mothers who wish to be close to their children on returning from a day's work.

WORKING-/LOWER-MIDDLE-CLASS SUBURB—MEDFORD
Exterior

Neighborhood relations in Medford are dominated by a notion of privacy that has emerged to contrast life in a post–World War II working- and lower-middle-class auto suburb with life as it once was in an urban neighborhood or in a small town or rural community. The essence of this notion is that there is no reason why neighbors should, or would, spend social time together just because they are neighbors. Friendships between neighbors are not discouraged, but neither are they required or expected. Indeed, the dom-

inant expectation is that neighbors will lead separate social lives. This attitude is summed up in a series of related phrases residents use to describe social relations in Medford. People "leave each other alone," "keep to themselves," "don't bother each other." There is broad agreement in the sample of residents interviewed that cordial detachment is the norm for social and neighborly relations in Medford.[41] A woman in her late thirties said: "As regards sociability, we're not that kind of neighborhood. Everyone works and values their privacy in this neighborhood. We don't socialize because we're all doing our own thing. If I'm out here in front washing my car, I'll chat with my neighbor on that side. Or if someone needs help pushing their car, we help, but . . ." And a woman in her mid-fifties commented: "Everyone gets on pretty well here. But they keep to themselves. For instance, I don't know the neighbors. The only people you get to know in the neighborhood are people with children the same age as yours. You get to know them through your kids at school. A new woman moved in next door. I went to say 'hello.' She said, 'Don't bother me!'" The view that people get to know other people in the neighborhood mainly through their children was common.

Residents varied in their opinion of this norm. Most liked it or at least thought it was appropriate to the life-styles of busy and mobile people in this kind of auto suburb. A minority regretted it. But everyone agreed on the description of the norm.[42]

Such a notion of privacy is reflected in the character of street life in Medford, which is more like upper-middle class suburban Manhasset than like the traditional notion of an urban working-class community. Little adult social life occurs in front of the house, and residents of Medford are not much more likely than residents of Manhasset to sit there. Three-quarters almost never do, and most of the rest do so only occasionally. The main reason they mention for this is a desire for privacy.[43] As in Manhasset, adults who routinely sit outside their houses are likely to be elderly, stuck in habits learned in more social places and at earlier times. Still, unlike the upper-middle-class suburb, none of these Medford residents thought sitting in front of the house would lower the social tone of the area. There was no social taboo against sitting in front, just little reason to do so.

Such street life as exists in Medford is focused on the children. Children go from house to house to meet friends, and sometimes play on the streets.[44]

The prominence of backyards reflects this notion of privacy. As in the other three areas studied, backyards in Medford are important. They are

dominated by the pleasure garden (for adults and children), and especially by the pleasure garden with above-ground pool. Since these yards are larger than those in Greenpoint they can accommodate a pool big enough for adults to join the children. About half currently contain pools, and other residents are intending to install one. The trend took hold in the mid 1970s, when above-ground pools lined with vinyl became affordable, and accelerated in the late 1980s, when the polluted state of local beaches was widely publicized after raw sewage and medical waste washed ashore.

There is some enthusiasm for flowers and the contemplative garden. However, the chlorinated water splashed on the grass and soil, as well as a lack of spare time, limits the spread of flower gardens. Only 20 percent of the houses contain backyards dedicated to flower gardens (and some of those also have a pool).

Although more than half the residents grew up in houses with a kitchen garden, a generation later, in this modern auto suburb, the productive garden is of minor or no importance (even less important than in Greenpoint). Twenty-five of these yards contain no vegetable section at all and another five only a tiny patch. The dominant view is that planting vegetables is uninteresting, takes too much time, and is pointless, for roadside stands sell inexpensive fruit and vegetables grown from local farms. The following comments reflect these sentiments: A woman in her forties: "I used to plant vegetables (and flowers) but I don't have time." A woman in her mid-fifties: "I don't plant vegetables. You can go out and buy them for a dollar. I don't like yard work of any kind. I have someone come in to mow and seed." One woman's "vegetable plot"—a small dirt area about one yard square and in the shadow of the pool—contained just a single thirsty-looking plant, of whose name she was unsure: "It's an herb of some kind. A friend of my husband's gave it to me. Growing vegetables is a lot of work, which is why I don't. Anyway I'm not interested in it." One man once planted vegetables just before his (Italian) father came to visit from Florida; the idea was to give the old man something to do during his stay.

Residents of Medford tend to fence their backyards in on all four sides, like residents of Manhattan. The backyards of 87 percent were fenced all around; moreover, the side and back fences are almost always solid (wooden boards or bushes) rather than open wire fencing. Part of the reason for these fences is the prevalence of pools, for pools must by law be fenced in to prevent neighboring children from wandering into the area and drowning. Also three-quarters of the sample have dogs, usually for security against

burglars, and dogs must be fenced in. Finally, there is the desire for privacy, often linked with the backyard pool. Many adults do not, for example, want neighbors, whom they may not know, to see them in their pools.

Internal Layout

Medford houses are almost all versions of the ranch style (see fig. 22). Their basic floor plan is the familiar, unified living-dining-kitchen space— the heart of the modern home without servants, boarders, or lodgers. The first developer, who built abut a third of the homes in Medford, constructed a simple ranch house in which the merged living/dining area flows into the kitchen (which can contain a small table to seat four), which in turn flows into the living area. On the other side of the house are three bedrooms (see fig. 23). This simple ranch model, with slight variations, accounted for 40 percent of the houses sampled. A second developer, who built about another third of the houses, put up homes that were just more elaborate versions of this basic model. One elaboration involved adding a basement, either a low one (the "bi-level ranch") to house the boiler so that an extra closet could now go upstairs where the boiler had been, or a taller basement (the "high ranch") for use as recreation space. Twenty-five percent of the houses sampled were bi-level or high ranches.

A different version was the "split-level ranch," which had, on the entry level, a merged dining room and kitchen on one side and a living room on the other. A few steps below was a den/play/recreation room and a bathroom. Above the entry level were three bedrooms and a bathroom.

These designs are fairly satisfactory to most residents. In a few houses bedrooms have been added, usually to one side of the house. Two families added "formal dining rooms" (a room separate from the living room and the

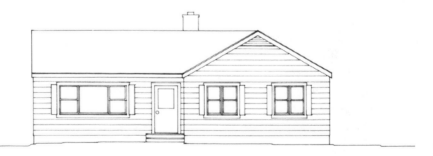

FIG. 22. Medford ranch.

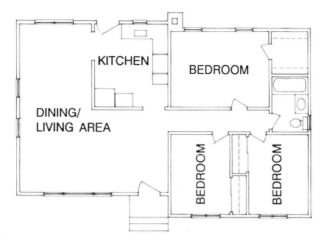

FIG. 23. Medford ranch, indoors.

kitchen) but apparently not with success. In one case the dining room is scarcely used. In the other case it has been converted into a den.

The den/family room is the main new room to appear. The split-level ranch began with such a room, and it has remained in all such houses sampled. Six other houses have created a den/family room either by building an addition or converting another room—always on the main level. Half of the houses with high basements have converted them into recreation rooms (with pool tables, etc.) but these are not usually called den/family rooms, and are seldom viewed as such. As with the suburban houses in Manhasset, there seems to be a feeling that a den/family room ought to be nearer the heart of the house.

CONCLUSION

The suburbanization of urban as well as suburban life; the waning of productive vegetable gardens and the conversion of backyards into leisure sites; privacy (as evidenced, for example, in the eviction of strangers from the house); the importance, yet fragility, of the nuclear family (as evidenced in the penchant for "cosy" family rooms); and a pervasive segregation of neighborhoods by race (evidenced by the almost entirely white character of the four neighborhoods studied above, despite their proximity to black neighborhoods): these constitute some of the major motifs of residential life.

These themes also, in many ways, cut across social class. Certainly there are discernible differences between the social classes studied, but it is important to pause before deciding that they constitute basic taste differences, on which theories of the role of culture in a system of class domination can be based. For example, the upper-middle class in suburban Manhasset generally do not sit in front of their houses. They tend to believe that to do so is inappropriate, above all because such behavior is associated with lower social classes. The working class in suburban Medford have no such belief; but they generally do not sit in front of their houses either. The relationship between beliefs, behaviors, and social class thus may be complex.

Some behavioral "differences," it may be argued, are not typical of a social class, but are confined to a numerical minority. Other "differences" may be trivial. An example of both these possibilities is the famous pink flamingos of the working class. Indeed, a few working-class residents in Greenpoint and Medford *have* placed plastic imitations of nature (not just pink flamingos, but also imitation ducks, flowers, windmills and so on) in their yards. Yet a few upper-middle-class residents of Manhattan have also placed imitations of nature around their houses, albeit stone rather than plastic (for example, stone frogs in a Japanese garden or the "antique" stone lions that adorn the facades of two of the town houses). The significance of these differences revolves around such questions as the materials used (plastic or stone) and the examples of nature copied (flamingos and flowers or frogs and lions). Anyway, only a minority within each social class engages in these practices, and they occur in the context of a preference, widely shared among all social classes, for a tame and cultivated nature.

Other apparent differences between social classes which may initially be thought to be rooted in occupation or education, and therefore be said to underpin stable differences in taste, may actually derive from such factors as differences in what people can afford (income) or differences in context (for example, safe versus unsafe neighborhoods).

Consider, for example, the difference between the above-ground pools placed on concrete in the working-class backyards in urban Greenpoint and the "tastefully" landscaped in-ground pools of some of the upper-middle class in suburban Manhasset. This difference reflects the cramped context of working-class backyards and the vastly lower price of above-ground pools as much as it reflects any basic difference in taste between social classes.

Or consider the explosive question of attitude to the movement of blacks into a neighborhood. There is an idea that white working-class residents are more likely than white upper-middle-class residents to violently oppose the

movement of blacks into their neighborhoods. If true, this may have a lot to do with differences in the extent to which racial segregation is stable or controlled.[45] The dominant white neighborhoods of Manhattan's Upper East Side and Manhasset are unlikely to receive an influx of black homeowning residents, partly because of the price of the houses and partly because of more or less institutionalized patterns of racial segregation (in the Manhasset area, blacks reside in neighboring Spinney Hill; on the Upper East Side most blacks reside in Harlem and its fringes, and so on). By contrast, patterns of racial segregation in the working-class neighborhoods are either less stable (such as in Medford, which has a black residential population around its white core) or their continued stability may require more effort on the part of white residents (as in the white Italian section of Greenpoint, adjoining the huge and growing black ghettos of Flatbush and East New York).

Other differences are as much related to such contextual circumstances as the crime rate and turnover of communities as they are to class-based tastes. An example is the question of high versus low fences around backyards. In Manhattan, the upper-middle class, concerned about crime and in possible view of numerous strangers living in adjoining apartment buildings, build tall fences around their backyards. The same people in their summer vacation homes in the Hamptons and elsewhere, where they feel that their neighbors are people like themselves and nonresidents pose little threat, may have walls that are far lower and even tolerate an open facade to the beach. In the Italian section of working-class Greenpoint, closer to large and feared black ghettos, fences are high, as they are in suburban working-class Medford, where crime is again a concern and neighbors often do not know one another. By contrast, in the Polish section of working-class Greenpoint, where neighbors tend to have resided for many years and to know each other, fences around backyards are often low (two to three feet), allowing neighbors to chat with each other.

Thus many seemingly clear examples of differences in "taste" between social classes turn out, on examination, to be elusive and hard to pin down. That so many people nevertheless are convinced that "basic" differences in taste between the classes are widespread and easy to spot raises the suspicion of a proclivity among some of the middle and upper-middle class to take trivial differences, or even similarities, and perceive them (deliberately or by accident) as significant distinctions. This idea has, indeed, been formulated as a theory by such writers as Quentin Bell. Their view is that in advanced capitalist societies which permit some class mobility (the extent of which should not, of course, be exaggerated) higher social classes are constantly

threatened by lower social classes. In this context there is a tendency for the higher social classes to constantly stress their difference from lower social classes, however slight and sometimes even nonexistent the real basis for this may be.[46] This proclivity underlines the need to proceed cautiously before deciding that basic differences in taste have been uncovered.

2

Empty Terrain: The Vision of the Landscape in the Residences of Contemporary Americans

THE POPULARITY OF LANDSCAPE PICTURES AMONG ALL SOCIAL CLASSES

Depictions of the landscape pervade the houses studied. Hills and mountains, meadows, oceans, rivers and bays, trees and bushes, skies that are clear, flecked with clouds, or darkened at night, suns rising or setting—such scenes, in endless combinations, are the most popular topic of the pictures on the walls of all social classes.

To make manageable the task of classifying the pictures on the walls of the houses studied, I analyzed a subsample. This subsample consisted of those paintings, reproductions, and photographs in each house that were "prominently" displayed—that is, those that occupied a wall alone, or occupied a wall alone except for other depictions of the same subject matter. The results show that landscapes rank first in popularity in all four neighborhoods. Landscapes (defined as paintings over half of whose content is land, water, or sky) constitute 34% of all the pictures displayed in Manhattan, 32% of those in Medford and Greenpoint, and 31% of those in Manhasset (see table

2). Landscapes are either the first or second most common topic of the pictures in 85% of the houses in Manhattan, 75% of those in Greenpoint, 72% of those in Manhasset, and 67% of those in Medford.

An insignificant exception occurs in the Hamptons, one of the two neighborhoods from which smaller samples were drawn. A quarter of the Hamptons houses sampled had no landscape pictures prominently displayed.[1] This is not, however, because these elite residents lack, or transcend, the common taste for landscapes. These Hamptons houses are situated in an idyllic section of an area already seen by the New York wealthy as outstanding for its scenery: they are on a thin strip of land (Dune and Meadow Roads) with water on each side, and they look south at the Atlantic Ocean and north at the Shinnecock Bay. When asked about the absence of landscape pictures in their houses, these Hamptons residents commonly replied that no possible painted scene could rival the actual landscape visible from the houses. One resident said, "When you're looking at the ocean, why look at a picture?" Another explained, "I didn't want a painting to detract from the natural landscape." Anyway, the other 75% of the Hamptons houses sampled were not noticeably deficient in the display of landscape pictures.

To be sure, there is much variation in the artistic quality of the landscape pictures on display in the four main areas sampled. Landscapes that are original "works of art," for example a Monet, Vlaminck, Corot, or an eighteenth-century Japanese print by Hiroshige, are found only in the homes of the upper-middle class, and especially in Manhattan. The landscapes in the homes of the working class are by not so well known or unknown artists, or (less commonly) are inexpensive reproductions of works of art. Such differences between social classes are discussed later in the chapter. (Note, though, from the start, that most of the landscapes in the homes of the upper-middle class are not world-famous works of art either, for the latter are few and far between.)

Further, in certain other domains of subject matter, there are clear differences between the working class and the upper-middle class. Pictures of religious figures, for instance, are important in working-class Greenpoint (14.6% of the pictures) and Medford (8.6% of the pictures), but less so among the upper-middle class. Abstract art is important in upper-middle-class Manhattan (13.9% of the pictures) and is present in Manhasset (4.5% of the pictures), but is of no importance in either Greenpoint or Medford. But here I want to stress that few of the residents sampled, regardless of their social class, appear to tire of gazing at scenes of the landscape. Figures 24–32 are illustrative.

TABLE 2 The subject matter of the paintings and photographs prominently displayed on walls in houses

| | Neighborhood | | | |
| | Upper-Class Urban (Manhattan) (%) | Upper-Middle-Class Suburban (Manhasset) (%) | Working-Class Urban (Greenpoint) (%) | Working-Class Suburban (Medford) (%) |
Subject Matter				
Landscape[a]	34.9[b]	31.5	32.0	32.2
Cityscape	4.6	1.6	5.3	
People				
Religious persons	2.8	4.5	14.6	8.6
Family members (photos and portraits)	13.9	12.9	23.3	19.1
Friends and acquaintances	0.9			
Others	12.9	16.4	4.7	8.6
Abstracts	13.9	4.5		1.7
Flowers	4.2	23.1	12.0	10.4
Animals, birds, or fish	5.6	2.2	4.0	12.1
Still life (fruit, vegetables, or drinks)	2.8	1.9	4.0	3.5
Other	3.3	1.2		3.5
TOTAL	99.8	99.8	99.9	99.7
	(N = 322)[c]	(N = 311)	(N = 243)	(N = 230)

Note: The data include only topics that are prominently displayed on a wall. A topic is defined as "prominently displayed" if pictures depicting that topic constitute all (scored as one point), or at least three-quarters (scored as half a point), of the topics of the pictures on a particular wall. For example, a picture of a landscape that occupies a wall by itself, or only with pictures of other landscapes, scores one point; a landscape picture or a group of landscape pictures that constitute at least three-quarters of the pictures on a wall scores half a point.

Some topics are also displayed elsewhere than on walls, for instance on the flat surfaces of tables, dressers, and shelves. Family photographs, African, Oceanic, and pre-Columbian figures ("primitive" art), and religious statues are examples. Their presence in the home will therefore be underestimated by the data in table 2. These topics are discussed in later chapters. In particular the fact that family photographs are often displayed, in movable fashion, on flat surfaces is of great significance, and is discussed in chapter 3. Table A-10 (appendix) recomputes the data of table 2 so as to include family photos displayed on flat surfaces.

The data include original pictures, reproductions, and photographs. They include items by anonymous or obscure artists as well as items by recognized artists. This is in order to focus on the subject matter of the pictures. Later in the chapter I reintroduce some of these distinctions.

The data in table 2 include pictures in the following rooms and areas of the house: the hallway, foyer, living room, dining room, kitchen, library, den, sitting room, family room, master bedroom, and guest room. They exclude pictures in the bathroom(s), children's bedroom, and basement.

[a]For the purposes of the data in table 2, a "landscape" is defined as a picture over half of whose content is land, water, or sky.

[b]For the means and standard deviations of the data in table 2 see table A-6.

[c]These numbers refer to picture-topics (defined in general note), not to households. For example, the total number of picture-topics prominently displayed in the Manhattan houses analyzed was 322.

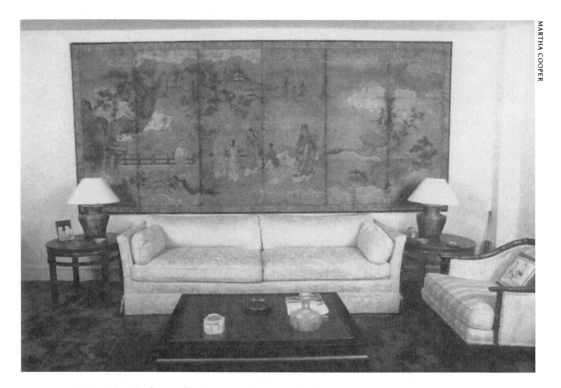

MARTHA COOPER

FIG. 24. Manhattan living room, Japanese landscape.

THE MATERIAL/HISTORICAL CONTEXT OF LANDSCAPE PICTURES

Analyzing landscape art in the context of the house is especially appropriate, for historically the connection between landscape art and the house and its surroundings is strikingly close. The very emergence of landscape painting as a distinct genre in the West has been linked to the development of a villa or country-house culture in the Renaissance. In medieval art the landscape appeared merely as a background for figures. It was in Renaissance Italy, when large numbers of urban dwellers began to buy villas in the country as second homes, that the taste for landscape art, as a self-sufficient topic, developed.[2]

Likewise, in America the movement of urban dwellers to quasi-rural (suburban) areas seems to have stimulated the demand for landscape art. In early American urban history, when city dwellers lived close together in an urban core—the "walking city"—portraits dominated the art scene.[3] But by

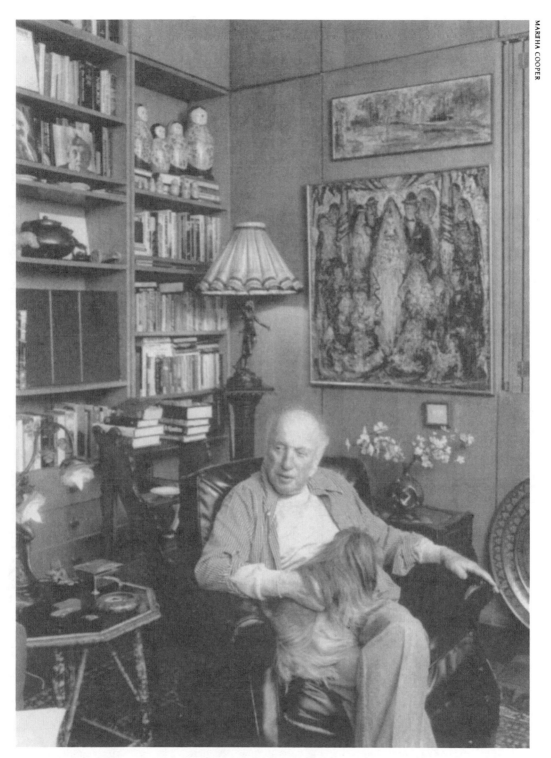

FIG. 25. Manhattan living room, landscape (upper right). Seated is the husband.

FIG. 26. Manhattan living room, landscapes.

FIG. 27. The Manhattan living room in figure 26, detail. The landscape over the fireplace is a Vlaminck.

FIG. 28. Manhasset living room, landscapes.

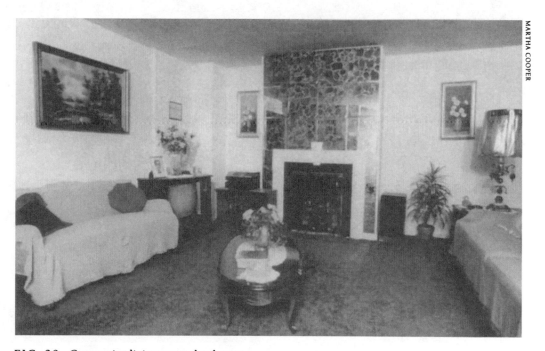

FIG. 29. Greenpoint living room, landscape.

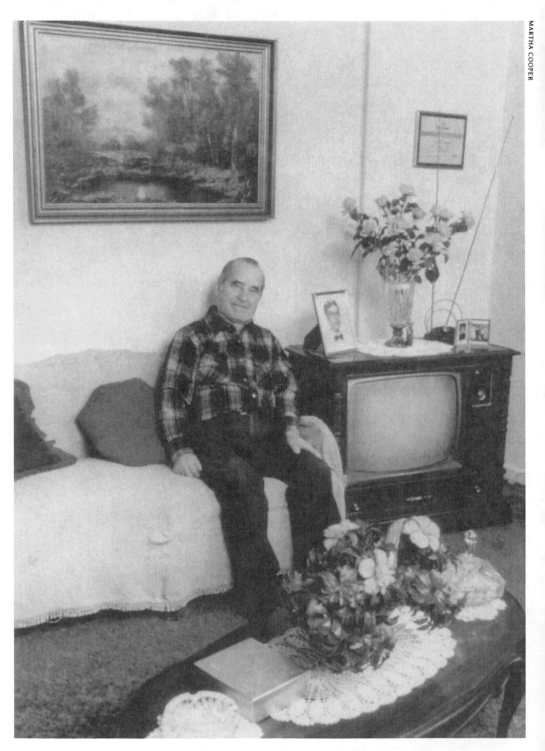

FIG. 30. The Greenpoint living room in figure 29, detail. On the couch is the owner of the house.

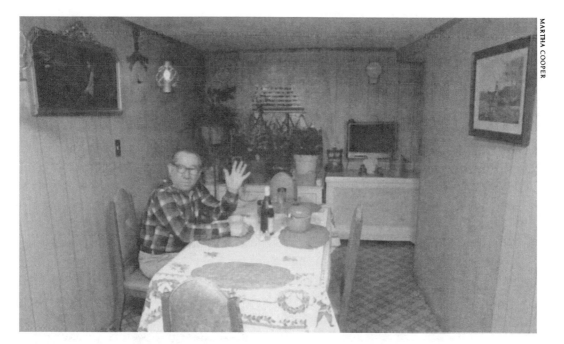

FIG. 31. Greenpoint dining room, landscape. The landscape is an English hunting scene. At the table is the owner of the house, who works as a doorman in Manhattan and acquired the landscape when it was discarded by a resident in the building where he works.

FIG. 32. Greenpoint living room, landscape.

the mid-nineteenth century, commuter suburbs had begun to develop and large numbers of middle-income people moved from the city to semirural suburbs, from which they commuted by ferry, omnibus, and railroad to jobs in the city.[4] During this same period landscapes emerged as a flourishing art in America, and their popularity continued to grow throughout the rest of the century.[5] In the twentieth century the speed and scale of suburbanization quickened, triggered above all by the automobile. Since World War II, blue-collar as well as white-collar Americans have moved in large numbers to newly created suburbs.[6] Nowadays few urban residents of at least moderate incomes fail to consider a move to the suburbs, even if they ultimately reject the idea as undesirable or beyond their economic means. Further, many city dwellers have attempted to "suburbanize" their homes and in particular any backyard space they have, as I pointed out in the previous chapter. In this sense suburbanization as a fact and as an ideal pervades modern American culture. Thus it is understandable that landscape paintings are now of central importance in the houses of all social classes, as well as in both urban and suburban neighborhoods.

Art historians such as T. J. Clarke and Robert Herbert have stressed the impact of suburbanization on the development of Impressionist painting in the nineteenth century. Their writings, as I said in the Introduction, implicitly raise the question of locating the impact of suburbanization on twentieth-century taste for art. This study's finding that landscapes are broadly popular among all social classes nowadays suggests the answer that the taste for landscapes has continued to grow with the taste for suburbanization, and, indeed, amounts now almost to an obsession.

This is one of several answers that I will suggest to the question of the impact of suburbanization on the twentieth-century taste for art. For example, in the chapter on abstract art I will argue that the landscape motif often appears, though in somewhat disguised form, in the abstract paintings that people display; hence suburbanization also underlies part of the appeal of abstract art.

Here, however, I want to argue that analysis of the *content* of the landscapes in the homes sampled suggests a further answer—that twentieth-century suburbanization and related phenomena have affected not just the appetite for landscapes, but the kind of modern landscapes that audiences prefer.

THE CALM LANDSCAPE

The content of the landscapes sampled has two striking features, both of which are possessed by almost all the landscapes displayed, regardless of the social class of their owners.

First, these landscapes reflect an overwhelming preference for a sedate and tranquil nature. Almost all are calm, not turbulent. Rivers flow serenely, oceans are placid; trees are unbent by wind; snow lies evenly, fallen but rarely falling.

Of the 349 landscapes prominently displayed in the houses sampled (and for which data on this were available), only two were turbulent. And one of these met its downfall during the study. It was an eighteenth-century religious picture, in reproduction, by Alesandro Magnasco (1677–1749) entitled "The Baptism of Christ," and it hung in a Catholic rectory on Manhattan's East Side. In the picture Jesus stands amid a stormy ocean and dark skies. A priest who lives in the rectory said, when first interviewed, that he intended to remove the picture; something about it bothered him—he did not know what. When interviewed later, he had begun preparations for its removal, leaning it against an unused door (see fig. 33). A year later the picture had gone, banished to the choir room in the church next door. Although the priest never decided what it was about the picture that disturbed him, a reason suggests itself from the vantage point of this study. The religious content could not be the problem, for the rectory is full of religious pictures. Nor is "landscape" a problematic topic, for there are other landscapes, to which the priest has no objection, in the rectory guest room. But all of these depict calm scenes. Thus it is reasonable to suppose that the turbulence of Magnasco's picture is what caused its banishment.

The only other turbulent landscape in the sample depicted a storm-tossed oil tanker. It hung in a working-class Medford house, and had been given to the residents by a brother who was a merchant seaman and therefore often had the experience, now unusual for twentieth-century Americans, of being at sea in a storm.

People's expressed reasons for liking landscapes parallel the finding about the prevalence of sedate scenes. Asked what attracts them to the landscapes on their walls, residents mention above all the tranquility of the subject matter. They like these pictures because they are "calm," "restful"; they offer "solitude" and "quiet"; they soothe. Respondents cite such qualities, and few others. Consider some examples. A Manhattan man, about a Chi-

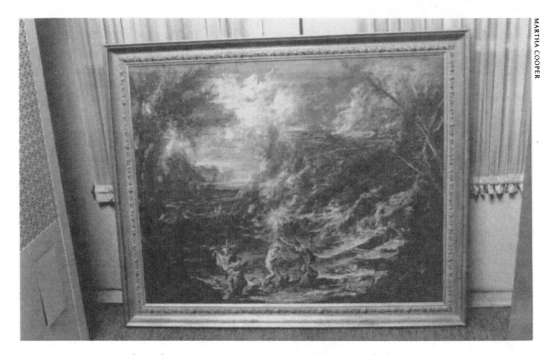

FIG. 33. Alesandro Magnasco (1677–1749), *The Baptism of Christ* (in reproduction), on the second-floor landing of a Manhattan rectory. This scene, highly unusual among the landscapes sampled for its storminess, has been placed on the floor by a resident, ready for its removal from the rectory.

nese garden scene, with mountains in the background: "It's so calm. That's what I like about it." A Manhattan woman, on her photographs of the coasts of Greece and Mexico: "They have a feeling of solitude, beauty, quiet, and peace." A Greenpoint woman, on a landscape of trees and a river: "It's very restful." Another Greenpoint woman, on a rural street scene lined with autumn trees: "It's peaceful and restful." A Manhasset man, about two beach scenes: "They're peaceful." A Medford woman about a beach scene, with seagulls but no people: "I like it because it's tranquil. No one bothers you."

The next most common reason given for liking a landscape—that it recalls a place or person of which the respondent is especially fond—is a distant second in terms of the frequency with which it is expressed.

Various, often overlapping, causes of this overwhelming preference for calm landscapes are apparent.[7] Almost all these causes reflect an orientation to nature as the arena for leisure. One is that home, and the viewing of landscapes therein, offers some respite from the perceived hustle and hub-

bub of the outside world, especially the world of work. For example, a Greenpoint man who teaches high-school science in the New York public schools, explained why he liked the serene landscape in his living room (the interviewer's question is in brackets): "I like it because it's calm. [Why do you like a calm landscape?] For fifteen years I ran the lunchroom at school. Have you every heard the sound of six hundred teenagers having lunch? It was murder." A Medford woman explained, "I prefer calm landscapes because everyone is always on the go nowadays; most people are in a hurry."

A second source of the preference for calm landscapes derives from the common modern orientation to nature—to the countryside and the shore— as scenery to drive past, whether as commuter or tourist, or as the arena for trips and leisure time. I asked residents who had landscapes of modern America how they thought of themselves in relation to the landscape depicted. No one mentioned cultivating the land. The largest number of residents saw themselves as engaging in some kind of, more or less active, leisure activity vis-à-vis the landscape, involving either being present in the scene or driving past and admiring it. For example, a Manhasset woman explained what came to mind when she looked at the landscape of autumn leaves hanging in the den: "Once a year my husband takes me to the mountains, to the Poconos or to Connecticut, to see the leaves changing color. The view from the car is wonderful. I get out of the car for an hour, and then we drive home." A Medford woman, asked about the beach scene in her bedroom, said that she thought of herself as "being there, lying on the beach." In relation to the grassy meadow scene in his living room, a Medford man thought of himself as "walking through the meadow or having a picnic there." Another Manhasset resident associated the landscape of Maine in her living room with the scenery she and her husband drive past on their way to visit their daughter in Quebec. Many of these residents connect landscapes hanging in their houses with favorite vacation spots.

A smaller group of respondents, when asked how they thought of themselves in relation to a landscape picture of modern America, saw themselves as just viewing the landscape in the house. For these people, the landscape picture was less a reminder of actual encounters with nature and more a substitute for the effort required to actually experience the landscape. For example, a Greenpoint woman liked the sunrise on her bedroom wall because she was "too lazy to get up to see the actual sunrise." A Medford man said, in relation to the triad of romantic beach sunsets in his den, that he envisaged himself as just sitting at home looking at the pictures, not being there at all.

Whether landscapes pictures are viewed as an easy substitute for the real experience of nature as a leisure activity or as evoking actual experiences, what is wanted, in fact and therefore in depiction, is a landscape that is calm and serene, free of excessive wind, rain, or turbulence that might mar the enjoyment of the spectator or participant.

Matisse, at the start of the twentieth century, said (and was criticized for saying) that he aimed at an art that was "devoid of troubling or depressing subject matter," that soothed and calmed the mind of the viewer, that was the mental analogue of "a good armchair which provides relaxation from physical fatigue."[8] The comments of the residents just quoted suggest that the landscapes they display afford some of these central qualities.

A final source of the preference for calm landscapes lies in the decline of the religious vision of nature, the vision of landscape as the expression of God. In certain earlier periods, a powerful and disrupted landscape often symbolized the power and majesty of God. The paintings of Thomas Cole in nineteenth-century America are obvious examples.[9] But very few of the people I interviewed now ascribe any theological meaning to landscapes.

Of course, modern America is not the only society and period that has favored calm landscapes. Renaissance Italy, for one, had the same preference; writing of that time, Richard Turner commented, "Most landscapes of the day offer a 'locus amoenus' where the weather is fair and the landscape friendly . . . wild and savage places tend to be absent."[10] But the modern vision of landscape has extended this ideal to almost every facet of the natural world. For example, although the notion of the countryside as a pleasant place has a long history, the notion of the sea as a leisure resort, rather than as dangerous, developed only in the mid-nineteenth century.[11]

But if this modern taste for tranquil landscapes represents, albeit in extreme form, a taste found in certain earlier periods, the second main feature of the landscapes in the houses sampled is unique to the modern period.

THE DEPOPULATED LANDSCAPE OF MODERN AMERICA

The landscapes in the houses studied convey a vision of the place of people in the terrain. According to this vision, people are appropriate in the landscape of nonindustrial societies or of industrial societies in the past but are inappropriate and unwelcome in landscapes that represent the modern world, especially contemporary America. In the houses studied, the vast majority of the landscapes that depict contemporary America are depopulated.

There is land, sea, and sky but seldom any people. Thus only 11% of the landscapes of contemporary America contain figures. By contrast, landscapes that depict America's past or the past of another industrial society, or that depict simple societies (in the past or present), are often populated. Thus 71% of these landscapes contain figures. Indeed, the presence of figures—in period dress or native clothing—is one of the main ways of identifying landscapes as depicting a nonindustrial society or an earlier period in the history of an industrial society. This pattern holds for the working-class and upper-middle-class areas as table 3 makes clear. In the Greenpoint houses sampled, not one of the landscapes that depict contemporary America is peopled, while in Medford there is only one that is. In the Manhattan and Manhasset houses only 25% of the landscapes that depict modern America are peopled.

Figure 34 uses the same data and makes the same point, but is based on a different statistical technique (logistic regression). This enables controls to be included not just for the type of neighborhood in which the picture is displayed, but also for the age, religion, and gender of residents. Again, a

TABLE 3 Whether landscape is peopled or not peopled, by society depicted and neighborhood of house where displayed

	Neighborhood			
	Working-Class (Greenpoint and Medford)		Upper-Middle-Class (Manhattan and Manhasset)	
	Society depicted in the picture		Society depicted in the picture	
Whether landscape is peopled	Contemporary America[a] (N = 106)	Non-industrial or industrial in the past (N = 44)	Contemporary America (N = 76)	Non-industrial or industrial in the past (N = 123)
	%	%	%	%
Peopled	1	64	25	73
Not peopled	99	36	75	27
Total	100	100	100	100

Note: The data refer to the subsample of pictures defined in table 2—pictures prominently displayed. All the landscape pictures involved in the calculations for table 2, and for which the data presented in table 3 were available, are included here.

[a]This category actually includes landscapes that depict any industrial society in the present time, not just contemporary America. But all except a few of these cases in fact do depict contemporary America. Hence in the text I sometimes refer to this category as "landscapes of contemporary America," and sometimes as "landscapes of advanced industrial societies in the present."

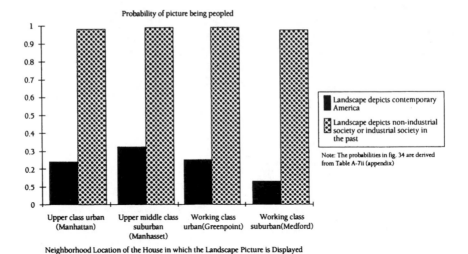

Probability of picture being peopled

Landscape depicts contemporary America

Landscape depicts non-industrial society or industrial society in the past

Note: The probabilities in fig. 34 are derived from Table A-7ii (appendix)

Upper class urban (Manhattan) Upper middle class suburban (Manhasset) Working class urban(Greenpoint) Working class suburban(Medford)

Neighborhood Location of the House in which the Landscape Picture is Displayed

FIG. 34. Predicted probability of a landscape picture being peopled, by type of society depicted in the picture, controlling for neighborhood.

landscape picture that depicts contemporary America is far less likely to be peopled than one that depicts a nonindustrial society or an industrial society in its past. Other variables, such as the social class of residents (as measured by the neighborhood of the house where the landscape is displayed) or the religion and age of residents, turn out to make little difference to this relationship. (See table A-7 in the appendix.)

Consider some examples. In the living room of a Manhasset house is a painting of a landscape, without people (fig. 35). The residents of the house bought it in Maine, and for them it represents contemporary Maine as they experience it (mostly as they drive past it). By contrast, in their dining room are six historical landscapes, all containing figures. These include a rural scene of a peasant and cow; a period harbor scene with two figures repairing a four-mast sailing ship; and a painting of a rural youth, entitled "Farmboy." In a Greenpoint living room is a landscape, painted by the adult daughter of the residents. It depicts the scenery around their vacation cabin in upstate New York, and is without people. By contrast, in their bedroom is a populated landscape of nineteenth-century America. In another Greenpoint living room is a depopulated contemporary landscape of upstate New York, where the husband and wife like to go camping (fig. 36). In a Medford house is a series of framed, inexpensive color poster-photographs that depict sunsets— no people. The sunsets, the residents believe, are probably somewhere in America, perhaps New Mexico (fig. 37).

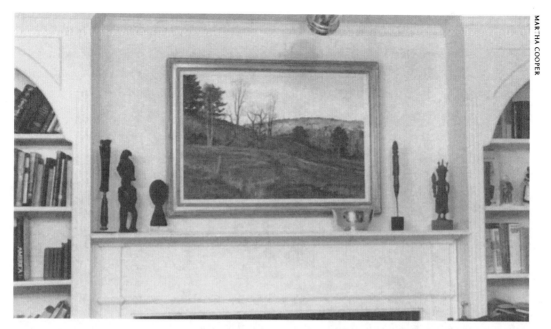

FIG. 35. Manhasset living room, depopulated landscape of contemporary Maine. Regardless of their social class, most residents prefer that landscape pictures depicting modern American be without people.

FIG. 36. Greenpoint living room, depopulated landscape depicting the area near the residents' vacation cabin in upstate New York.

FIG. 37. Medford living room, sunset.

A Manhattan town house has many historical landscapes, almost all peopled. There is only one landscape in this house that refers to the current period. It was painted by the wife and is a beach scene of contemporary France, without figures (fig. 38). The den of another Manhattan town house is full of landscapes (fig. 39). Only one—a sunset over water—refers to present-day America. It is a photograph, taken by the wife, of the view from their Cape Cod vacation house and contains no figures, just two tiny speedboats (fig. 40). On the other hand most of the other landscapes in the den do not refer to contemporary America and are peopled. A nineteenth-century etching of Harvard College (the husband is an alumnus) has small groups of students in the foreground; a period photo of the Charles River has someone rowing; a copy of a Corot contains a peasant woman; a picture of Venice has a gondola with two passengers and gondolier.

The comments of the people interviewed underline the findings of statistics. Figures are absent from landscapes of modern America by design, not chance. Most respondents do not want figures in the landscape of modern America as they experience it in fact, and therefore as they visualize it in a picture. Consider why. A common view is that people destroy landscapes. A Greenpoint man: "You don't want people there [in the country] to pollute

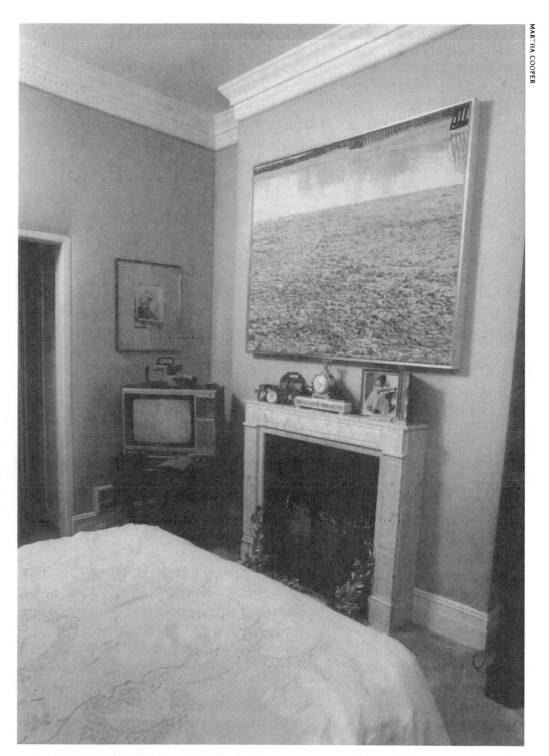

FIG. 38. Manhattan master bedroom, depopulated beach scene of contemporary France.

FIG. 39. Manhattan den, landscapes and other pictures.

FIG. 40. Manhattan den in figure 39, detail. The landscape, which is depopulated, depicts the view from the couple's Cape Cod vacation house.

nature; they'll throw around their garbage." A Manhasset man: "It's good no one is there [in his landscape]. Otherwise they'd probably have built a condominium by now!" A Medford woman, asked about a peopleless landscape of modern America, commented: "I'd rather have it without people. It's more peaceful, and people would spoil it. Yesterday we went to Cedar Island; people had thrown broken bottles and babies' diapers all around."

Another view is that one goes somewhere scenic to get away from people, so why put them in landscapes? A Greenpoint man: "When you go to the country, who wants to look at other people?"

A third view, which accurately reflects the mechanization of modern agriculture and of the methods of taking care of scenic landscapes, is that nowadays most natural landscapes have no people, so it is inappropriate to portray people in landscape paintings. A Greenpoint man commented on his picture—an inlet lake, trees in the water, and birds: "I wouldn't want to see a person in this picture. Where would a person be, standing on the water [laughs]!"

This preference that landscapes of modern society be void of people is striking, distinguishing this culture from almost all previous cultures. It is interesting to consider a culture whose attitude to the landscape was the exact reverse. In France from about 1830 to 1850, lithographs of the French countryside were in enormous vogue. But the public demanded that this countryside be peopled, with at least one or two peasants or other ordinary men or women. Certain artists who specialized in adding the figures were famous for their talent.[12]

This finding provides another answer to the question of the impact of suburbanization, and its twentieth-century form involving a stress on a privately viewed nature, on the modern taste for art. A particular ideal predominates that involves a scenic modern nature devoid of people.[13] This "nature" can be visited, driven by, and walked through, but preferably as an experience that is private to the spectator or participant (and his or her companions), unspoiled by the presence of strangers in the landscape. Some of the dynamics that underlie the modern backyard—the locus of a privately owned leisure space—are here reproduced, for both envisage a privately enjoyed leisure. But the ideal of the modern landscape can be cast on a much grander scale, for property ownership, which constrains the size of the backyard, is not a requirement here. Thus the scenic vision of the modern landscape can be expansive and available to all, for it depicts the perspective of the spectator rather than the owner of the terrain.

LANDSCAPE PICTURES AS MARKERS OF STATUS
AND CLASS DIFFERENCES

The features discussed so far of the landscapes in the houses sampled—their popularity, the marked desire for calm scenes, and the preference that scenes of contemporary America be depopulated—apply to the households of all the social classes studied. There are, however, certain features of the landscapes that do distinguish the pictures displayed by the working class in Greenpoint and Medford from those displayed by the upper-middle and upper classes. These features, far more clearly than the shared features just discussed, may relate to art works as part of a system of status and class domination, as *potential* items of prestige and markers of class privilege and superiority. These features concern the identity and prestige of the artist; the frequency with which foreign societies in general are depicted; the frequency with which certain foreign societies—Japan, Britain, and France—are depicted; and the frequency of "historical" landscapes that depict the past.

In these domains the contrast between houses of the upper-middle class (especially those on the East Side of Manhattan) and houses of the working and lower-middle class is clear (see table 4). For example, East Side residents often know the identity of the artist of at least some of the works they display. Thus they knew the identity of the artist for 64% of the landscape pictures. Further, if the artists are well known in the art world (a condition, of course, for the work to have substantial market value) residents are usually aware of this and pleased to communicate the knowledge to visitors. By contrast, working-class residents rarely know the identity of the creators of their paintings. For only 12% of the landscapes displayed in Greenpoint and 6% of those in Medford did a resident know who painted it, and in almost all of these cases that was because the artist was a relative or friend of the resident. Not one of the landscapes displayed in Greenpoint or Medford (in original) was by an artist of stature. As a result, none of the landscapes in the working-class homes is of more than trivial market value. Nor, in general, are Greenpoint or Medford residents interested in the identity of the artist or knowledgeable about art history or the current art world. For instance, a Greenpoint woman has a reproduction of Van Gogh's "Sunflowers" on her wall. Asked about the artist's identity, she examined the signature and said it was by someone called "Vincent"! This is typical of the level of knowledge of art history among Greenpoint residents interviewed. (Similarly, almost none of the Greenpoint or Medford residents that have Leo-

TABLE 4 Selected status-raising characteristics of landscape pictures

	Neighborhood			
Characteristic	Upper-Class Urban (Manhattan) (%)	Upper-Middle-Class Suburban (Manhasset) (%)	Working-Class Urban (Greenpoint) (%)	Working-class Suburban (Medford) (%)
Percentage of Landscapes for which the owner knows the artist's identity	64	60	12	6
Percentage of Landscapes that depict the past	77	54	30	15
Percentage of Landcapes that depict foreign societies (in past or present)	79	40	23	4
Percentage of Landscapes that depict Japan, Britain, or France	38	18	3	0
	(N = 105)*	(N = 84)	(N = 74)	(N = 72)

Note: Multiple regression analysis, controlling for such other possible causal factors as the religion and age of the residents and the number of landscapes in each house, confirms the importance of the residents' social class (neighborhood of residence) as a determinant of the features of the landscape pictures presented in table 4. See table A-9 (appendix).

*The data refer to the subsample of pictures defined in table 2—pictures prominently displayed. All the landscape pictures involved in the calculations for table 2, and for which the data presented in table 4 were available, are included here.

nardo da Vinci's "The Last Supper" hanging in miniature in their kitchens and dining rooms knows who painted it.)

A second difference between social classes is the extent to which landscapes portray societies other than America. Depictions of foreign societies are far more popular in upper-middle-class Manhattan houses than in Greenpoint or Medford. Seventy-nine percent of the landscapes in Manhattan houses depict foreign societies, but only 23% of those in Greenpoint and 4% of those in Medford.

Further, there are differences in the kind of foreign societies depicted. On the East Side of Manhattan, Japan followed by England and France are the most likely foreign societies to be depicted. Indeed, together these societies account for 38% of all the East Side landscapes. These countries are not, it should be noted, usually the countries of origin of the residents. In Greenpoint, by contrast, half of the foreign landscapes depicted are of the country of origin of the residents (notably Poland or Italy). There were only two landscapes depicting Britain, France, or Japan. For example, a Green-

point resident who works as a doorman in Manhattan has an English hunting scene, discarded by a tenant in the building where he works (see fig. 31).

Finally, depictions of the past are far more common in Manhattan's East Side than in Greenpoint or Medford. Thus 77% of the Manhattan landscapes referred to the past, only 30% of those in Greenpoint, and 15 percent of those in Medford.

A multiple regression analysis, controlling for the age, gender, and religion of residents, confirms the importance of residents' social class in explaining these four differences. See table A-9

CONCLUSION

What is the relevance of these findings for the three main theories that link art and culture to power and domination? To what extent does art serve as a status symbol? To what extent is it a means by which large corporations and the media exert ideological domination over subordinate classes (the Frankfurt theory)? To what extent does art function as a means by which dominant classes use culture as a device to exclude most members of dominated classes (as "cultural capital" theorists argue)?

The findings presented here suggest that, at the very least, these theories contain only part of the truth, that they are too general and too simple. For one thing, the areas of overlap between the working class and the upper and upper-middle class undermine the idea of a gulf between popular and "high" taste.[14] Further, the preference, shared by all social classes, not just for landscapes but for calm landscapes and for depopulated depictions of the contemporary American landscape has more to do with modern notions of nature and how it should be experienced than with status, and is embedded in the material and ideal context of twentieth century suburbanization.

Of course, paintings (originals and reproductions) can have multiple meanings and can be understood on several levels. Thus they *can* surely also exist as status objects—as items intended to reflect the power and social standing of their owners. Many of the paintings on the East Side of Manhattan clearly also operate in this sense. They do so by virtue of such considerations as the standing of the artist (to which is closely related the monetary value of the work), the extent of depictions of the past and of foreign societies, and the question of which foreign societies are depicted. It is these features which, in the eyes of many upper-middle-class residents interviewed, as well as in the eyes of many art and cultural critics, make these paintings superior to those displayed by the working class.

Yet the role and importance of these factors in the reproduction of the class structure is complex. It is surely less clear-cut than is maintained by those who go beyond seeing art as an expression of status aspirations and see it as operating primarily to reproduce the class structure and to support class domination. The basic idea of Frankfurt sociology, that culture constitutes ideological domination by large corporations, receives very little support from these findings. In what way have corporations affected the modern taste for landscape? To be sure, the brochures of home builders in the nineteenth and twentieth centuries have typically presented the house in the suburbs as embedded in a landscape that is green and uncrowded, an image that reality usually soon falls short of as more and more houses are built. But such brochures more plausibly use, and attempt to exploit, the taste for landscape than create it.

These findings also raise a number of questions about the view of "cultural capital" theory that preferences in art and culture, difficult to acquire since they are taught primarily in elite schools and families, serve to control entry into, and continued membership in, dominant classes. Among the most important issues are the following: What is the source of such differences in preferences for art and culture between social classes as do exist? For example, does the preference, apparent among sections of the upper-middle class, for having landscapes that depict Japan, France, or England, or for having historical landscapes, derive from lengthy education and socialization in well-to-do families? If so, these preferences might indeed act as a barrier to exclude lower classes from dominant class circles. On the other hand, these preferences might just as plausibly derive from the experience of living in certain areas (for instance, a cosmopolitan urban area close to numerous museums) or from mixing in adult life with others who have similar preferences. If so, the preferences can emerge during, or after, class mobility rather than being a condition for class mobility. A second question is how extensive or elaborate a decoding actually occurs when people relate to the work (to simply talk about "appreciating" the work begs some important questions). We should be careful not to assume that the (elaborate) decoding which an art historian or art critic might undertake is the kind of decoding that other members of dominant classes undertake.[15] In the case of these landscapes, much of the "decoding" seems simple, involving little more than the ability to understand that a painting depicts a particular country (Japan, England, France) or a particular time period (the past rather than the present), and the ability to read the artist's signature. A third, and related, issue is how much knowledge is involved in "appreciating" the work.

The possibilities range from extensive (deep familiarity with the history and art of Japan or France or England) to a smattering (knowledge of the names of some artists and art styles). It is not clear that much knowledge is needed to support a preference for landscapes of Japan, Britain, and France over landscapes of Italy and Poland.

Thus the case of landscapes suggests that artistic and cultural choices— at least those to which I have drawn attention here—are rooted in people's current lives and current experiences as much as in differences of education and family background. As such, they may be less conditions for entry into dominant class circles and as much changes that may occur during or after the process of entry.

The second main conclusion of these findings concerns the way some of the characteristics shared by the landscapes in the working- and upper- and upper-middle-class homes can illuminate the direction taken by twentieth-century taste in art. In particular, the clear and widespread preference that landscape depictions of modern society be depopulated while landscape depictions of nonindustrial societies, or of industrial societies portrayed in their past, contain figures is prefigured by Cézanne and Monet on the one hand, Gauguin on the other—perhaps the three most important influences on twentieth-century landscape art. Look first at Cézanne and Monet, whose major landscapes are set in France, the apex of modern society at the time these paintings were made. The absence of figures from the landscapes of Cézanne is striking (fig. 41). In Meyer Schapiro's words: "[Cézanne's] landscapes rarely contain human figures. They are not the countryside of the promenader, the vacationist, and the picknicking groups, as in Impressionist painting; the occasional roads are empty, and most often the vistas or smaller segments of nature have no paths at all." [16] Unlike Cézanne, Monet painted many landscapes with people, but it was his haystacks and water lilies— both depopulated—which so influenced twentieth-century landscape art (fig. 42). [17]

Contrast Gauguin's later landscapes. They are almost all set in Tahiti—a society clearly seen as primitive by comparison with metropolitan France— *and* they are full of figures. As John Rewald wrote, "It would seem that in Tahiti the natives attracted [Gauguin] almost more than the beautiful scenery, or at least that he seldom contemplated this scenery without simultaneously thinking of its inhabitants who, in his mind, were an inseparable part of it." [18]

This basic division between modern artists who paint landscapes, with-

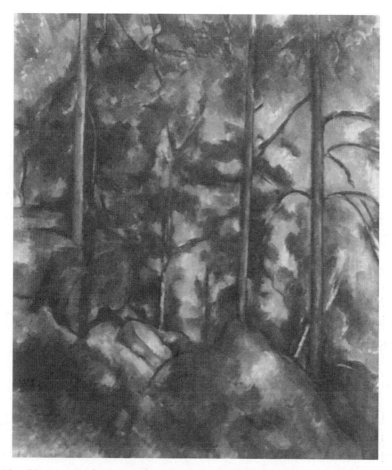

FIG. 41. Cézanne, Paul. *Pines and Rocks* (Fontainebleau?). (1896–99.) Oil on canvas, 32″ × 25-3/4″. Collection, The Museum of Modern Art, New York, Lillie P. Bliss Collection.

out figures, of their own society and artists who paint landscapes, with figures, of a "primitive" society or of an earlier historical period of their own society informs twentieth-century art. Painters such as Cézanne, Monet, Kandinsky, and Mondrian on the one hand and Gauguin on the other mark a clear and well-known pattern. What is not known is that the same pattern of preference exists among the *audience* for art, including the working class, as this study has revealed.

I do not want to discuss the motives that led these artists to paint as they did, but I do want to suggest some reasons for their enormous popularity among audiences in modern society. The landscapes these artists painted fit a constellation of tastes that I have briefly sketched here, tastes which are

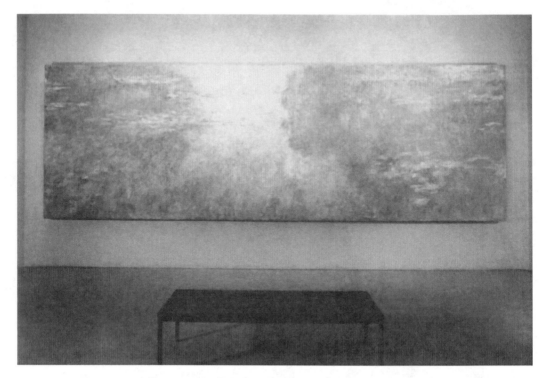

FIG. 42. Installation view of Monet, Claude, *Water Lilies* (c. 1920). Oil on canvas, 6'6-1/2" × 19'7-1/2". Collection, The Museum of Modern Art, New York. Mrs. Simon Guggenheim Fund. Cézanne, almost all of whose landscapes are without figures, and Monet's famous *Water Lilies* prefigure a widespread modern taste for landscapes that depict the modern world as void of people.

anchored in the lives, above all in the residential and leisure lives, of those who purchase their works, whether in original or in reproduction. To account for the attraction, for twentieth-century audiences, of depopulated landscape depictions of modern society, there is no need to resort to explanations in terms of how museums and other elite cultural institutions, still less large corporations, have imposed their tastes on the public. Further, the discovery that the working class too, when looking at landscape depictions of modern society, prefers them to be without figures is an additional reason to eschew such explanations, for the working class is largely unaware of museum culture. At the very least, what is needed is a theory that assigns a more active role to the tastes of the art-buying public as they are embedded in the material context of house, neighborhood, and leisure life. It is this public, with its associated preferences, that interacts with the choices of artists and critics to drive the taste for landscapes in twentieth-century art.

3

Portraits and Family Photographs: From the Promotion to the Submersion of Self

The painted portrait was once a staple of well-to-do homes in Europe and the United States. These portraits were intended to present their subjects, mostly residents and their kin, as unmistakably important people. Even the great portraits of the bourgeoisie after the French Revolution are still formal and often heroic, showing the sitters as the successors of the old nobility, always celebrated in their best clothes and manner. Until the Impressionists, portraiture celebrated its subjects by depicting them as persons of social consequence and often of power.[1]

Yet the painted portrait has fallen into decline. Now family photos pervade the American house. Even among the wealthy, portraits have mostly given way to family pictures.

If art was mainly about status—about attempts to impress others with the social standing of the owner—then the rich would have continued to commission portraits of themselves, depicted as important by leading artists. They would, in this way, have distinguished their resi-

dences from those of others able to afford only photographs or portraits by lesser artists. Thus the tradition of painted portraits would not have declined so sharply among the well-to-do.

Indeed, the causes of the decline of the painted portrait and of the rise of family photographs have not received the attention they deserve. In part this is because of the acceptance of two seemingly obvious, but in fact inadequate, explanations of the phenomenon. One is that the decline of the painted portrait was caused by the rise of abstract art. Clement Greenberg, for example, made the famous claim that abstract art's dominance made it impossible to be an artist of significance if one painted the human figure.[2]

A problem with this view is that abstract art is, in fact, only popular among a section of the well-to-do, whereas the demand for painted portraits has declined across almost the entire spectrum.

Further, this explanation obscures a central issue. Not only have painted portraits of the well-to-do declined in number in the twentieth century, but also the dominant form in which they have survived has turned away from the classic depiction of a clearly recognizable person presented as substantial and important. This has been achieved in various ways, such as by presenting the subject with irony or satire, or at leisure (a nonserious activity); these modes all suggest that the subject of the portrait, and perhaps even the portrait itself, should not be taken too seriously (figs. 43–45). But the mode of moving away from the classical depiction of the subject as important that has drawn most attention in the art world is the symbolic or "emblematic" portrait, involving a deliberate unrecognizability that often makes difficult the very identification of the subject (fig. 46). As Richard Brilliant has written, many such portraits use "a private symbolic language that effectively circumvents the portrait's potential audience. . . . Such symbolic or emblematic portraits were never meant to be easily deciphered, nor the person hidden behind them easy to know. These artworks, products of an avant-garde, like the imagery of secret cults, are not intended for any but the initiated."[3] The problem, then, is not just to account for the decline of the portrait, but to explain, among the avant-garde who are still interested in having portraits of themselves, the taste for depictions that undermine the subject's importance to the extent of even obscuring his or her identity. Is this, as in the conventional point of view, the result of the rise of abstract art? Or, on the contrary, is it possible that the rise of abstract art, at least in the realm of abstract portraits, is itself in part the result of whatever fuels this drive to unrecognizability?

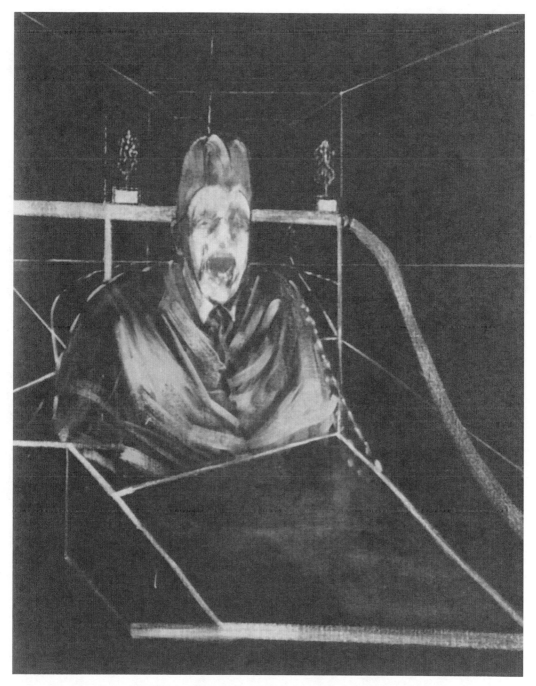

FIG. 43. Bacon, Francis. *Number VII from Eight Studies for a Portrait* (1953). Oil on linen, 60″ × 46-1/8″. Collection, The Museum of Modern Art, New York. Gift of Mr. and Mrs. William A. M. Burden. Courtesy of Museum of Modern Art and Marlborough Fine Art (London). Twentieth-century portrait painting has moved away from the classic depiction of the subject as substantial and important. It has done this by using various devices—satire, irony, depiction of people at leisure, and above all by making the subject of the portrait hard to identify. See also figs. 44–46.

FIG. 44. Close, Chuck. *Study for SELF PORTRAIT* (1968). Photograph, pen and ink, pencil, white paint, wash, and blue plastic strips on cardboard, 18-1/2″ × 13-1/4″. Collection, The Museum of Modern Art, New York. Gift of Norman Dubrow. Courtesy of Museum of Modern Art and the Pace Gallery.

FIG. 45. Warhol, Andy. *Seven Decades of Janis* (1967). Synthetic polymer paint silkscreened on eight joined canvases, each 8-1/8″ × 8-1/8″; overall, 16-1/4″ × 32-3/8″. Collection, The Museum of Modern Art, New York. The Sidney and Harriet Janis Collection. ©1993 The Andy Warhol Foundation for the Visual Arts, Inc.

The second obvious explanation of the decline of portraits and the rise of family photographs focuses on the spread of the camera—technological displacement. The camera, it is implied, by giving everyone the ability to make their own portraits, displaced the traditional portrait artist.[4]

That the camera has had a major impact is undeniable. But the rise of the camera cannot fully explain the change from painted portraits to family photos. Family photos are not just classical portraits in the medium of photography—their content, use, and mode of display differ. In Meyer Schapiro's words:

> Modern writers have supposed that it was photography that killed portraiture, as it killed all realism. This view ignores the fact that Impressionism was passionately concerned with appearances, and was far more advanced than contemporary photography in catching precisely the elusive qualities of the visible world. . . . [Yet] the Impressionist vision of the world could hardly allow the portrait to survive; the human face was subjected to the same evanescent play of color as the sky and sea . . . [it] became a surface phenomenon, with little or no interior life, at most a charming appearance. . . . If

FIG. 46. Picasso, Pablo. *Head of Marie Thérèse* (1938). Oil on canvas, 18-1/4″ × 15″. Collection, The Museum of Modern Art, New York. Gift of Jacqueline Picasso. Courtesy of Museum of Modern Art and ARS.

the portrait declines under Impressionism, it is not because of the challenge of the photographer, but because of a new conception of the human being.[5]

But what is this new conception of the human being that killed off most portraiture? Schapiro offers only fragments of an answer.

Why then has the painted portrait declined in the twentieth century, why has the most avant-garde current of portraiture that has survived favored depictions that make the subject of the portrait hard to recognize, and what is the meaning and role of family pictures?[6] I will address these questions by analyzing family pictures and such painted portraits as exist, in the houses studied. I will draw attention to a number of features of family photographs which are the key to understanding these questions. These features include their strikingly large numbers, the shift from formal to informal depictions, the narrow range of subjects on which they focus, their characteristic and unusual mode of display, and a taboo against individualism that they imply.

OVERVIEW

Photos of people, almost all of whom are family members, are common on the tables, shelves, and walls of the middle and working classes. They are displayed in every Manhasset house studied, every Greenpoint house except one, every Medford house except two, and in 73% of the Manhattan houses (table 5). Further, the appetite for these pictures is often large, sometimes huge. Of the houses that display family pictures, those in Manhasset display an average of twenty-nine photographs, in Greenpoint an average of twenty-six, in Manhattan an average of twenty-two, and in Medford an average of fifteen. The extreme cases are striking. A Greenpoint grandmother displays eighty-three photographs; and a Manhattan house has forty-seven in just the den (fig. 47). Nor are such pictures confined to one room. They are present, on average, in about three rooms per house in Manhasset and Greenpoint, and in almost four rooms per house in Manhattan.

This point should not be overdrawn. A minority of the Manhattan sample, for example, believe that family photos are not art and therefore should be confined to albums, which accounts for most of the Manhattan residents who display no such pictures. This view is especially prevalent among men who have jobs that involve artistic production (for instance, photographer, filmmaker, art dealer, architect, or advertising executive). Professionally concerned about artistic quality, they are aware that their talents

TABLE 5 Family photographs displayed, by type of neighborhood in which the house is located

	Neighborhood			
	Upper-Class Urban (Manhattan)	Upper-Middle- Class Suburban (Manhasset)	Working-Class Urban (Greenpoint)	Working-Class Suburban (Medford)
Percentage of homes that display family photographs	73%	100%	97%	95%
Mean number of photographs displayed per house[a]	22 (N = 40)[b]	29 (N = 40)	26 (N = 40)	15 (N = 40)

Note: For a multivariate analysis showing that the number of photographs displayed is basically independent of the social class of residents see table A-11 (appendix).

[a]The divisor for calculating these means includes only households that display at least one family photograph.

[b]The total number of households sampled in each neighborhood.

TABLE 6 Painted portraits displayed, by type of neighborhood in which the house is located

	Neighborhood			
	Upper-Class Urban (Manhattan)	Upper-Middle- Class Suburban (Manhasset)	Working-Class Urban (Greenpoint)	Working-Class Suburban (Medford)
Homes that display a painted portrait[a]	45% (N = 40)[b]	20% (N = 40)	15% (N = 40)	10% (N = 40)

[a]These figures on portraits are limited to likenesses of persons known, or once known, to the head(s) of the household or to a relative or friend of the head(s) of household (see note 8 of chapter 3).

[b]The total number of households sampled in each neighborhood.

are, in part, likely to be judged by the appearance of their home. However, women in such occupations do not exhibit such a reluctance to display family photographs, perhaps because they are more concerned with the social than with the artistic significance of family photographs. (See table A-11.) (Notice that the wife is usually the spouse who takes the initiative in displaying family photographs.)

Still, houses without family pictures, or even with just a few, are on the wrong side of history. With the exception just mentioned, family photos, as items of display, are flourishing among all social classes, with no limit yet in

FIG. 47. The den of a Manhattan house.

view. Indeed, family photos rival landscapes in popularity if the paintings and photographs prominently displayed in these houses are counted to include not just those on walls but also those placed in movable fashion, on tables and shelves, a characteristic mode of display for family pictures that I will argue is highly significant (see table A-10 in appendix).[7]

Portraits, painted or drawn, of family members or friends are far less common. Consider Manhattan's East Side—a likely site for portraits. Fifty-five percent of the houses contain none (see table 6). And where portraits do exist, the taste for them is easily sated—a single instance often suffices. Of the Manhattan houses with portraits, 67% contain just one, while four is the largest number in any single house. (These figures on portraits are limited to likenesses of persons known personally, or once known personally, by the head(s) of household or by a relative or friend of the head(s) of household.)[8] Portraits are even less common in Manhasset (in 20% of the houses), Greenpoint (in 15% of the houses), and Medford (in 10% of the houses), with two as the maximum number of portraits in any of these houses. Several of these portraits in Manhasset, Greenpoint, and Medford

are inexpensive drawings by street artists, often with a deliberately cartoon-like quality that suggests the portrait should not be taken too seriously.[9]

Moreover, about half of the portraits, in all four neighborhoods, depict not the adult residents or their forebears, but their children. Thus, there is nothing that remotely approaches an ancestral portrait gallery.[10]

FORMAL TO INFORMAL

Two or three generations ago, almost all the family photos on display would have been formal.[11] The family photos displayed nowadays reflect a shift from formality to informality. "Formal" here refers to pictures that depict people either in noncasual clothing or at certain special occasions (such as weddings, graduation, or religious rituals), or both. Most family photos now depict people at leisure—in the backyard, at the beach, on trips and outings within the United States or abroad. Only 12% of the photographs on display in Manhattan are formal, 30% of those in Manhasset, 31% of those in Medford, and 33% of those in Greenpoint.

The decline of formal photos is clearest on the East Side of Manhattan. In 83% of the houses with photos on display, informal photos clearly outnumber formal photos.[12]

The comments of Manhattan residents reflect this phenomenon, for dislike of formality within the house is common. A woman discussed a galaxy of photos of her little grandson, as a baby, toddling, lying on the sand, by a hotel swimming pool, in his grandmother's arms, and so on (fig. 48): "I like candid (informal) shots. [Why?] I don't like pretense, people who pose." An investment banker explained why he puts his family pictures on tables and shelves, rather than on the wall: "We wanted an informal type of house. I was married before to a woman who wanted a formal, structured house. It was very uncomfortable." A venture capitalist, well-connected in the art world, explained why he has no formal portrait of himself: "Most of the painters I know would laugh if I asked them to do that [paint a formal portrait]. We live in a far more informal world now." Sometimes formality is even mocked. For example, the same joke occurs in two Manhattan houses. A formal picture of a resident wearing a top hat and tails is placed, for humorous effect, among many informal pictures.

The other neighborhoods studied exhibit the same trend toward informal pictures, though less clearly than the East Side of Manhattan. Informal pictures clearly predominate over formal ones in 63% of the Manhasset houses, 60% of the Greenpoint houses, and 55% of the Medford houses.[13]

MARTHA COOPER

FIG. 48. The garden room of a Manhattan house.

There is another piece of evidence of the ascendancy of informal pictures. Some people have updated a family picture taken several years earlier. In the new photo the original subjects are arranged in the original pose; the two versions are then placed side by side. In the old picture people are often formally dressed; in the "updated" version the same people are often dressed informally. But the opposite change never occurs. There is no example of subjects dressed informally in an older version and formally in the "updated" picture. Family history, in the popular mind, moves in only one direction, from formal to informal.

What about the content of the formal pictures that are displayed? Two or three generations ago a wedding photo used to be almost obligatory for the well-to-do working class, as well as for most of the middle class (unless, of course, the latter had a wedding portrait instead).[14] This is no longer so. Wedding photos of the adult head(s) of household are least frequent in Manhattan, displayed in only 7% of the houses occupied by a married couple, and most frequent in Greenpoint, where, however, they are only in just over half of married couples' houses (fig. 49).[15] Depictions of occupational success—becoming partner, advising the Mayor, receiving an author's award,

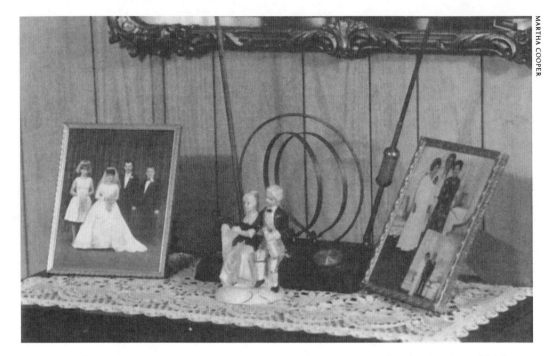

MARTHA COOPER

FIG. 49. Greenpoint living room. Wedding photos of the husband and wife, and of the wedding of the wife's sister.

and so on—are found in some of the upper-middle-class homes (in 45% of the Manhattan houses and 27% of the Manhasset houses); but, for obvious reasons, are rarer in the working-class households.[16] Religious photographs, usually of children taking first communion or being confirmed, are found in about half the working-class households (fig. 50), but are unusual in the households of the middle and upper-middle class. And graduation pictures (again, mostly of the children or grandchildren) are not uncommon in all the neighborhoods except Manhattan. For the rest, the formal photographs displayed in all the neighborhoods except Manhattan fall into two main categories. Either the special occasion they depict is the photograph itself; the subjects are well dressed and well groomed, and the photographer is often a professional. Or the special occasion is some family celebration (birthday, family reunion, wedding anniversary).

The portraits in this study reflect the same trend toward informality. Consider those in the East Side houses. The largest group (57%) are informal. Only 23% are formal, while another 20% are abstract. The informal portraits consist of the following kinds of themes: teenage daughter, hair

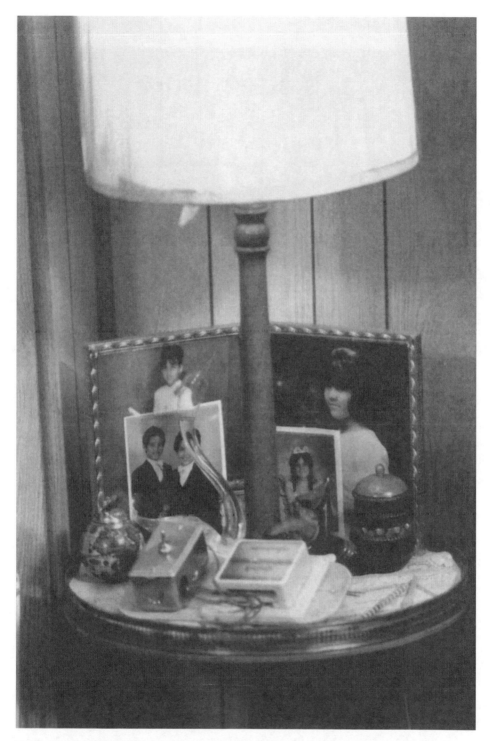

FIG. 50. Greenpoint living room. First communion photos of the daughters and grandsons of the husband.

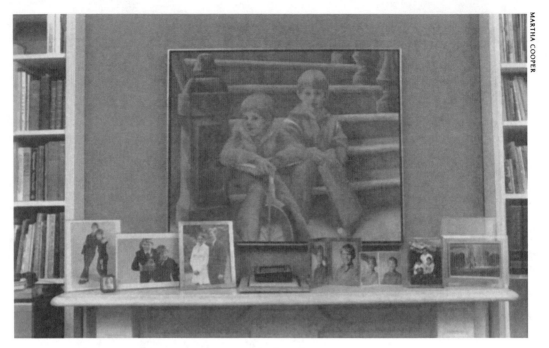

FIG. 51. The den of a Manhattan house, portrait.

ruffled by the wind (occurs twice); two brothers, aged seven and nine, in jogging suits and with bicycle on the steps of their house (fig. 51); parents, children and family pets sitting in the grass of their summer house; parents and children in leisure clothes (occurs twice); husband (as a young man) in a straw hat at the beach (fig. 52).

There are just eight formal portraits on the East Side, displayed in six houses. Examples include a nineteenth-century, ancestral picture of a stern-looking relative who founded Branton, Ontario (fig. 53); a Renoir-like portrait of a young daughter in short dress; a wife in evening gown, hanging in the seldom-used library, amidst the husband's collection of antique musical instruments; and a nineteenth-century ancestor who was lost at sea (fig. 54).

Likewise, all the painted or drawn portraits in Greenpoint, Manhasset, and Medford are informal, except for three (see fig. 55).[17]

The history of portrait painting also reflects this shift from formality to informality. The turning point comes with the Impressionists and Post-impressionists, especially with Van Gogh. Van Gogh's portraits are distinguished by their openness and outdoor quality, and the subjects are mostly

FIG. 52. Staircase of a Manhattan house, portrait of the owner as a young man. The owner, as he looks nowadays, is seated in figure 25.

FIG. 53. The second-floor landing of a Manhattan house, portrait.

FIG. 54. Manhattan living room with early nineteenth-century portrait of an ancestor lost at sea. The current heads of the household (foreground), though pleased to display an ancestral portrait, are unwilling to display a portrait of themselves depicted as substantial and important people. Like most residents interviewed, the idea of such a portrait makes them feel uncomfortable.

FIG. 55. Room in a Greenpoint house. On the right wall is a portrait; on the left wall is the photograph from which the portrait was painted.

plain people. These, as Meyer Schapiro has written, are the first democratic portraits, with no real forerunners in old art.[18]

The decline of the formal portrait as well as of the formal photograph parallels the decline of the formal sections of the modern house, the tendency for rooms such as the hall, traditional library, front parlor and formal living room to atrophy. In this connection it is interesting that informal family pictures are most likely to be placed in the more intimate sections of the modern home—the den or family room, kitchen, finished basement, bedrooms, bathrooms, and staircase. By contrast, any formal photographs, and the occasional portrait, tend to be placed in what remains of the more formal areas of the house.[19]

THE NARROWNESS OF SUBJECT MATTER[20]
Absence of Non-kin

The subject matter of the photographs in the houses studied is astonishingly narrow. First, almost all of them *are* family pictures. There are precious few photos of nonfamily members—friends, colleagues, peers, or strangers. Only 3.9% of the pictures fall into this category, and about half of these also contain a family member in the picture.

Even when non-kin are depicted, they are usually part of a context which highlights kin relations and, above all, the nuclear family. For example, in Greenpoint many of the nonfamily people depicted in photographs occur in wedding pictures (the creation of another nuclear family), as best man or maid of honor or as the guests. Likewise in Manhattan the few non-kin in photographs almost always occur in contexts where the symbolism of the family, especially the nuclear family, is dominant. Thus in one house a photo of a black maid—a former and cherished housekeeper—is surrounded by a display of thirty pictures of the nuclear family. This is one of only two depictions in Manhattan of a nonfamily member alone in a picture. The small number of other nonfamily members depicted occur in the same pictures as family members.

The absence of the school photograph—a child together with the entire school class—underlines the reluctance to display pictures of non-kin. Many residents have class photographs of their children, but stored away. Only two homes display class photographs prominently and, surely no coincidence, one of these belongs to a Japanese couple. They live in Manhasset, where their daughter attends the local school. *Her* class picture is on the living-room mantel—the focus of the room. Individual shots of her are less prom-

inent, off to the side. Three other homes do display class photos, but not prominently.[21] For the rest, residents prefer to display the individual school photographs of their child, separate from the other members of the class.

Here, too, family pictures reflect changes in the modern house. In the nineteenth century, adults often lived in houses with people to whom they were not related—boarders, lodgers or servants. This is now unusual, as was stressed in chapter 1, and on the visual level, is represented in this reluctance to display photos of modern Americans who are not family members.

Lack of Depth

If these photos concentrate on family, they do so selectively. Indeed, the vision of family history that they present is shallow.

Photos of at least one parent are displayed by about three-quarters of the adult residents in Greenpoint and Manhasset, and by around half of those in Manhattan and Medford.[22] Thereafter, family history dwindles. One or more pictures of a grandparent are in 35% of the houses in Manhasset, 25% of those in Medford, and 18% of those in Greenpoint and Manhattan. Nothing earlier exists in Greenpoint or Medford. In Manhattan, four houses have pictures of a great-grandparent, or relative of that generation, as do five houses in Manhasset. That is all.

It is reasonable to wonder if the family history on display is brief because photos of earlier kin are not available. I do not have complete data on this point. But I know that family history and genealogy could be much more comprehensively represented, in many cases, if people displayed some of the pictures they have stored away.

There is, it is true, a move to display "ancestral" photographs. Thus of the residents who show a photo of a grandparent or great-grandparent, several started to do so recently. It is too early to properly analyze this. But in several cases the practice seems superficial and needs to be contrasted with that of societies in which lineage and ancestry play an important role.[23] For example, the phenomenon is sometimes part of an antiquing movement. Consider a photo of a grandparent in Greenpoint: the young woman who displays this picture took it to a specialist who converted the black and white to a fading brown, reshaped the picture from square to oval, and added an oval wooden frame.

Further, satires of ancestral photos are as common as ancestral photos themselves. Nine houses in the whole sample display photos of relatives earlier than the grandparents' generation, but fourteen houses display "fake" versions of such photos that are intended to make fun of the ancestral phe-

nomenon. Examples of the latter, often taken at amusement parks or tourist sites, include a husband "with" the signers of the Declaration of Independence, a son dressed as Wyatt Earp and his sister dressed as a cowgirl, a daughter wearing Colonial clothes, and a nuclear family at a "medieval" banquet in a Welsh castle seated next to the "King and Queen."

Moreover, the practices described above exist in a society where the young are freer from material obligations to their older kin than in most societies. The growth of private pensions and social security, the confinement of seriously ill older people to hospitals and nursing homes, and the tendency for the retired to migrate to warmer parts of the country such as Florida and California all limit the financial obligations of the young to their older, living kin. In this context, the occasional ancestral photo is as often an ornament as a sign of deep ties between generations.

The portraits in this study (formal and informal) run a parallel course. Only four houses display a portrait of any relative earlier than the current adult residents. One is the Manhattan house with a portrait of the ancestor who founded Branton, Ontario (fig. 53). Another is the Manhattan house with a portrait of the relative who drowned at sea (fig. 54). A third is a Greenpoint house where the owner has a portrait of his mother, who died several years ago (fig. 55).

Six houses—two in each area studied except for Medford—display "quasi-ancestral portraits." These look like old family portraits but are not, since the person depicted is not a relative. A Manhattan house, for example, has two nineteenth-century portraits of husband and wife. They were bought for the formal living room after a dealer had pronounced them authentic— that is, genuine portraits of someone else's family (fig. 56). A Greenpoint house has an oval nineteenth-century portrait of a woman who is not, as far as the owner knows, a relative.

To buy portraits for their artistic and decorative value rather than as a record of persons known is not new. The first properly documented example occurs in the sixteenth century.[24] But, in that period, this phenomenon was tiny when compared with that of commissioned portraits of kin and friends. These modern cases of quasi-ancestral portraits are especially interesting because, while they are few, they outnumber ancestral portraits. Six houses have paintings that resemble ancestral portraits but are not, while only four houses have actual ancestral portraits. Neither ancestral portraits nor quasi-ancestral portraits are important; but the former are even less important than the latter. Behold the minor importance of lineage in modern America.

FIG. 56. The back living room of a Manhattan house with "quasi-ancestral" portraits. These appear to be ancestral portraits, but in fact depict persons unrelated to the residents.

CLUSTERING AND THE INDIVIDUALISM TABOO

In a period seen as individualistic, and in a society seen as even more so, family pictures provide a surprise. There is a taboo, implicit but strong, against presenting adult residents of a house alone. Though often alone in a picture, they are rarely alone in the display. A picture of another family member is almost always very close by. Clusters dominate the placement of family pictures. Eighty-seven percent of the family pictures in this study are in groups of four or more (91% of those in Manhattan, 90% of those in Manhasset, 88% of those in Greenpoint, and 73% of those in Medford). Indeed, one part of a house often contains ten or fifteen photos of the same, limited number of people (mostly husband, wife, and children), crowded together—a kind of family photo bonanza (fig. 57).[25] An example is the Manhattan town house of a married couple in their sixties. They have one daughter who lives in Minnesota and has two children. On a table in the den is the following grouping (fig. 58): in the front and middle ground are four pictures of their daughter as a baby, and six pictures of her as a girl, teenager, and young woman. In the left background is the wife, as a young child with her sister; and in the right background is the husband, as a boy with his sister.

Residents and their families are seldom presented alone. "Solitaries"— one photo displayed by itself of one person—are rare, and many of these are children. Rarest of all is the "adult-resident solitary"—one picture, displayed alone, of a current adult resident of the house (depicted in adulthood). There is one in Greenpoint, three in Manhattan, four in Medford, and five in Manhasset. Less than half of one percent of the family pictures in this study are adult-resident solitaries.[26] This implies a taboo against such pictures (though no respondent ever said so, unless asked point-blank).[27]

Again, portraits run parallel to family pictures. Although 43 percent (fifteen) of the East Side portraits depict one or more adults who reside in the house, only three of these portraits both depict a solitary adult and are on solitary display.[28] The rest avoid the impression of aloneness, in the following ways. Two-thirds of them are either family portraits (depicting husband, wife, and often the children, in the same picture), or are displayed as family portraits (for example, the husband's portrait displayed next to the wife's). The others deemphasize the individual importance of the subject: for example, the picture may be hung in an unobtrusive location or surrounded with other pictures. An example is the portrait of a resident who is now a successful photographer as a young man (when he was unknown), in

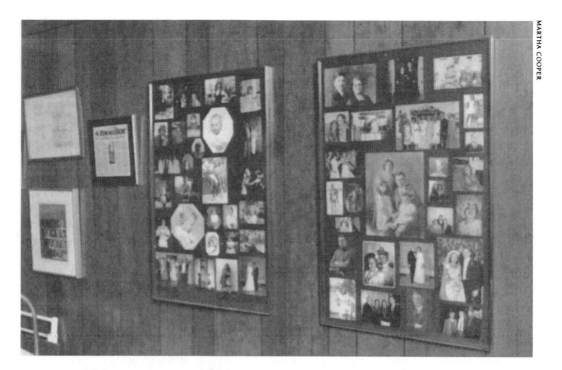

FIG. 57. Den of a Manhasset house.

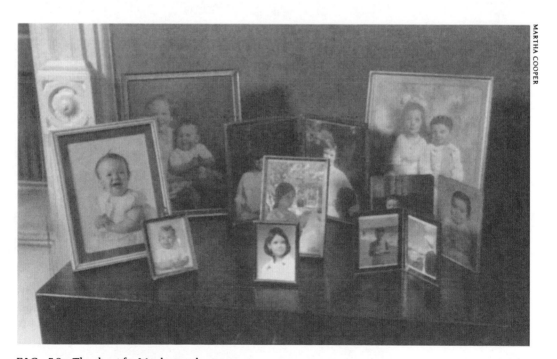

FIG. 58. The den of a Manhattan house.

an informal setting at the beach. It is modestly displayed on the stairs leading down to the kitchen and surrounded by other pictures (fig. 52).

Most adult respondents, in all the areas studied, clearly do not want an individual portrait of themselves, or a large photograph of themselves, displayed alone. So that I could investigate this "taboo" further, I asked residents if they would want an individual portrait of themselves. Almost all said no. Interesting are the reasons given. The commonest answer, from residents of all four areas, was that an individual portrait was too egoistic (see table 7). This answer occurred again and again. Consider these comments. A Manhattan man: "It's presumptuous. It's an obvious expenditure on one's own vanity." A Manhasset woman: "It's narcissistic, decadent. I'd have portraits done of the kids, but not of myself. [Why not?] I don't need to see myself staring at a wall." A Medford man: "I hate painted portraits. It's self-centered, it's like a show-off person." A Manhasset man: "I would think it rather egotistical if I saw someone with a portrait of themself." A Manhattan woman: "I wouldn't want a painted portrait of myself. It would be too self-centered, unless it was very small." A Greenpoint man: "I wouldn't want to look at myself like that." Another set of people within this group explained that a family portrait would be acceptable, but not an individual portrait. A Manhattan man commented: "I'm very family-oriented. I wouldn't want just myself." A Manhasset businessman: "We've often thought of a family portrait. But I wouldn't want an individual portrait of myself. [Why not?] Well, that denotes wealth, it's a W.A.S.P. custom. [Yet in other ways this man, who is Jewish, has no hesitation in copying rich Protestant models. For example, he is one of the few Jews who lives in Manhasset.]"

Further, the suggestion of an individual portrait, or an individual photograph displayed alone, easily triggers alarm among adults. An East Side architect: "I don't want a portrait of myself. [Why?] I'm not sure. [Only partly in jest] Perhaps it's like those tribes that think they'll lose their soul if they're photographed. I'm afraid to lose my soul." A Manhasset businessman [emphatically] "No! I wouldn't want a portrait of myself. [Why?] I don't know why, but I'd rather have a picture of my wife and children and me."

The practice of clustering family pictures and the unwillingness of adult residents to show or see themselves alone, though difficult to analyze, surely partly reflect an awareness of the fragility of the modern family and a concern to capture and freeze time and relationships.[29] For many adults an image of themselves as alone—if only on the walls of their homes—may represent a failure to achieve or sustain a marital or quasimarital relationship, and is therefore to be avoided. This may be why adults are more willing to

TABLE 7 Reasons why respondents would not want a painted portrait of themselves alone

	Neighborhood			
Reasons	Upper-Class Urban (Manhattan) (%)	Upper-Middle-Class Suburban (Manhasset) (%)	Working-Class Urban (Greenpoint) (%)	Working-Class Suburban (Medford) (%)
Egoistic	53	54	51	47
Too expensive	21	24	31	36
Do not trust the artist to do an adequate job	14	10	1	
Do not know/ never thought about it	8	9	15	14
Other	4	3	1	4
Total	100	100	99	101
	(N = 76)ᵃ	(N = 70)	(N = 78)	(N = 81)

ᵃThese numbers refer to the total number of reasons given. An attempt was made to get reasons from both heads of household for each of the 10 households sampled in each neighborhood. Also, some respondents gave more than one reason; in such cases the main two reasons given were counted.

depict their nonadult children that way, because the children are not yet expected to sustain such relationships. And hence the wish to repeat, again and again, one motif—the closeness of the nuclear family. Family photographs jostle, crowd, and huddle, a metaphor for the family closeness that, in life, is hard to attain and harder to sustain. The fragility of the modern family—to which none of these residents wishes to draw attention overtly in picture displays—nevertheless cannot be entirely denied.

Here is an important cause of portraiture's unpopularity. Depictions of adults alone, central in traditional portraiture, run afoul of the modern distaste for this image. Much of the history of portraiture consists of people presenting an identity that is clear and fixed and which exudes self-importance. The modern attitude toward the visual presentation of self within the home could scarcely be more different.

THE MOVABLE MODE OF DISPLAY

Awareness of the fragility of the modern family explains, in part, another distinctive feature of family pictures—their mode of display. They are more likely to stand free on tables, dressers, and other flat surfaces than to hang on walls. In the houses studied, only one in three rooms displaying family

pictures has any on the walls. Certainly family photos on walls are not rare; they constitute about a third of all family pictures displayed. But the movable mode of display is more common, and distinguishes family photos from other two-dimensional pictures, which always hang on walls (the more permanent mode).

The free-standing arrangement makes it simple to subtract, add, and regroup photos. For example, after a divorce pictures of former family members—a spouse or an in-law—can easily be removed, and the remaining pictures arranged to reflect the new composition of the family. Consider, for example, a working-class family in Greenpoint. The husband's present wife is his third, and both his daughters are divorced. Thus pictures of his marriage to his current wife, and pictures of his daughters, at present without husbands, are movable on the table and television (figs. 49 and 50). The only photo fixed on a wall is of the wife's parents—both dead and therefore an eternal couple in the family history (fig. 59).

The movability of family photographs offers another parallel between family pictures and modern portraiture. An East Side resident had a portrait of his wife and two children, painted by Bob Stanley. The original picture consisted of eight panels, bolted together—each family member was depicted twice, on two panels. When the husband and wife divorced, they undid the panels, and the wife took her two. The husband rearranged and rebolted the remaining panels of him and the children, which now hang in his house (fig. 60). Thus the Stanley was salvageable. By contrast, the couple's "marriage" portrait, by Braque, was not, for it was painted on one canvas. It was a painting of husband and wife, given them as a wedding gift by the artist. The divorce rendered this portrait undisplayable.

Here is another possible reason for the declining attraction of portraiture in the twentieth century. The family/marriage portrait, depicting husband and wife on one canvas, has, like the individual portrait, been a staple of the portrait tradition. Yet the possibility, ever present in modern marriage, of divorce surely deters some couples from having themselves depicted in a form that divorce would render unusable. It is also possible that, for a number of residents, all too aware of the fragility of the modern couple, the depiction of their relationship in a form that is so starkly permanent implies a hubris about the future course of their marital life that, consciously or not, they are unwilling to risk. Here is another nail in the coffin of traditional portraiture.

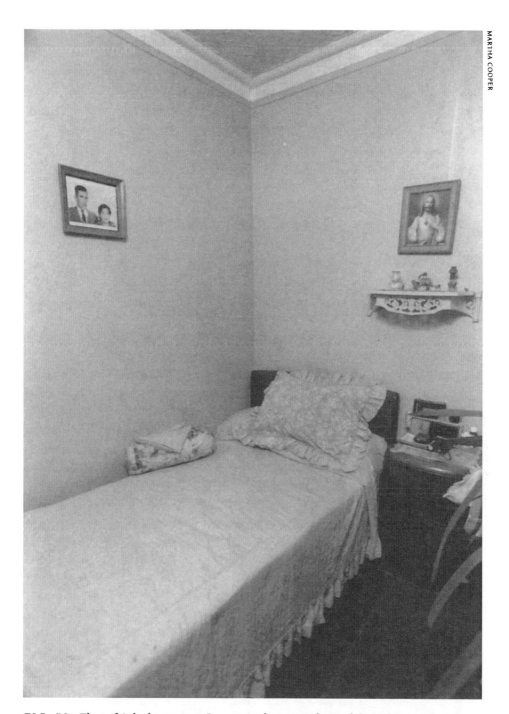

FIG. 59. The wife's bedroom in a Greenpoint house. A photo of the wife's parents, who are dead and whose marriage is therefore unshakable, hangs in a somewhat fixed mode on the left wall. By contrast is the residents' own marriage photo, in a movable fashion, on a television (see figure 49). This is, in fact, the husband's third marriage, and both his daughters are also divorced.

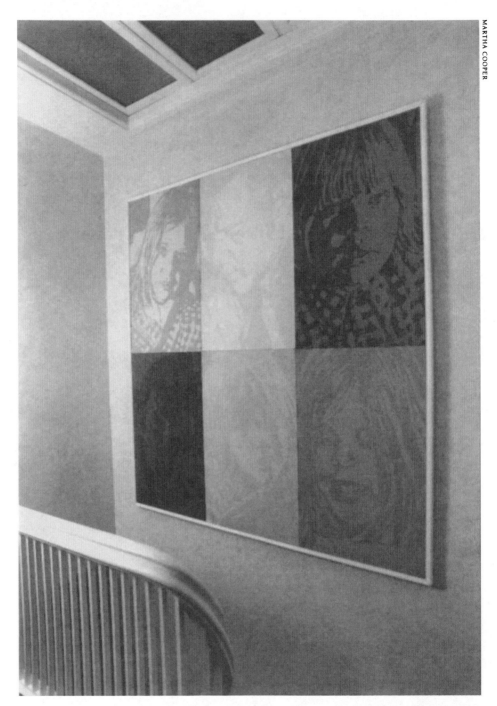

FIG. 60. The top-floor landing of a Manhattan house, portraits by Bob Stanley. The original work consisted of eight panels, bolted together, depicting the nuclear family (the husband, wife, and two daughters were each depicted twice). When the couple divorced, the wife took her two panels and the remaining six were rearranged and re-bolted.

NUMBERS, INFORMALITY, AND A CENTRAL MEANING OF MODERN LIFE

Family pictures reflect another striking feature of modern life. This is the idea that a central aim of life is to spend time enjoying the company of family members. The more such moments a person has experienced, the greater life's value. Family pictures here serve as records and reminders, not of power, status, or ancestry, but of good times. Over and again respondents, asked why they took so many photos, said they wanted to record each moment. Consider these comments. A Manhasset man: "Why do I take so many [family] photos? I want to capture moments. [Which moments?] Happy times, my kids at play. For instance, in this picture my kid was riding his bike, being a tough guy. He thought he was so cool. It [the picture] captured a moment." An East Side resident, explaining why she displays so many (forty-two) family pictures around the house: "It's so you can see the family wherever you are, and remember good times." Another East Side resident pointed to one of the many family pictures displayed in the den. It was a picture he had taken of his young daughter while he was with her at the beach (fig. 47): "Then I can remember *this* moment—going across the sand."

That family pictures reflect the idea that a central purpose of life is having enjoyable times with one's family explains three distinctive features of these photos—their quantity, their repetitiveness, and the preference for informal scenes. Numbers are crucial, since the more pleasurable moments one has enjoyed, the better. The visual repetition of similar, even identical, scenes makes sense, since there is little value in variety. The point is to achieve the same or similar moments as often as possible. And informality reflects the drive for pleasurable times with the family rather than for power or occupational success.

Valuing quantity explains a striking observation. The houses where informal photos predominate contain far more photos than the houses where formal photos, the more traditional mode, predominate (fig. 61). This is because of the different dynamics of the two types of picture. There is little merit in displaying many formal pictures, for often the formal occasions are not repeatable. There is only one first communion or high school graduation. Other formal occasions, though repeatable, may not be enhanced by repetition. To marry once is probably better than to do so two or three times. But quantity definitely enhances informal pictures. The more enjoyable times spent with the family, the better.

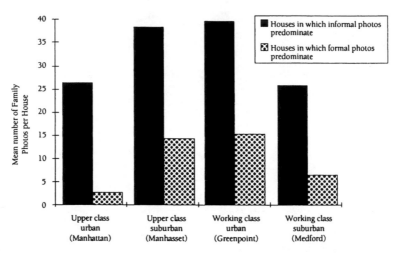

FIG. 61. Mean number of family photos per house, by whether informal or formal photos predominate in the house.

CONCLUSION

The meanings conveyed by family photos are complex and varied. Like portraiture, family photos are a "deceptively accessible genre.[30] Yet the multiple meanings of family photos have their limits, for family pictures are closely connected to social and material life, especially to that of house and neighborhood. In family photos we can trace the decline of formality in the house, the emergence of new conceptions of the purpose of life outside the workplace, the instability of modern marriage, the demise of boarding and lodging, and the weakening of financial obligations toward older, living kin.

Many of the causes of the decline of portraiture and of the spectacular rise of family pictures likewise derive from social life. It is clear from a comparison of the family photos and the portraits in this study, and from the recent history of portraiture, that portraiture has not remained frozen. It has reflected some of the same tendencies as family photos, for instance the growth of informality, a move away from the presentation of individual adult residents as persons of central importance in their own right (clearest in the case of "abstract portraits"), and the obsessive multiplication of similar images.[31]

Portraiture and family photos are both responding to new forces, but not with equal success. The adoption of new modes may have slowed, but has not halted, portraiture's long decline. Family photos wax strong because

they are clearly much better at reflecting the new social forces than are portraits. The camera can satisfy effectively the desire for recording enormous numbers of moments. Photographs are easily stored away, responding to the desire for a treasury of moments. And photographs can be taken quickly; when there is a change in the constitution of the nuclear family, for instance a divorce, new photographs can easily replace the old.

Above all, the painted portrait suffers from an enormous handicap—the fact that few adults wish to see themselves represented alone in the house. This is the albatross of twentieth-century portraiture, for the single adult figure has been a staple of the genre. The "marriage" or family portrait does not fully resolve the difficulty. Partly this is because the possibility of divorce always renders such a portrait potentially unusable.

This taboo goes far to explain not only the decline of painted portraits, but also the dominant form they have taken in the twentieth century. The shift to portraits that often make the very identification of the subject hard may have less to do with "the rise of abstraction" and more to do with an attempt to reconcile the twentieth-century individualism taboo with the portrait tradition. If individuals are reluctant to hang a clearly recognizable depiction of themselves alone on the wall, one solution is to hang one that is less clearly recognizable. Thus the demand for "abstract" portraits may be less an independent cause than an effect of this individualism taboo, itself founded in the instability of modern family life. Other attempts (in twentieth-century art generally as well as among the portraits displayed by the residents sampled) to reconcile the portrait tradition with the instability of the modern family are those portraits that make it clear that the subject is not to be taken too seriously, for instance depictions with a satirical or cartoonlike quality or depictions of the subject engaged in unimportant leisure.

To this analysis the idea that the demand for art is primarily about status contributes little. Perhaps status considerations inhibit a minority of the upper-middle class, especially men involved in the production of culture, from displaying family photos. They may believe that family photos are not, aesthetically, fit to coexist with the other artistic and cultural items on display. But the majority of the upper-middle class are not so inhibited. Further, for most of the well-to-do, any possible status gains from commissioning a portrait of themselves by a well-known artist are outweighed by disadvantages relating to the inappropriateness of the painted portrait in the fragile context of the modern family.

The other theories that link art to power contribute even less here. There

is little evidence that the decline of painted portraits and the rise of family photographs has been brought about by large corporations and their allies on Madison Avenue (the Frankfurt sociology approach). On the contrary, these developments are rooted in shifts in social life beyond the ability of any group to control. And the idea of "cultural capital" theory that art serves to distinguish dominant from dominated classes faces the difficulty that differences between the social classes are not as clear-cut as the theory requires. Family photos are widespread in the homes of all social classes. And while the upper-middle class is more likely than the working class to display painted portraits, less than half the upper-middle class do so.

Abstract Art

"Only the 20th century has witnessed the final elevation of pattern-making into the autonomous activity of 'abstract art.'"

Ernest Gombrich

THE AUDIENCE FOR ABSTRACT ART

The audience for abstract art has been idealized in much twentieth-century theory. Unexamined notions abound of the superior capacities—intelligence, aesthetic sensibilities, and so on—of those who like abstract art as compared with those who do not. Le Corbusier, for example, referring especially to Cubism, wrote (in 1921) that "the art of our period is performing its proper functions when it addresses itself to the chosen few. Art is not a popular thing, still less an expensive toy for rich people . . . but is in its essence arrogant."[1] Ortega y Gasset said (in 1925) that abstract art, having eliminated the "human element" which attracted the masses, could only be appreciated by a minority who possessed "special gifts of artistic sensibility."[2] Ingarden argued (in 1928) that the more abstract the work of art the greater the intellectual effort involved by the audience.[3] Benjamin (in 1936) explained the broad unpopularity of Picasso's work as a result of the fact that "the masses

119

seek distraction" whereas art "demands concentration from the spectator."[4] Clement Greenberg (in 1939) maintained that abstract art appealed only to the most "cultivated" segment of society—"the avant-garde"—who engaged in the process of "reflection" necessary to appreciate abstract art; by contrast the "masses," as well as most of the rich and middle class, had been seduced by "kitsch," which "predigests art for the spectator and spares him effort."[5] And Bourdieu (in 1984) wrote that the working class requires art to be practical, an attitude incompatible with the "detachment and disinterestedness" needed to relate to abstract art.[6]

Given these impressive endorsements, it is a surprise to discover that in fact we know very little about the audience for abstract art, and in particular about what happens when people look at the works. No one has ever asked, in a systematic way, what people who like abstract art see in it, what goes on in their minds when they view it. Sociological surveys have done little more than document that some people like abstract art and others do not. Bourdieu, for example, asked respondents to name their favorite painter from a list that included Leonardo, Renoir, Kandinsky, and Picasso.[7] Sociologists have scarcely asked why people like (or dislike) abstract art, let alone investigated the experiential process involved.[8] Thus the view that admiring abstract art involves some kind of superior experiential act rests on flimsy ground. Indeed the idealized image of the audience for abstract art is a classic example of the tendency to invent art's meaning for an audience, rather than to discover it through research.

Understanding what occurs when people look at abstract art is not just a matter of filling a gap in our knowledge. Abstract art is unarguably the central component of twentieth-century art and a central component of twentieth-century culture. As a result it has stimulated some of the most influential theorizing about modern culture. Few important theories of modern culture do not also imply a view of the audience for abstract art. Similarly, a theory of modern culture that does not fit the case of the audience for abstract art would probably be in serious trouble. Thus analysis of the audience for abstract art constitutes a critical case study for debates about modern culture.

Consider, for example, how the idealized model of the audience for abstract art fits with the idea of "cultural capital" theory, according to which high art serves as a device for controlling entry into the dominant class. Those who like abstract art do so, it is argued, because of their extensive intellectual and experiential training ("cultural capital"), acquired in the

education system and in well-to-do families of origin, which they bring to bear to understand ("decode") the works. This "taste for high culture," exemplified in a liking for abstract art—so difficult for others to acquire—can then serve as the basis for excluding others (the "dominated class") from desirable economic, political, and social positions. In turn, viewing and liking abstract art, as a component of high culture, strengthens the solidarity of the dominant class.

Indeed, advocates of "cultural capital" theory would doubtless say that it is on such genres as abstract art and "primitive" art, whose attraction is largely confined to the upper echelons of the class structure, that their argument depends. Landscape pictures and family photographs may be broadly popular throughout the class structure, but it is abstract art and "primitive" art that exemplify the relation between high culture and class dominance.

Looking at the audience for abstract art offers a chance to examine these arguments on their strongest ground. What is the nature of the experiential act undertaken by viewers of abstract art? Does a liking of abstract art involve specialized knowledge that is difficult to acquire and which can therefore serve to limit access to the social circles of the dominant class? Do these viewers merit the special status assigned to them in so much twentieth-century cultural theory?

Definition of Abstract Art

First, the definition of abstract art. This has been a topic of some debate in twentieth-century art, though probably not as much as it should have been. For example, although artists such as Kandinsky and Mondrian were willing to refer to their works as "abstract," artists such as Naum Gabo were not.[9]

Still, a particular definition of abstract art is accepted (implicitly or explicitly) by most twentieth-century writers, as well as by almost all of those interviewed in this study. Thus few respondents interviewed—either working or middle class—had difficulty, when asked, in deciding what was abstract art (or "modern art," which they often used as a synonym—see table 8, note). Abstract art, for most of them, had two features. First, it eschewed easily recognizable images of the external world: it was "non-representative." Second, it was presented as "art"; for example if it was a picture it was usually framed, hung on a wall, and considered of aesthetic value. This definition will serve here.

WHO HAS ABSTRACT ART?

Abstract art is, indeed, an elite taste, concentrated among sections of the middle and upper-middle classes. It is almost absent, in original or in reproduction, from the working-class households (see table 8). Only two households in suburban Medford and none in Greenpoint had art they identified as abstract, and the degree of abstraction in those two Medford households was moderate. For example, a Medford woman displayed a framed poster, acquired from the liquor store where she works, advertising Paul Mason wines. The poster, in the owner's words, is "abstract but not heavy-duty abstract." It depicts a recognizable, though distorted, wine glass, whose contents have the unlikely colors of orange and blue. Even among the upper-middle class in Manhasset, only about a third of the households displayed any abstract art. And not one household there featured abstract art, in the sense of making it the dominant motif in a room (rather than being the motif of one or two items displayed in a room with other, representative pictures).

By contrast, 55% of the Manhattan households displayed abstract art. And nineteen (32%) featured abstract art in at least one room, in the sense just defined. Figures 62–65 are examples of abstract art as displayed in the houses sampled. (For a multivariate analysis see table A-12 [appendix]).

The comments of residents when asked whether they liked or disliked abstract art followed a similar pattern (see table 9). Abstract art was not particularly liked among the working class or the upper-middle-class suburban residents. It was liked by only 25% of the residents in Greenpoint, 33% of those in Medford, and 38% of those in Manhasset.

Manhattan residents are more enthusiastic. Sixty-eight percent said they liked abstract art. But even in Manhattan a sizable group (32%) disliked abstract art.

That a majority of the suburban upper-middle class, and even a large minority of the Manhattan residents, dislike abstract art scarcely supports the view of cultural capital theory that a staple of high culture such as abstract art is used by dominant classes as a criterion by which to exclude members of the dominated class.

WHY PEOPLE DISLIKE ABSTRACT ART

What do people have against abstract art? A common objection is that the artists are charlatans who cannot draw and cannot paint. Abstract art, in short, is a fraud. This is one of the two main criticisms made by working-

TABLE 8 Whether abstract art is present in the house

	Neighborhood			
Presence of Abstract Art	Upper-Class Urban (Manhattan) (%)	Upper-Middle-Class Suburban (Manhasset) (%)	Working-Class Urban (Greenpoint) (%)	Working-Class Suburban (Medford) (%)
Homes with abstract art	55	32		5
Homes without abstract art	45	68	100	95
Total	100	100	100	100
	(N = 60)[a]	(N = 60)	(N = 40)	(N = 40)

Note: $p<.001$ (chi-squared test). Respondents were asked if they had any "abstract art." Some respondents, especially among the working- and lower-middle class, were unsure about the meaning of the phrase "abstract art"; in such cases, the question was reworded, with "modern art" substituted for "abstract art." This almost always clarified the question to respondents, whose answers then usually made it clear that they understood "modern art" as a synonym for "abstract art."

[a]For Manhattan and Manhasset, the 40 houses sampled were supplemented with an extra 20 in which the interviews focused on the topics of abstract art and "primitive" art.

TABLE 9 Attitude of residents toward abstract art, by type of neighborhood in which the house is located

	Neighborhood			
Attitude to Abstract Art	Upper-Class Urban (Manhattan) (%)	Upper-Middle-Class Suburban (Manhasset) (%)	Working-Class Urban (Greenpoint) (%)	Working-Class Suburban (Medford) (%)
Like abstract art[a]	68	38	25	33
Dislike abstract art	32	57	40	40
No opinion		5	35	26
Total	100	100	100	99[c]
	(N = 92)[b]	(N = 95)	(N = 55)	(N = 57)

[a]Respondents who said they liked some, most, or all abstract art were classified as liking abstract art. Respondents who said they disliked all or almost all abstract art were classified as disliking abstract art. As in the question reported in table 8, respondents who said they were unsure what was meant by "abstract art" were offered a reworded question, with "modern art" substituted for "abstract art." See table 8, note.

[b]The base numbers refer to the number of head(s) of household interviewed, with husband and wife each defined as a head of household. Where possible, I interviewed both husband and wife. Thus, for example, in Manhattan I obtained attitude data for 92 of the head(s) of household in the 60 households sampled (see also table 8, note a).

[c]The figures do not add up to 100% because of rounding.

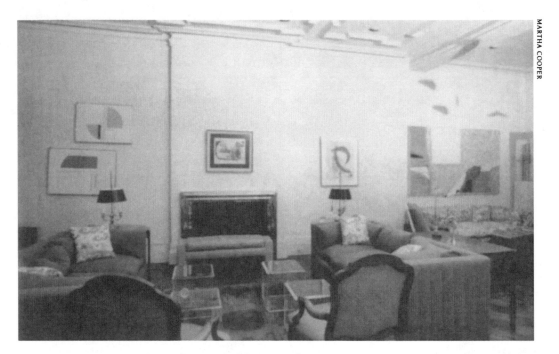

FIG. 62. Manhattan living room featuring abstract art.

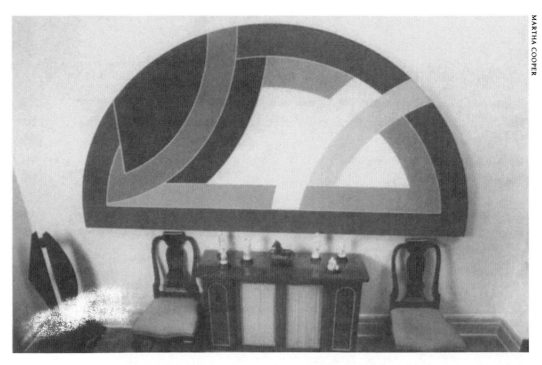

FIG. 63. Manhattan hallway, Stella.

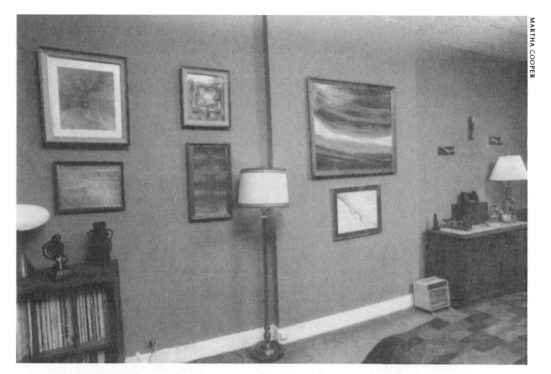

MARTHA COOPER

FIG. 64. Manhattan bedroom.

class people (see table 10). The view is typically expressed with vehemence. Here are some examples. A female Greenpoint resident, in her mid-twenties: "It [abstract art] looks like someone stepped on it." A Medford carpenter, who sees abstract art when he renovates the vacation homes of wealthy people in the Hamptons on Long Island: "The paint fell off the truck and they cut the asphalt off and hung it on the wall. That's abstract art to me. I just see confusion."

This view that abstract art is a deception is not confined to the working class. It is also common among suburban residents of Manhasset (the third most common objection there, but in frequency not far behind the other two), and is found too among the minority of Manhattan residents who are critical of abstract art (see table 10). A Manhasset resident, herself an amateur painter: "Some of the modern stuff is o.k., but a lot of the stuff is either ugly or a put-on. These million-dollar price tags are a big put-on. Most of the French Impressionists could paint; *they* really did wonderful things. But a lot of the modern artists can't paint. Jackson Pollock is a big hoax. It's nothing but drips." A Manhattan architect: "Abstract art? It's a zero! It's

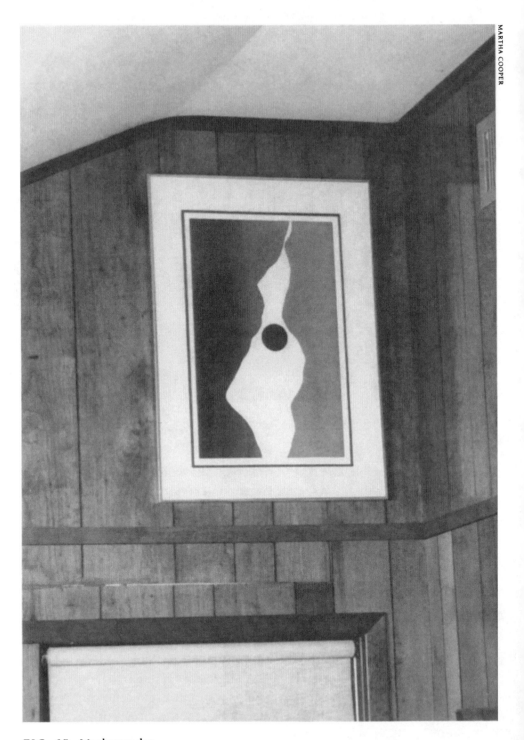

FIG. 65. Manhasset den.

something foisted on us by charlatans and sold by charlatans. At least Picasso and Klee had it in them to do something else. When they painted their own children, they didn't give them three heads. Gottlieb, Motherwell, they're frauds. Jackson Pollock is the worst. Abstract art became a highly intellectual thing. But art has to have an immediate feeling. If I see a Rembrandt, it has an immediacy. You don't have to have someone writing a book about it."

A second complaint about abstract art is that it has no meaning. This is one of the main objections among upper-middle-class residents. A Manhasset man in his fifties: "It doesn't have any message for me." A Manhattan woman in her forties: "They [abstract paintings] don't mean anything. Take the German expressionists. I'm not German, and to look at it it's ugly. It doesn't say anything to me." A Manhasset woman in her sixties: "I stand looking at two blobs, trying to find a meaning in it. The meaning is that they can get fantastic sums of money for the works!"

Another common criticism among upper-middle-class Manhasset resi-

TABLE 10 Main reason(s) for disliking abstract art, by type of neighborhood in which the house is located

	Neighborhood			
Main Reason(s) for Disliking Abstract Art[a]	Upper-Class Urban (Manhattan) (%)	Upper-Middle-Class Suburban (Manhasset) (%)	Working-Class Urban (Greenpoint) (%)	Working-Class Suburban (Medford) (%)
The artists are charlatans, frauds	23	21	30	36
Has no meaning	38	26	13	13
Ugly	28	10	9	
Harsh, cold unemotional	3	23		
Too complex to understand/ ultramodern			48	52
Other	8	21		
Total	100	101[c]	100	101
	(N = 39)[b]	(N = 78)	(N = 23)	(N = 23)

[a]These are the reasons given by respondents who were classified in table 9 as disliking abstract art.

[b]Some respondents gave more than one reason for disliking abstract art, in which case their top two reasons for disliking abstract art were included here. The base numbers in parentheses thus refer to the total number of reasons counted in the analysis for each neighborhood. For example, in Manhattan 29 respondents who did not like abstract art gave a total of 39 reasons for their dislike.

[c]The figures do not add up to 100% because of rounding.

dents is that abstract art is "cold," "harsh," and "unemotional." A Manhasset man who deals in Japanese art: "Abstract art doesn't affect me visually and it doesn't affect me emotionally. It leaves me cold." A Manhasset woman: "I don't really like it [modern art]. It's too harsh, it's not soft. It doesn't reflect nature. I like things to be warm and comfortable."

Finally, there is a pair of objections found among the working class which imply that abstract art is an item of high culture that is part of an alien world beyond their understanding. Thus some of these residents object either that abstract art is too complex to understand or that it is too modern, "ultra modern." These working-class people do not care for abstract art, but believe that this is because they are not equipped to understand it and do not move in cultural circles that might. Such respondents are similar in outlook to the significant group of working-class respondents (35% in Greenpoint, 26% in Medford—see table 9) who say they have no opinion on abstract art, mostly because they feel that they do not know much about it.

WHY PEOPLE LIKE ABSTRACT ART

These findings will not surprise those who believe that abstract art is the domain of an intellectual and cultural elite who alone are capable of appreciating it. Indeed, it will confirm their view. Why should working-class residents, or even most upper-middle-class suburbanites, possess the skills to appreciate abstract art?

It is residents of Manhattan's Upper East Side who offer an almost perfect group for examining the widely posited model of the audience for abstract art—an audience with superior capacities who engage in some kind of special (and superior) experiential act when they view the works. In terms of their education, income levels, occupations, and access to museums and other cultural institutions, these Manhattan residents are as likely to fit the model as any residential group in the United States. Indeed, given New York's dominance of the modern art scene since World War II, this audience are as likely to fit the model as any residential group in any country (with the possible exception of neighborhoods composed mainly of artists). How, then, do they relate to the works? What is involved when they "appreciate" the art?

Abstract Art as Decoration

Theorists of abstract art have offered a number of opinions as to what it is to appreciate the works. Some say it is to relate in an imaginative manner to

the works; others that it is to receive pleasure from the art; still others that it is to comprehend the artist's intentions; many do not say at all. Yet these writers, and the modernist movement in general, were agreed on what would *not* count as appreciating abstract art. They were united in opposition to art that was "decorative." For example, Kandinsky warned against producing "works which are mere geometric decoration, resembling something like a necktie or a carpet." Mondrian cautioned that "all art becomes 'decoration' when depth of expression is lacking." Indeed, the critique of merely "decorative" art was one of the cornerstones of modernism. The Austrian architect Adolf Loos, in a famous pronouncement, declared that "cultural evolution is equivalent to the removal of ornament from articles in daily use." And Frank Lloyd Wright said that "any house decoration, as such, is an architectural makeshift, however well it may be done." [10]

It is, then, salutary to discover that of the reasons East Side residents gave for liking abstract art, the largest number (54%) involve the view that it is the design or decorative qualities in the works that attract them. Residents like the colors, lines, shapes, or overall effect. This is also the main reason why residents of Manhasset like abstract art (see table 11).

The concept of the "decorative" is, of course, complex, concealing sev-

TABLE 11 Main reason(s) for liking abstract art, by type of neighborhood in which the house is located

Main Reason(s) for Liking Abstract Art[a]	Neighborhood			
	Upper-Class Urban (Manhattan) (%)	Upper Middle Class Suburban (Manhasset) (%)	Working-Class Urban (Greenpoint) (%)	Working-Class Suburban (Medford) (%)
Decorative/design				
Pure decorative/design	38	36	57	68
Decor (how the art fits with the room)	16	18	7	
Permits imagination to				
wander	33	26	14	21
Other	12	20	21	11
Total	99	100	99	100
	(N = 91)[b]	(N = 50)	(N = 14)	(N = 19)

[a]These are the reasons given by respondents who were classified in table 9 as liking abstract art.

[b]Some respondents gave more than one reason for liking abstract art, in which case their top two reasons for liking abstract art were included here. The base numbers in parentheses thus refer to the total number of reasons counted in the analysis for each neighborhood. For example, in Manhattan 63 respondents who liked abstract art gave 91 reasons for their attitude.

eral currents that should be distinguished. Thus of the Manhattan residents who say it is the design or decorative qualities in the abstract works that appeal to them, just under a third focus explicitly on what can be called "decor"—on how the art fits with, or improves the look of, the room. For example a woman discussed a large (6′ × 4′) painting that dominates her living room: "That's a painting we love. We have a sedate room, and that painting explodes. It gives the room light. [Interviewer: "What does it mean to you?"] It doesn't really mean anything. The artist usually says, 'It isn't supposed to have meaning.' I've learned not to ask artists about meaning." A man in his early fifties discussed the various abstract paintings that hang in his bedroom (fig. 64): "I like them because they're colorful. They brighten up the wall [sections of which are painted gray, with a central section painted salmon]. I aimed for colorful art because of the grayness of the wall and the grayish carpet." The lawyer who is on the art committee at work that chooses paintings for the office likes abstract art, which (with "primitive" art) dominates her home (fig. 62), because "I like the colors. I think of art in semidecorative terms. I think of how it will blend into the room. To me lines and colors are important in themselves. For instance [discussing a large, bright tapestry by Sonia Delaunay] I like the vibrant colors—the dark sinks and recedes. And we wanted a tapestry to absorb sound, since we had taken up the carpets." These comments about decor hardly, in themselves, demonstrate that abstract art has meaning only for someone who has a lengthy cultural training. Nor do they support the notion of a clear class difference underlying the experiential act of liking abstract art, especially since there is a conventional view that associates the working class with choosing "art" specifically in order to fit with the room furnishings—"sofa" art, as it is sometimes dismissively called.

However, residents for whom abstract art is "decorative" more commonly focus on the design qualities of the art without, as in the cases just cited, explicitly linking these to the room where the art is displayed. This can be called the "purely decorative" attitude. The dealer in "primitive" art: "To me it's [abstract art] basically design—pure design and decorative design. My favorite is Klee—it's the design that I like." A Manhattan woman, a photographer, in her late fifties: "Being a mathematician, I love Mondrian. [Why?] I see balance and color in the paintings. I feel comfortable with them." A Manhattan man who heads an advertising agency, describing an abstract painting hanging in the formal living room: "I like the effect it creates—its iridescence, luminosity. It's very attractive. And I like the color." A Manhattan woman who is a professional sculptor: "I love it [abstract art].

It's so clear, everything else seems so fuzzy. It seems to come down to the central forms and shapes. I think it's very beautiful." The Manhattan venture capitalist for whom Braque had painted a wedding portrait discussed a Stella hanging in his living room (fig. 63): "Why do I like it? It's one of the best colored Stellas of its period. I like this sort of abstract art. I like the colors and the way it looks." A professional photographer in his early sixties:

> I like some abstract art. I like some Picasso and I very much like Mondrian's paintings. What I like about it are the lines. [What do you like about the lines?] Well, I like the way they go. I have a precise sense of how I like things to look. For example, these eggs [he has a basket of painted Russian Easter eggs on a table]; it is important to me in what position these eggs are arranged. If someone rearranges them, I can tell. That's what I like about Mondrian, the arrangement of the lines.
>
> I also very much like the later work of Helen Frankenthaler [a friend of his]. [Why?] The colors, the total look. They [the paintings] don't mean anything to me. I don't know if they're meant to mean anything.

These comments, all of which fall within the domain of the decorative, raise difficult problems for evaluating the quality of the experience undergone in viewing abstract art. Abstract art may, for these viewers, be decorative but surely, it will be said, it is not, for all of them, merely decorative. Does not the notion of "decorative" dissolve into various categories (in addition to the distinction made already between "decor" and "purely decorative")? Is there not a difference, among those who see abstract art as decorative, between viewers with an "artistic" and viewers with a "nonartistic" eye? In liking the decorative qualities of abstract art are not some of these residents training on the works a set of mental faculties, aesthetic and otherwise, that are qualitatively superior to those that the working class and the less talented or educated sections of the upper-middle class bring to bear when they regard decorative items?

These are not questions that can be delved into further here. What can be said is that few of those who argue that the experiential act of looking at abstract art is superior to that of looking at representative art have delved into them at all; and those who have did not resolve the problem. Among the latter, Clement Greenberg is an interesting example. He believed that, even for the artists, modern art was closely associated with the decorative. Indeed, he argued that modern painting was almost inevitably "decorative."

"Decoration is the specter that haunts modernist painting." For Greenberg then, the task of the modern artist was somehow to infuse decoration with art.[11] But how did one know if an artist had successfully infused the decorative with art? Here Greenberg lapses into subjectivism, veiled in obscurantist language, often suffused with an evaluative language drawn from cuisine. For example, discussing artists who in his opinion have failed to infuse the decorative with art, Greenberg complains that one artist's oils have a "saccharine color and gelatinous symbolism"; another artist's colors resemble "stale Florentine sugar." As Donald Kuspit has written, "Greenberg's use of the qualitative terms of cuisine is itself inherently emotional; they are not unequivocally descriptive terms. It is impossible to say they are accurate, only that they are evocative. . . . Of course, one can argue that the rhetoric of cuisine is a kind of perceptual shorthand, but it is hard to say what intuitions it abbreviates."[12]

Thus there may be, among the audience for abstract art, as among the artists, an avant-garde or "artistic" attitude toward decoration on the one hand and an unsophisticated or mass attitude toward decoration on the other hand. However, until some clear criteria are offered that will enable an observer to distinguish those comments or actions of respondents that indicate "avant-garde" or "artistic" attitudes toward decoration from those that indicate unsophisticated or mass attitudes, the argument is not convincing.

The Creative Response?

Still, the second most common reason that East Side residents give for liking abstract art does seem to support the stereotype of the audience for abstract art. Abstract art, some respondents say, permits the imagination to wander. It allows a creative response to the work. Far less than representative art does it guide, determine, and fix the viewer's response. Thirty-three percent of the reasons Manhattan respondents gave for liking abstract art fell into this category, as did 26% of the reasons respondents gave in suburban Manhasset.

The idea that "great art" is distinguished by its ability to unleash the creative imagination of the audience is widespread.[13] Thus this kind of relation between the spectator and the art looks more promising for the argument that enthusiasts of abstract art engage in some kind of superior experiential act (as compared with those who dislike abstract art or prefer representative art).

Consider some examples of East Side respondents who expressed this view, about abstract art in general or about particular works. A woman in

her early forties: "I like abstract art, It gives you a lot to think about. I like to have on my walls things that make you dream a bit, that are not realistic." A man in his mid-forties: "I like abstract art because it doesn't pin you down. I can look at the lines and colors and see all kinds of things. Chagall is my favorite artist: I like the imagination in his work." A man in his mid-fifties, discussing an abstract painting: "There are two ways of looking at this. That's what intrigues me about it."

Granted that only a small minority of respondents gave this reaction to abstract art. But perhaps this is just what theoreticians such as Le Corbusier and Greenberg had in mind when they argued that abstract art was capable of being understood by only a few.

It would, however, be a mistake to stop here. The question arises as to what images respondents create when they view their abstract art. On what objects does their imagination settle when it is turned loose by abstract art? To settle this question, respondents who liked abstract art because they could look at it creatively were asked what images came to mind as they gazed at their works. The answer was striking. Over half saw landscapes, in one form or another. As they looked at the works they seemed to see the ocean, waves, the beach, clouds, the sun, mountains, meadows, and so on. A Manhattan man said: "I see clouds floating." A Manhattan woman, talking about a whitish painting: "I look at this and I imagine it's the snow of the Russian steppes." A Manhasset woman on an abstract painting by a Mexican artist: "It reminds me of the Yucatan. If you look at it, its almost like the excavations of an old city." A Manhattan man who liked the ambiguity in his abstract paintings (fig. 64): "I look at this and I wonder, 'Is this in the midst of a haze, or is it a spot on Jupiter with the clouds around it?' Or take this picture. Am I at the top of the Grand Canyon looking down at the Colorado River, or am I down by the river looking up, with the sun coming over the top?" A Medford woman: "I love modern abstract art. [Why?] Well, you can use your imagination. You can see clouds or the ocean or whatever you want."

The problem with accepting such comments as evidence of a distinctly creative relation between viewer and art work is that landscapes are the most popular topic of the paintings displayed in all four neighborhoods sampled, as we have seen. The landscape motif is pervasive among all social classes. Thus the minority who allow their imaginations to wander over abstract paintings appear to come to rest at the same point as almost everyone else—the landscape. This, in itself, scarcely counts as creativity. It might, of course, be argued that the landscapes that this minority discern in their

abstract art are more creative, in some way, than the landscapes that typically appear in displayed pictures. This argument remains to be demonstrated, like the view that the decorative qualities that the upper-middle class see in abstract art are somehow aesthetically superior to the decorative qualities that the working class see in their drapes, porcelain, clothing, and so forth.[14]

Notice, too, that the avant-garde who display abstract paintings also like to display landscapes. Indeed, *every* Manhattan household sampled displays prominently at least one landscape picture. However, those Manhattan residents who feature abstract art in their homes tend to have fewer landscapes than the others. (Among all Manhattan residents, the average number of prominently displayed landscapes is 2.9; among the nineteen Manhattan residents who feature abstract art in at least one room, sixteen have fewer than this mean number.) But if the avant-garde display fewer landscape pictures than do other residents, that is less because they lack the taste for landscape pictures than because this taste is satisfied in slightly different ways. Some of them "discover" landscape depictions in their abstract art; others (for example, a few residents of the spectacularly scenic section of the Hamptons sampled) have no landscape pictures prominently displayed simply because their desire to view the landscape is met by the natural scenes visible from their houses.

What else do respondents who like abstract art because it allows their imagination to wander envisage in the works, in addition to landscapes? Interpersonal relations, and in particular family motifs, are the next most common topic. For example, a Manhasset woman, head of the psychology department at a major university, looks at her favorite abstract painting and sees "closeness and distance between a couple" (fig. 65, top left). Yet we have already noted that family photos, widespread in the homes of all social classes, are centrally about interpersonal relations, and often about the fragility of the nuclear family. Thus here too doubts arise as to whether looking at abstract art can be said, in general, to involve a distinctly creative effort.

THE DECLINE OF WALLPAPER AND THE RISE OF ABSTRACT ART

If abstract art is liked, by many, for its decorative qualities, then one key to understanding its attraction for a twentieth-century audience may lie in the history of home decoration, above all in the vogue for plain white walls in the early decades of the twentieth century and in the associated dislike of decorative wallpaper.

Wallpaper in the nineteenth century contained purely decorative motifs

or a variety of representative topics or both. Already by 1788 wallpaper, often imported from France, was reported as in widespread use among the wealthy and middle class in the United States.[15] It became increasingly popular in Western Europe and the United States. In 1850 Andrew Jackson Downing noted, with approval, that it was the preferred method of covering the walls of country cottages, with whitewash as a cheaper alternative for the less important rooms.[16] The vogue for wallpaper spread rapidly in the middle and late nineteenth century, primarily as a result of falling prices, associated with the mechanization of production.[17] Eighteen-eighty saw what a historian of American wallpaper refers to as "a multi-patterned, multi-bordered wallpapering craze."[18] By 1900 wallpaper was so common that it was the favorite way that New York landlords "redecorated" a vacant apartment before re-renting it.[19]

During the next three decades an attack on wallpaper, and a move to promote plain white walls, was mounted by representatives of "modernism," the "International Style." The idea that architecture should be functional in fact and in appearance, central to the work of architects such as Le Corbusier and Frank Lloyd Wright, left little room for wallpaper that was decorative or that contained representative images. Wallpaper was attacked as ornamental, overcomplex, and dishonest, for it often "concealed" the wall and gave a two-dimensional surface the appearance of being three-dimensional and something other than a wall, such as a landscape or flowers or people; or it imitated materials such as plaster or wood. Above all wallpaper was attacked as being "decorative." Adolf Loos's famous critique of ornamentation lambasted wallpaper. Thus after announcing that cultural evolution was equivalent to the removal of ornament from articles in daily use, Loos continued, "Lack of ornament has pushed the other arts to unimagined heights. Beethoven's symphonies would never have been written by a man who was obliged to go about in silk, velvet and lace. But whoever goes to the Ninth Symphony and then sits down to design a wallpaper pattern is either a rogue or a degenerate."[20] Le Corbusier railed against the widely prevalent "damasked wallpapers, thick with colour, with their motley designs."[21] By 1925 he was recommending that all walls should be white. In an essay titled "A Coat of Whitewash," he noted that whitewashed walls were common in simpler societies, but disappeared as modern, ornamental, and inauthentic culture invaded, whose symbol was wallpaper. Modern society must rediscover whitewash. "The tasks of our age—so strenuous, so full of danger, so victorious—seem to demand of us that we think against a background of white."[22] So the leaders of fashion and taste turned against wallpaper. As Lynn wrote, "By

the 1900s most of the major taste makers (architects, decorators and design-
ers) had lost interest in *creating* wallpaper patterns."

These two developments—first, the availability of inexpensive wallpaper
leading to its spread beyond the houses of the wealthy and the middle classes
and, second, the disapproval of wallpaper by the avant-garde—surely fed off
each other. The spread of wallpaper among lower social classes probably
caused unease among the rich and middle class, and a desire for a new
direction that would distinguish their tastes from those of people lower
down the social hierarchy. The ideas of the avant-garde fueled that dissatis-
faction and provided the new direction—plain, painted walls, especially
white walls.[23]

On these plain white walls the avant-garde hung their artwork, but now
something was missing—the decorative design motifs that had been pro-
vided by wallpaper. How to decorate white walls? Abstract art represented
the perfect solution. Now lines, patterns, and designs could return, no
longer as despised wallpaper but repackaged and reframed as avant-garde
art. This is not to argue that the vogue for white walls was the only cause
for the attraction of abstract art among twentieth-century audiences; but it
is to suggest that it was a central cause, one which has been overlooked.
Notice too that my argument here is about the audience for abstract art, not
about the artists. I do not want to suggest that for the artists who produced
abstract art the decorative was a major factor, although so eminent an art
historian as Ernest Gombrich has flirted with this more radical idea.[24]

CONCLUSION

What appears as a liking for abstract art conceals several different dimen-
sions. This is why attempts to analyze the causes of the attraction of abstract
art have proven so frustrating. Abstract art as "decoration" is probably cen-
tral to its attraction for a large segment of the twentieth-century audience.
A second cause appears in the comments of the minority of residents who
like abstract art because it allows their imaginations to wander. In these
cases, the imagination often comes to rest on the genre of landscape. Thus
some of the same factors driving interest in viewing images of the landscape
may also underlie interest in abstract depictions. A third cause of audience
interest in abstract art is connected to the tension between the traditional
portrait and the fragility of the modern, nuclear family; as I suggested earlier,
"abstract" depictions represent one solution to this problem.[25] These three
separate motifs (and further research will surely uncover more) all appear to

casual observers as undifferentiated "abstract" art. Thus abstract art is understood by its audience in several different ways, each with its separate social roots, many of which are fully discernible only in the private context of the home.[26]

This also suggests why the model according to which, in the twentieth century, artists and critics nurtured "the desire for abstract art" that was then passed along (or taught) to the upper-middle class is too limited and prone to exaggerate the extent to which tastes in twentieth-century art are controlled and controllable. Not only does this model imply that the meanings that artists and critics give to the works are basically the same as those given by the audience, but it also implies that the "taste for abstract art" is a single phenomenon, rather than a variety of phenomena with a deceptively common veneer, and with varied social roots which no one group can manipulate.

These findings, then, are centrally relevant to theories of culture and power. In particular, they caution against exaggerating the role of power and status. There is some support here for the idea that art may sometimes be associated with status striving, but not support for the idea that such status strivings are the dominant force underlying the taste for a particular genre.

By contrast, these findings, for the critical case of abstract art, cast doubt on the claim of cultural-capital theorists that tastes in art constitute a major barrier between the dominant and the dominated classes, and on the related idea that lengthy training, acquired in one's family or in the education system, is needed to produce the tastes, knowledge, and capacities which underpin an interest in high culture. If abstract art is, for many of its audience, about such factors as decoration, then the apparent gap between those who like abstract art and those who do not looks less like a chasm than a crack. Everyone (the working class, the middle and the upper-middle classes) uses purely decorative motifs—lines, colors, and so on. It is just that while the working class use such motifs on their wallpaper, drapes, china and so on, a section of the middle and upper-middle class also present these motifs "framed" as abstract art, either literally in the case of two-dimensional works or in some other ritually accepted way that denotes "art." Here, moving from one taste culture to another requires, in principle, no elaborate cultural training; rather, it appears to be a simple step, involving little more than the decision to present decorative motifs as abstract art.

Of course, it is important to note that those who have taken such decisions are concentrated among sectors of the middle- and upper-middle

classes, rather than being randomly distributed throughout the class structure. But this leaves open the central question as to why they have done so. Is it because of elaborate prior training, as the theory of cultural capital insists? Or is it because of less elaborate prior experience, for example a passing acquaintance, gained perhaps in their families or in the educational system, but perhaps elsewhere such as in the popular press (recall *Life* Magazine's famous symposium in its 1948 issue that presented the case for and against abstract art)?[27] Or is the decision to display abstract art not basically made as a result of prior training and experience, but rather as a result of or during the process of entry into the middle and upper-middle classes? The discovery that many of those who like abstract art do so because of its decorative qualities, or because they can envisage landscapes in the works, leaves room for all these possibilities, while the theory of cultural capital suggests only the first. This is not to deny that some people who display abstract art do so because of elaborate cultural training, nor is it to deny a frontier between the "cultured" and the uncultured. It is just to say that an elaborate cultural background is not a *necessary* condition for displaying abstract art, and may in fact have little to do with the reasons why many of those who display abstract art do so.

5

"Primitive" Art

"You don't need the master-piece to get the idea."
Picasso, on "primitive" art.

"Congo masks are . . . more grotesque than beautiful."
Alain Locke, African American advocate of the aesthetic
merits of "tribal" African art, 1927.

Only in the twentieth century did Westerners begin to view "tribal" artifacts as art. During the previous century, ethnographic museums often preserved these objects and presented them—Darwin style—as indicators of the technological level reached by the societies that produced them. Earlier, they had been, for the most part, either ignored or viewed with horror as examples of pagan idol worship.[1]

The terms "primitive" and "tribal" are notoriously unsatisfactory as applied to art, and yet notoriously hard to improve upon in discussing the reception of the artifacts in the twentieth-century West. I use the terms here because this is a study of the audience for "tribal" art and these are the terms that drove the interest of twentieth-century audiences in the artifacts.[2]

Why, in the twentieth century, did Westerners begin to see "tribal" objects as "art"? Until recently, the standard explanation stressed the aesthetic acumen of certain artists, directors of cul-

tural institutions, and critics, saying little about the rest of the audience that viewed and purchased the objects. Thus 1906–7, when a few vanguard figures—Picasso, Matisse, Apollinaire, and others—"discovered" the aesthetic merits of African and Oceanic masks and figure sculptures, was a significant year.[3] The conventional explanation further stresses how, later, the directors of select galleries and art museums recognized the aesthetic merit of "primitive" art.[4] Examples in the United States, all located in New York, include the Alfred Steiglitz Gallery's 1914 display of African figures, the first exhibition anywhere of African sculpture as art; the 1935 Museum of Modern Art show "African Negro Art," which stressed "primitive" art's influence on modern painting and sculpture;[5] the 1957 opening of the Museum of Primitive Art in New York (the first American museum devoted to "primitive" art); and the Metropolitan Museum of Art's agreement, in the late 1960s, to absorb the Museum of Primitive Art and build a special wing to house it. Nelson Rockefeller, whose private collection had formed the nucleus of the old Museum of Primitive Art, hailed this last decision as the end of a long struggle to place "tribal" art on an equal aesthetic footing with the great arts of the world. He wrote, "[Now] the long-neglected creative work of the so-called primitive artists of Africa, the Americas, and the islanders of the Pacific . . . will be available side by side with the best creative work of Egyptian, Near Eastern, Greek, Roman, Asian, European, American, and modern artists."[6]

This explanation of the attraction of "primitive" art in the West (like the idealized image of the audience for abstract art) fits with the idea of cultural capital theory, that upper-middle-class taste is based on aesthetic capacities formed through long training—education, family socialization—and is thus hard for subordinate classes to acquire. Thus the avant-garde sections of the upper-middle class audience, marshaling their trained aesthetic capacities ("cultural capital") and taking their cue from the artists and critics—the true driving force of cultural and artistic history—come to see the aesthetic merits of "primitive" art.

Recently a group of critics has challenged the assumption that "primitive" art became accepted in the West mainly for reasons of aesthetics. These critics have perceived a political-ideological motive in the display of "primitive" art, specifically in Western museums. They say that museum exhibitions typically suggest that the artistic and cultural life of tribal ("non-Western") societies climaxed in a "traditional" ("pre-Western contact") past, and that in adopting Western ideas and materials, this artistic life degener-

ates and is absorbed. Thus museum displays imply that "tribal" societies are unable to create a new and vital art and culture that may draw on modern Western culture without being dominated by it.[7]

There is an important point here. Nevertheless, the audience plays, in this account, an even more passive role than in the traditional one. It is the familiar one of being the target of ideological manipulation (Frankfurt sociology style), in this case by museums.

There is, then, a lacuna in both explanations. This is the role of the audience which appears, stereotyped and largely deduced from theory, as a more or less passive recipient—either (in the traditional explanation) of the aesthetic judgments of artists and other experts, which it uses its artistic training to validate, or (in the more recent explanation) of the ideologically motivated manipulations of museums and their directors. Indeed, thus far unstudied is the extent to which the Western audience that views and purchases "tribal" art participates in a process whereby new meanings, unforeseen by Western artists and critics, emerge and consequently influence the course of cultural history.

One reason for the limited role assigned to the audience is that researchers have focused on "tribal" objects in the Western museum or gallery rather than on those in the private house. While the audience does not select the items for display in museums and galleries, this is clearly not true of the home, where the main audience, the residents, are precisely those who choose the items for display. It is, therefore, less plausible to imply that the audience's role here in assigning meaning to the items is passive.

There are, in fact, historical reasons for assigning a central place to the analysis of "primitive" art in the modern home. Long before the objects of "tribal" societies found their new places in major Western art museums, they had already made their way into private homes. As Susan Vogel, the director of the Museum (formerly Center) for African Art in Manhattan, has written, "Until the 1970s, except for sporadic art exhibitions and natural history museum displays in a few large cities, little African art was to be seen in America if it was not in private homes."[8]

To explore the relation between race and primitive art, a sample of households of African Americans was added to the main samples. The sample was drawn from Spinney Hill, the middle-class black suburb that forms a section of Great Neck.

THE CONTOURS OF AUDIENCE INTEREST IN "TRIBAL" ART
What Is "Primitive" Art?

I asked residents of all the areas sampled if they had any "primitive" art. Thus "primitive" is here a subjective term, referring to objects that people classified as such. The objects that residents mentioned fell into two main categories. A small category, which I will not analyze here in detail because of its insignificant size, consisted of works by Western artists—mostly twentieth- but sometimes nineteenth-century—who paint or sculpt in a "primitive" manner. The dominant category (83% of the items mentioned) consisted of objects from non-Western societies, especially Africa, Oceania, and Native America. Within this category, African art dwarfed the rest, being present in 76% of the houses with "primitive" (non-Western) art and constituting 72% of the items of "primitive" art displayed (see table 12).[9] The next most common category was Native American art. Notice, within the category of Native American art, the disproportionately large presence of pre-Columbian art, as contrasted with North American Indian or Eskimo art. Thus of the houses with "primitive" art, 29% contained a pre-Columbian piece, but only 10% contained any North American Indian item and only 3% anything Eskimo. Aside from this point about the composition of the Native American items, the general pattern in the houses sampled corresponds to the main use of the term "primitive" art in twentieth-century cultural circles. By the 1920s, in the West "primitive" art had come to refer primarily to tribal objects from three regions—Africa, Oceania and Native America—with African art predominating.

In fact, the association of these three regions is problematic, for their arts do not intrinsically have enough in common to justify their being grouped together. In many respects there are closer ties between African and European art traditions than between African art and either Oceanic or Native American art, as Suzanne Blier has pointed out.[10] Why the arts of these regions—Africa, Oceania, and Native America—have in the modern West been linked as "primitive" art is a central yet unanswered question.

The Focus on the Person

What categories of "primitive" art do people display? Depictions of the persona—that is figures, heads, or masks—predominate. There are a total of 178 items that refer to the human person. Only twenty-four items do not (see table 13); these latter include musical instruments, weapons, ornaments, baskets and tools, textiles and hieroglyphics.[11] Figures 66–69 give

the flavor of these households and of the "primitive" figures, faces, and masks displayed.

The dominance of the person holds true regardless of the "quality" of the items. In fact only 34 percent of the houses with "primitive" art had pieces that experts had judged to be of quality. Yet in the cases of these "quality" pieces, the focus on the person was just as pronounced, for all except two were masks, figures, or heads.[12] (The nonquality pieces in the houses were mostly mass produced for the tourist trade—"airport art," as experts have dismissively referred to such pieces.)[13]

TABLE 12 Region of origin of "primitive" art items in the houses sampled

	Percentage of Houses with "Primitive" Art That Contain at Least One Item from This Region		Percentage of All "Primitive" Art Objects in Houses Sampled That Come from This Region	
Region of Origin[a]	All Neighborhoods Sampled (%)	"White" Neighborhoods Only (%)	All Neighborhoods Sampled (%)	"White" Neighborhoods Only (%)
Africa	76	67	72	69
Native America				
Pre-Columbian Central and Latin America	29	33	11	12
North American Indian	10	12	3	3
Eskimo	3	4	1	1
Oceania[b]	27	29	9	10
Other	12	14	4	5
Total			100	100
	(N = 59)[c]	(N = 51)[d]	(N = 202)	(N = 186)

Note: "Primitive" refers to those items that residents defined as "primitive" and which come from non-Western societies. These constitute 83% of the items residents defined as "primitive" (a total of 202 items). Excluded here are the smaller number of items—17% of those mentioned—that residents defined as "primitive" but which consist of works by *Western* artists who paint or sculpt in a "primitive" manner.

The figures here and in table 13 exclude a Manhattan rectory whose collection of "primitive" art is very large and distinctive in content and intent. To include this collection, whose dynamics resemble a nineteenth-century ethnographic museum, would obscure the tendencies in the other houses studied.

[a]In recording region and period of origin, I accepted residents' own classifications. Thus I make no attempt to, for example, distinguish an "authentic" pre-Columbian piece from an imitation.

[b]Oceania here includes Australia, New Zealand, New Guinea, Indonesia, and the associated islands including those of the South Pacific.

[c]This is the total number of houses in the sample that contain "primitive" art, as defined above.

[d]This is the total number of houses in the sample, but excluding those in African American Spinney Hill, that contain "primitive" art, as defined above.

These findings also parallel twentieth-century Western selectiveness in reacting to "primitive" art. Despite all the talk about the recognition, in the twentieth century, of the aesthetic merits of "primitive" art, it is a subcategory of that art that has caught the Western imagination. It is depictions of the "primitive" persona—figures, faces, and masks—that have primarily excited the interest of artists, museums, and the public. The focus on African sculpture is, for example, well known for such artists as Picasso and Vlaminck. Further underlining the centrality of the subject matter, rather than aesthetic merit, for these vanguard artists is the fact that the masks and figures that so captivated them were, as art experts agree, far from the (aesthetically) finest examples. Putting the matter beyond doubt, Picasso, when asked about the mediocre quality of the pieces in his collection, replied: "You don't need the master-piece to get the idea." [14]

The same focus on the "primitive" person is widespread among museums and the public, as much evidence suggests. In a revealing recent experiment, the Center for African Art asked ten people prominently associated with African art and African American culture to each choose ten objects from about one hundred photographs of African art as "varied in type and origin, and as high in quality, as we could manage." Susan Vogel, the organizer of the experiment, commented, "I put into the pool of photos a number of fine nonfigurative items such as textiles, vessels, a hammock and other artifacts. On the whole they excited little interest. Only one object completely lacking in representational features was chosen: a bronze vessel."

TABLE 13 Content of objects displayed as "primitive" art

Object	Total Number of Each Item	Percentage of Houses with "Primitive" Art That Contain at Least One Such Object
Person		
Full figure	117	69
Head or head and shoulders	23	36
Mask	38	46
Other		
(weapons, ornaments, baskets, fabric, musical instruments)	24	25
Total	202	
		(N = 59)[a]

These figures exclude the Manhattan rectory, referred to in table 12, note.
The total number of houses in the sample that contain "primitive" art.

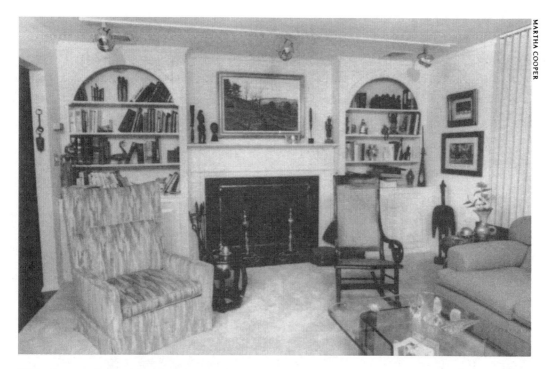

FIG. 66. Manhasset living room. "Primitive" personae (figures, faces, and masks) constitute the vast majority of items of "primitive" art displayed in the houses sampled; items from Africa predominate.

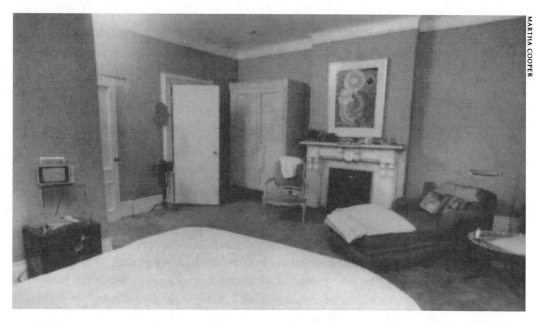

FIG. 67. A Manhattan bedroom.

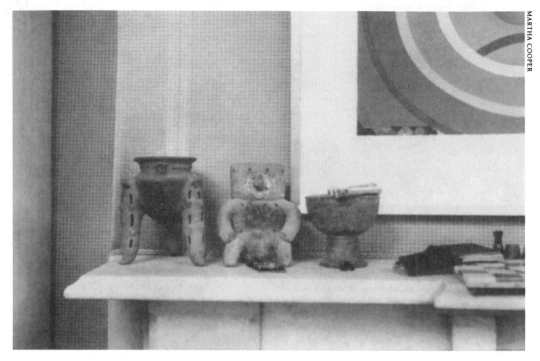

MARTHA COOPER

FIG. 68. Manhattan bedroom in figure 67, detail of pre-Columbian figure. To the left is a pre-Columbian vase.

Western museums do from time to time mount exhibitions of other types of African art, for instance, jewelry, textiles, pottery, and basketry. But these exhibitions tend to have a defensive quality, underlining the fact that the bulk of public and expert interest lies in the sculpture. For example, in 1972 the MOMA presented an exhibition of African textiles and decorative arts (jewelry, costumes). Roy Sieber, who curated the exhibition, began the catalogue tartly:

> Together this essay and its illustrations constitute an introduction to the rich and varied world of African textiles and decorative arts, particularly costumes and jewelry. The study of these traditional forms has been neglected by the West, where attention has been focused primarily on the sculpture of Africa. This attitude not only stems from Western aesthetic values but results in a geographical emphasis on West Africa where most traditional sculpture is to be found. However, the richness of invention and variety in the arts of personal adornment is pan-African and may, indeed, reveal the breadth and

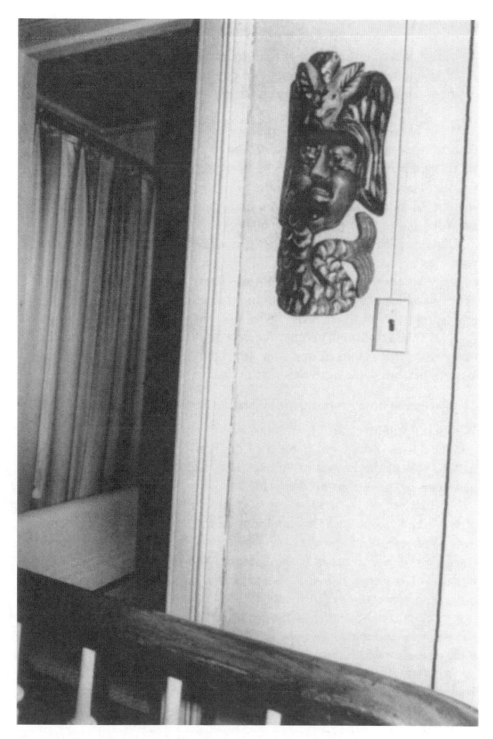

FIG. 69. The upstairs landing of a Manhattan town house.

range of the aesthetic life of traditional Africa with greater accuracy than the limited formulations that currently serve in the West as a basis for most studies in African art.[15]

I am of course discussing a *tendency,* albeit a pronounced one, to favor depictions of the "primitive" persona. There are numerous individual exceptions, especially among scholars. Thus, one of the most important early twentieth-century statements about "primitive" art was Franz Boas's *Primitive Art,* in which the author paid a great deal of attention to nonfigurative artworks and praised their artistic qualities.

This modern Western preference cannot be explained in purely aesthetic terms, as in the claim that African depictions of the person are artistically superior to other African artistic forms. There is a long history of preeminence in Africa of such other types of art as cloth and tapestry, basketwork, jewelry, pottery, and furniture.[16] Why, then, has Western interest in "primitive" art in the twentieth century focused on depictions of the person, especially since this occurred at a time when interest in depictions of current *Western* persons—the portrait—was in decline?

The Reception of "Primitive" Art by Social Class, and the Problem of Masks

Who has "primitive" art? It is fairly popular among the upper-middle and middle classes. Fifty-eight percent of the houses on the East Side of Manhattan, 40% of the houses in Spinney Hill, and 22% of those in Manhasset had items of "primitive" art (see table 14).

"Primitive" art is, however, of negligible interest to the white working class. Only one house in Greenpoint and one in Medford had any. The attitude of almost all of the working class toward "primitive" art fell into two categories, either distaste or indifference. The following comments, from working-class people asked if they had any "primitive" art, exemplify distaste, with especially negative reactions to masks. A woman in her late forties: "Those masks are creepy, they're scary!" A man in his late thirties: "African statues and masks give me the heebie-jeebies, They make me think of things I don't want to think of, like Amityville."

It is tempting to dismiss such working-class attitudes as examples of aesthetic incompetence. This would be too simple. For one thing, a number of anthropological studies of "tribal" masks and figures in their societies of origin suggest that the native attitude also typically varies from fear, in the ceremonial context, to a kind of indifference otherwise. Fear predominates when the objects are endowed by ritual with special qualities. Indeed, the

objects, especially the masks, are often intended specifically to frighten. In-
difference, on the other hand, predominates outside the ceremonial context.
For instance, in many societies most of the sculptures and masks are out of
sight and inaccessible much of the time. (These remarks, of course, apply
only to masks, figures, and faces, not to such genres as clothing, jewelry, and
basketry.)[17]

In a classic study of art among the Kalabari in West Africa, Robin Horton
found repulsion or indifference to be the dominant native attitude toward
the sculpture. Most of the sculptures and masks were kept stored away in
ill-lit shrines which most people could not get into, and were only taken out
when the rituals were performed. Even when in use, they might not be seen
by the spectators, for many of the masks were worn on top of the dancer's
head, facing the sky, directed toward the spirits. Thus these masks, in the
West supposedly admired for their aesthetic qualities, were not even in-
tended for human gaze in their societies of origin. I do not want to suggest
that the attitude of the American working class to these objects is particu-
larly close to that of the people in the societies that produced them, for there
are clearly huge differences between the two cultures. I just want to suggest
that the question of which social class in America has the more appropriate
attitude to the masks is not an easy one to answer.[18]

There is another reason why the working-class attitudes cannot be dis-
missed out of hand. Aesthetic distaste for the *masks* is also common among
upper-middle-class residents, even among those who themselves display

TABLE 14 Frequency of "primitive" art, by type of neighborhood in which the house is
located

	Neighborhood				
Frequency of Primitive Art	Upper-Class Urban (Manhattan) (%)	Upper-Middle Class Suburban (Manhasset) (%)	Middle-Class Suburban Black (Spinney Hill) (%)	Working-Class Urban (Greenpoint) (%)	Working-Class Suburban (Medford) (%)
Homes with "primitive" art	58	22	40	2	2
Homes without "primitive" art	42	78	60	98	98
Total	100	100	100	100	100
	(N = 60)ª	(N = 60)	(N = 20)	(N = 40)	(N = 40)

Note: For the definition of "primitive" used here, see Table 12, note.
ªThe houses sampled in Manhattan and Manhasset (40 in each neighborhood) were supplemented with
an extra 20 in each neighborhood, in which the interviews focused on the topics of abstract art and
"primitive" art.

masks. Indeed, just over half the residents with masks in their houses thought they were ugly. An Upper East Side woman, asked about an Indonesian mask prominently displayed in front of the living-room fireplace, said, "What can one say? There is something ugly about it. It's not pretty, it's a little frightening, it's evil, like the devil. [Then why do you display it?] I really don't know." Another Manhattan man had only one "primitive" piece in his house—a large mask, which he thought was "ugly," that dominated the dining room. A Manhattan architect disliked the New Guinea mask in his dining room. Although a Manhasset woman's house was full of African figures, she insisted that her husband keep the masks in his office. "My husband would have masks all over the house, but I don't like them. I don't like them looking at us." A Manhattan woman had in the past displayed two huge Sri Lankan masks in her dining room, one of which had "snakes coming out of its ears and people hanging from its mouth." The masks used to "bother people sitting opposite them at the table"; they also "bothered the little kids. My daughter's friends were afraid to walk through to get to the kitchen." For the latter reason, she and her husband finally put the masks in storage, but she said, "even though they may be ugly, I find them attractive in a different sense."

The view that an entire category of art displayed was ugly is confined in this study to "primitive" masks. From time to time, residents would express dislike of another artistic item in their house, but such comments were not, as in the case of masks, concentrated on a specific genre.[19] Anyway, such cases were unusual (apart from "primitive" masks), for if one spouse disliked an item its chances of being displayed were usually doomed. The willingness of residents to display masks that they nevertheless found ugly is intriguing. Here the attraction of masks appears to lie in their unaesthetic rather than in their aesthetic qualities. This underlines the need to seek out the symbolic meaning that the objects must possess.

In fact, although this has never been commented upon, "primitive" masks—at least those that diverged most strikingly from depictions of the human face—took far longer than figures and faces to gain acceptance in the West as items of artistic merit. For example, in 1927 Alain Locke reviewed a collection from the Belgium Congo. He extolled the visual qualities of many types of artifacts—figures, faces, jewelry, musical instruments, weapons—but drew the line at the masks, which he described as "bizarre and grotesque." Locke's dislike of the masks is the more striking because he was perhaps the leading black advocate in America of the aesthetic virtues

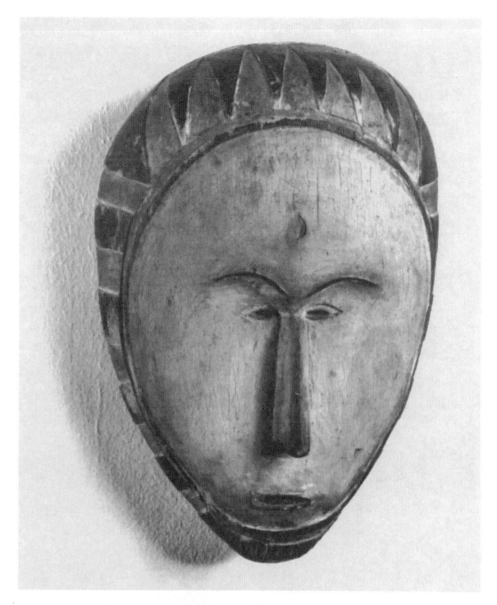

FIG. 70. Mask. Fang. Gabon. Painted wood. Musée national d'art moderne, Centre national d'art et de culture Georges Pompidou, Paris. Formerly collections Maurice de Vlaminck, André Derain.

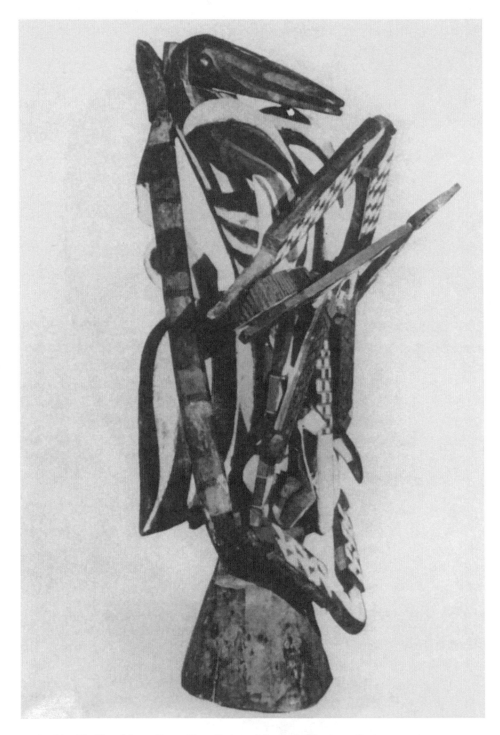

FIG. 71. Bird headdress, Baga, New Guinea. Musée de l'homme, Paris.

of African art; a central philosopher of the Harlem Renaissance, he articulated an aesthetic theory that called for black artists to acknowledge their African heritage.[20] The landmark 1935 MOMA exhibition "African Negro Art" did include masks, but in the catalogue James Sweeney, the curator, expressed qualms as to whether the masks deserved as high a ranking as the figures.[21] It is true that pioneer artists such as Picasso were enthusiastic about masks from the start. Still, many (perhaps most) of the masks that first interested the artists were those that most closely resembled figure sculpture. For instance the Fang mask, which Vlaminck acquired in 1906 and which later became so famous that one authority described it as "the principal tribal icon of twentieth century primitivism," is basically a sculpted face (fig. 70).[22] For the most part, it was only later that groups of Westerners came to accept the "strangest" masks: those that clearly diverged from the human face into "monstrous" depictions of "fantasy" creatures (fig. 71). This shift, which corresponded to Surrealist interest in the fantastic world of the unconscious, was accompanied by a focus on Oceanic art, whose art was seen as depicting the magical-fantastic world of the primitive.

The findings from the households sampled thus raise certain more general questions about the shape of twentieth-century interest in "tribal" art. Why the association of African, Oceanic, and Native American artifacts as "primitive" art, with African art predominant? Why the focus on depictions of the "primitive" person, in the forms of figures, faces, and masks? And why the willingness of certain upper-middle-class residents to display masks they perceive as not just fantastic but even "grotesque" or "ugly"? The theory that "primitive" art in the modern American house has a political dimension explains some of this.

THE POLITICS OF DISPLAYING "PRIMITIVE" ART

Displaying "primitive" art may be a political act, for its display is highly correlated with political party affiliation. Table 15 shows that, in terms of attitudes towards "primitive" art, there is a marked difference between two types of residents who display "tribal" art. One group places the art in a position of honor and views it as coequal to the best of Western art. Among such residents, 66% are registered Democrats and 29% are unregistered. Only 5% (two households) are registered Republicans.[23] A second group, much smaller in number, views the art either with derision or in Darwinian terms as precursors of forms later perfected in the West. Persons in this

group are either registered Republicans or are unregistered. None are registered Democrats.

The reason why the respectful display of images of "primitive" persons—at least those from Africa, the predominant type—should be highly correlated with Democratic politics is not hard to discern. The art of Africans is associated in the United States with the cultural tradition of American blacks—African Americans; to respect African art is to respect, one or two steps removed, African Americans. Further, to introduce an image of a black into a white house and neighborhood is to violate, albeit symbolically and privately, the racial segregation that pervades American neighborhoods. Almost everyone in the city or suburbs knows if their own and nearby neighborhoods are "white," "black," or (in unusual cases) racially mixed.[24] To display an image of a black African in a place of honor in a modern American house could scarcely be an innocent or accidental act. Now, in the field of modern American politics the Democratic party is firmly viewed as the party that is associated with African Americans. Indeed, of the various groups—the South, the poor, blue-collar workers, Catholics and Jews, blacks—that

TABLE 15 Political affiliation of residents who have "primitive" art, by their attitude to the art

Political Affiliation[a]	Attitude to Their "Primitive" Art	
	View It as Co-Equal with Western Art[b] (%)	View It with Disrespect or in Darwinian Terms[c] (%)
Democratic	66	0
Republican	5	60
Unregistered	29	40
Total	100 (N = 93)	100 (N = 15)

Note: chi square < p .01.

[a]The source for this data on political affiliation is respondents' voter-registration records. Households with "primitive" art where husband and wife have each registered for a different political party were excluded; however, such cases are rare (only three households). (Commoner, however, is the phenomenon where residents' voting-age children living at home have registered for a different political party than that of their parents.)

[b]Respondents who view "primitive" art as co-equal with Western art are defined as those who both view their "primitive" artifacts as art and do not meet the criteria for a "disrespectful/Darwinian" attitude as defined in note c.

[c]Includes respondents who make derogatory comments about their "primitive" artifacts, as well as respondents who, while not making explicitly derogatory comments, view the artifacts from an evolutionary (Darwinian) perspective, as inferior versions of forms later perfected in the West.

Note that if one spouse made a derogatory comment about the art, it is assumed here that the other spouse's attitude is also derogatory.

once constituted the famous electoral coalition that coalesced around Frank-
lin Roosevelt and the Democratic party, nowadays only blacks remain as
committed Democratic party voters.[25] It is, therefore, understandable that
those who esteem "primitive," especially African, art should also be Demo-
cratic in their politics.[26]

Yet not all who display "primitive" art view it with respect. A minority
of residents who display "primitive" artifacts deride them or perceive them
as inferior versions of forms later perfected in the West. Residents of such
households are either Republicans or nonvoters; none are Democrats (table
15).

Consider this in detail. Four of the households viewed their artifacts with
derision. For example, a Manhasset woman had an African mask in her bath-
room ". . . as a joke. Sometimes it scares people, and then we have a good
laugh." An East Side woman who had a Polynesian face on her kitchen wall
commented that it was "bizarre having a cannibal in the kitchen!" (see fig.
72). In addition to these households where "tribal" persons are ridiculed,
three other households display items that, while not intended as derogatory,
present "tribal" societies from an evolutionary perspective as inferior ver-

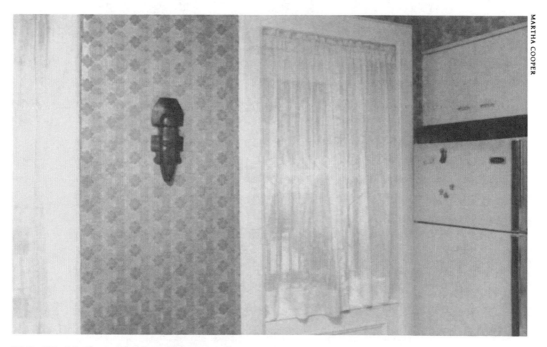

MARTHA COOPER

FIG. 72. Manhattan kitchen, Polynesian face.

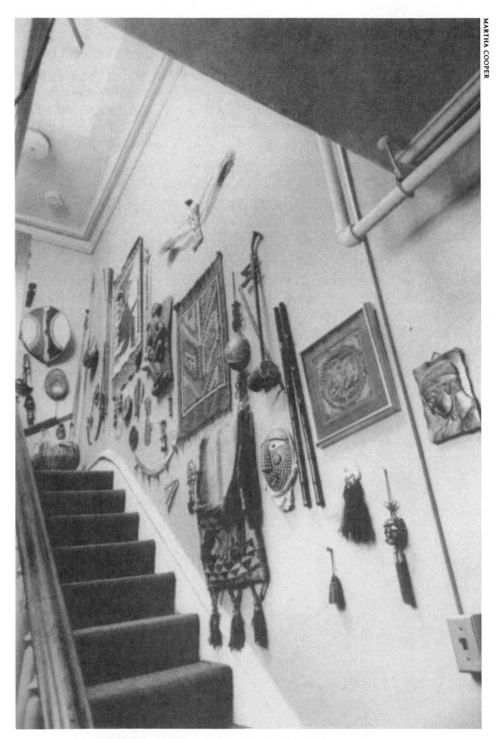

FIG. 73. Manhattan rectory, stairway from third to fourth floors.

sions of forms later improved upon by Western society. For example, a priest in Manhattan who directed the Catholic missionary effort abroad saw "primitive" artifacts as precursors of Christianity. As he said, "When I look at these I feel I'm at the pre-faith experience. Like they do have a concept of an afterlife. You can trace the development of the church from these kinds of beliefs." His collection was arranged accordingly to record the progress toward Christianity of the people he studied (fig. 73). The "tribal" artifacts hung on the wall that led from the third floor to his fourth-floor apartment; his apartment above was full of the symbols of Christianity—the entire layout a metaphor for the ascent of mankind from pagan to Christian beliefs.

Thus "primitive" figures can also be symbols of the right, echoing and perhaps updating a long tradition (which flourished in America from the 1890s to the 1950s, declining with the assertion by African Americans of a more aggressive identity during the Civil Rights Movement) of using material objects—salt and pepper shakers, cookie jars, ashtrays, etc.—that depict black people in a degrading and stereotyped manner as subservient, powerless, and often with grossly caricatured features.[27] In the United States, Aunt Jemima is the best-known character depicted in such objects.

This political aspect of the display of "tribal" artifacts goes some way toward explaining both the dominance of African art and the dominance of images of the person. *African* art is clearly an appropriate symbol for the expression of attitudes toward American blacks ("African Americans"), and *figures* and *faces* are clearly better at this than are pottery, jewelry, and fabrics, which nonexperts might not recognize as the art of black Africans.

"Primitive" art, in this context, is (at least partly) about attitudes toward blacks, as it was also, in important ways, in Europe in the early decades of this century—albeit with differences reflecting the changed time and place. James Clifford, who recently criticized conventional explanations for the attraction of "primitive" art in the West which focus on the aesthetic taste of certain artists and writers in Paris in the 1900s, makes the European case clear. Picasso, Apollinaire, and the others "discovered" "primitive" art in the context of a period of growing "négrophilie" in Paris and elsewhere in Europe. This included the recognition of a variety of evocative black figures—the jazzman, the boxer (Al Brown), and the "sauvage" Josephine Baker. Enthusiasm for African art was thus linked to racial perceptions of blacks, who, in Europe, were prized for their vitality, rhythm, and erotic and magical power.[28]

THE SOCIAL DIMENSION
Black Households

Yet there is clearly much left unexplained, as the data from the black households sampled suggest. At first sight, residents of the middle-class African American households in Spinney Hill, asked about "primitive" art, do not differ markedly from white households asked the same question. The main difference is that African American households are likely to see some ancestral connection, however distant, between the "tribal" art and their own culture.[29]

But in the African American households, it makes no sense to stop at this question. For depictions of "tribal" blacks ("primitive" art) are only a fraction of the depictions of blacks displayed in these houses (see table 16). For example, classical religious pictures in which black figures substitute for whites are displayed in 60% of the houses. An example is *The Last Supper* with Jesus and the disciples as black.[30] Also, some households have depictions of black political leaders, frequently Martin Luther King, or black entertainers. In addition, some households have paintings of blacks in everyday, usually American, scenes, for example in church or playing music. Finally family photographs are displayed in every house studied.

Thus in these black households depictions of "tribal" blacks ("primitive" art) form the extreme end of a continuum that can be constructed based on the "distance" of the blacks depicted from residents' own lives and experiences. This continuum runs from tribal blacks and classical religious figures portrayed as blacks (the most distant from residents' own lives), through American black political leaders and blacks in everyday American scenes, to photos of residents' own families.

What is striking about the white households with "primitive" art is that almost all have chosen to depict only that subcategory of blacks that is most distant from the lives and experiences of actual African Americans. (Three white households are exceptions; they display, respectively, a picture of Martin Luther King, a photograph of a black maid, and a contemporary photo of a Harlem street scene.) This suggests another dimension of the appeal of "tribal" persons as images for display. In white households, the simultaneous presence of images of "tribal" persons and near absence of images of African Americans symbolizes a truth about the actual exclusion of the latter in modern American life. The racial separation that pervades modern American life, especially in the residential sphere, is thus reflected in this decision to display "tribal" persons but not African Americans.

Note, in this context, that displaying images of "tribal" Africans as art started to become fashionable among the American upper-middle class on the East Coast in the 1920s, 1930s, and 1940s, the period when blacks from the South started to migrate north in large numbers and to fill out urban ghettos in cities such as New York and Philadelphia. This was, as well, the time when blacks began to replace whites such as the Irish as the main category of live-in and nonlive-in servants in northern cities.[31] The period also saw the "Harlem Renaissance," when black artists explicitly aimed to produce "black" art, and engaged in cultural activities at least some of which were well known to, and attended by, culturally avant-garde whites.[32] Thus a white foundation, the Harmon Foundation, funded the main artistic institution of the Harlem Renaissance, an annual, juried exhibition (first held in 1926) featuring painting and sculpture by black artists.

For politically liberal Northern whites, these events were probably important factors in the decision to accept "tribal" African artifacts as art; further, displaying such artifacts would have been, and continues to be, a gesture toward the ancestral culture of these now numerous and more culturally assertive black residents of the region, and adjuncts to the household. On the other hand, for politically conservative Northern whites, the decision to display the same images, by drawing attention to the "primitive" and uncivilized origins of American blacks, perhaps suggested the basic incompatibility of the latter with contemporary white American neighborhoods and with the white nuclear family. In both cases the display of images

TABLE 16 Black art/iconography in black households (Spinney Hill)

Category of Art/ Iconography[a]	Houses with Each Category of Art (%)
"Primitive" art	40
Classical religious depictions, with black figures[b]	60
Black political leaders or entertainers[c]	45
Artistic depictions of blacks in everyday scenes	25
Family photographs	100
	(N = 20)

[a]The items are grouped in terms of their distance from respondents' lives, with the most distant items ("primitive" art) at the top of the column and the nearest items (family photographs) at the bottom.

[b]For example, *The Last Supper* with a black Jesus and disciples, or images of Jesus alone as a black man.

[c]Images of Martin Luther King predominate here.

of "primitive," but not modern, American blacks symbolized the pervasive racial segregation of American society. Recall, for example, that the famous Cotton Club in Harlem excluded blacks from the audience, members of whom had to pass a skin test that showed they were white enough to be admitted.

This suggests the monocausality of the traditional view that avant-garde whites in New York in the 1920s and 1930s came to accept African artifacts as art because they were influenced by the New York art elite, who were in turn influenced by the Parisian artists who "discovered" African art. This view surely contains much truth, but to link the new white taste for African art to the Harlem Renaissance and to contemporary demographic movements of blacks into the region is just as plausible.

Here may be a partial explanation, too, of the taste for displaying pre-Columbian figures, as well as an explanation for that taste having developed among collectors somewhat later than did the taste for African art. For much of the preceding analysis is also likely to apply ("mutatis mutandis") to the question of Hispanics or "Latinos," on the East and West Coasts, vis-à-vis the households of whites ("Anglos"). Thus, collecting pre-Columbian art began to become voguish among the avant-garde in New York from about 1950 on, which coincided with the start of the period in which Puerto Rican migration to the East Coast, and to New York City in particular, exploded, followed later by sizable immigrations from other Latin American countries.[33] Further, many of these Hispanic immigrants have also been excluded from white neighborhoods, though less rigidly so than African Americans, yet they too are present as domestic servants. (Among the Upper East Side residents sampled, servants both live-in and nonlive-in, are usually blacks or Hispanics from Latin America.) Thus for white residents who are liberals, images of pre-Columbian persons are a symbolic recognition of the cultures of these newly important immigrant groups. For example, an Upper East Side psychoanalyst has a pre-Columbian figure on his desk; a strong Democrat, he believes that the Puerto Rican presence in the city brings us "a consciousness that we would not otherwise have, a vigor, a stress on the human dimension rather than on just bricks and mortar." By contrast, for conservative residents, the same images of pre-Columbian figures can underline the nonwhite, non-European origins of many persons from the regions associated with this type of art. For example, a Republican couple on the Upper East Side have a pre-Columbian whistle, shaped like a man, in their living room (fig. 74). Twenty years ago the husband had failed in a bid to get elected to political office in New York and he still ruefully attributes his

FIG. 74. Front living room of Manhattan house, pre-Columbian man-whistle.

loss to his Democratic opponent's strong showing among the "Puerto Ricans who live above Ninety-sixth Street." It is probably no accident that his wife liked the man-whistle and in particular the feathers on the man's head, because they reminded her of exotic (notice nonhuman) birds. And despite their often different political and social attitudes to the large Hispanic presence in the region, for both Democrats and Republicans alike the presence in their homes of ancestral (pre-Columbian) images and the absence of images of contemporary Hispanics symbolize the separations between Hispanics and whites that continue to mark the United States and especially its neighborhoods.

By the same token, the striking scarcity of depictions of North American Indians or of Eskimos in the houses studied (see table 12) is surely due to the dearth of such groups as a physical presence or as a social/political issue in the New York region. Few residents sampled have any contacts with American Indians or Eskimos, in contrast with routine encounters with blacks and Hispanics both outside the home and within, often as servants or domestic help.

There is no need to point out that in regions with larger populations of North American Indians, the latter's arts are more likely to be displayed in the homes of upper-middle-class residents.[34] What has not been pointed out, or at least not been paid the attention it deserves, is that these arts, when displayed by residents of such regions, are likely to resonate with symbolic meanings that express residents' feelings towards these "native" peoples.

This discussion also suggests reasons for the attraction of masks. For masks enable many of these meanings to be taken further, even to extremes. Masks dramatize, to the point of depicting ugliness, the differences between "tribal" persons and modern Americans. They may also blur, to the casual eye, the question of which "tribal" peoples are associated with them. They thus tend to symbolize the general category of non-Western persons. At the same time the "frightfulness" of many of these masks also appeals to a range of political attitudes. For conservatives, it can underline the uncivilized nature of these peoples and validate the exclusion of their modern representatives. For liberals, it can express a tolerance central to liberalism by honoring cultures that are seen as strikingly different from that of the West. Thus one East Side resident liked the mask he displayed from New Caledonia because "you can see they're more adventurous than we are—the colors, the shapes, the ideas of spirit ancestors."[35] Another East Side resident liked her two African masks, and one from New Zealand, because they reminded her of

"societies without all this technology that we live with here, stereos, televisions, VCRs."[36]

The gesture of extreme tolerance implicit in the display of images (figures or masks) of "tribal" persons who are so unlike the nuclear family occurs in the context of a family life that is, for residents of all political outlooks, in fact, increasingly private and exclusive and prone to define all but a few as "outsiders." Recall that as regards the composition of the modern household, nowadays most upper-middle-class residents, as well as those of the working class, definitely prefer their residential unit to consist solely of the nuclear family. Indeed, the belief that members of the nuclear unit—husband, wife, and their young children—ought to have stronger social bonds with each other than with any other persons is what distinguishes the modern Western family from other (earlier Western, and non-Western) forms.[37] Neither strangers (as servants or boarders) nor those kin who are not part of the nuclear family are usually welcome as residents of the modern household, though both groups were common in nineteenth-century households. Certainly there are pressures to make exceptions. The chores of childcare, especially if both spouses are in paid employment, induce a minority of the upper-middle class to accept a live-in servant to look after young children, though the servant's presence is typically resented as an intrusion on the privacy of the nuclear family. Also, when presented with a relative, especially a parent, who is elderly and alone or sick, some households will modify their unwillingness to include people who are not members of the nuclear unit. Still, for almost all residents, the ideal household contains only the nuclear family. Other aspects of the art and visual representations that residents display, for instance, portraits, family photographs, and landscapes, are marked by a clear sense of the predominance of the nuclear family as a residential and leisure unit, as I have argued. Thus the depiction of "tribal" persons who so obviously violate this dominant modern orientation needs to be scrutinized. One interpretation (that can coexist with the other interpretations I have already suggested) is that the extreme tolerance concerning who will be present in the home that is symbolized by these images of "tribal" persons camouflages an extreme intolerance concerning this question in fact. Indeed, the Manhattan upper-middle class, who are least likely to have even sick or elderly parents move in, are the most likely to make the hospitable gesture to outsiders implicit in the display of images of "primitive" persons.

There may also be a sexual dimension, albeit minor, at play in the display of "tribal" objects. Nudity is a dominant mode in the presentation of "tribal" figures. By contrast, human nudity is rare in the other visual imagery displayed in the houses studied. There is an occasional painting of a Western woman with breasts uncovered, but rarely a painting of one with genitals uncovered (fig. 75). There is an occasional plaster cast of a naked woman. But these cases are few.

Usually residents do not comment on the nudity of the "tribal" figures displayed in their homes, which means that erotic symbolism can only be inferred. An unusual case in which the owner vocalized the erotic symbolism is that of a figure of a Bali man-animal, in the living room of a Manhattan house. The figure's penis is erect, as the owner was eager to point out (fig. 76). And in the master bedoom, underlining this resident's interest in erotic imagery, is a lifesize plaster cast of a naked, Western female (fig. 77). Notice also, in the dining room of the Perls family's home, where part of their fa-

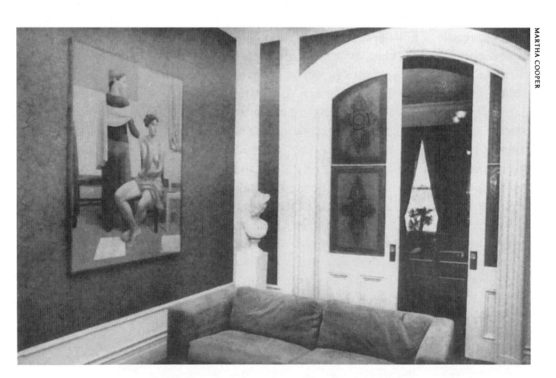

MARTHA COOPER

FIG. 75. Manhattan house, front living room. Apart from objects of "primitive" art, human nudity is rarely depicted in the houses studied. The painting in this house and the torso in fig. 77 are exceptions.

FIG. 76. Manhattan living room, Bali man-animal.

FIG. 77. Manhattan house portrayed in figure 76, bedroom. On the floor is a bronze cast of a female torso.

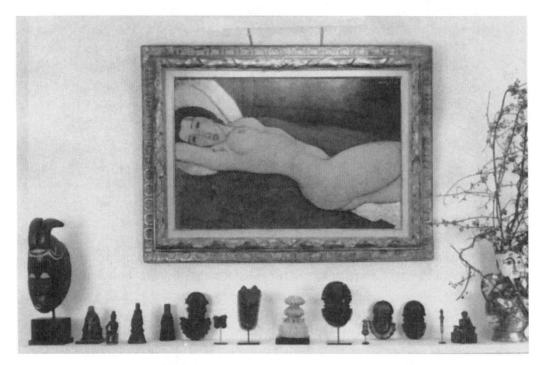

FIG. 78. The dining room of the Perls home, January 1990, with Benin art displayed beneath *Nu couché* by Amedeo Modigliani, 1918. Courtesy Perls Galleries, New York.

mous collection of "primitive" art is displayed, the clear connection of this art with Western erotic imagery (fig. 78).

Again, this nudity can validate both a liberal and a conservative political and social attitude. For conservatives, the nakedness may underline the uncivilized nature of these peoples. For liberals, it is part of a movement to embrace the different, the exotic, and the sexually uninhibited.

In the eyes of the Surrealists, "primitive" art, especially the art of Oceania, was above all erotic. It was a visual reflection of the life/eros drive of "primitive" man, whose sexually liberated culture, unlike that of the West, did not inhibit and repress this drive. Further, Africans in Western culture have long evoked sexually charged stereotypes. There is, too, a tradition in Western anthropology that has viewed the sexually less-inhibited practices of certain tribal societies as offering a marked contrast to Western societies.[38]

Still, it would be a mistake to see eroticism as the paramount meaning of the "tribal" artifacts in this study, though it may well be a motif. For one

thing, only the figures display genitals or female breasts; masks and faces do not. Further, though the images of "primitive" figures may be naked, few are in explicitly sexual poses. The Bali figure referred to above is one of the few instances. By contrast, Asian Indian art, which no residents classified as "primitive," more clearly fulfills an erotic function. Residents of several East Side houses have Indian figures, intertwined in sexual poses, and often explicitly conveying an erotic meaning.

It is, however, likely that the erotic symbolism of "primitive" art was more important in Western households in the past, at a time when such alternative modern sources of erotic symbolism as books, magazines, and pornographic television stations and home videos were absent.

A CASE STUDY

"Primitive" art, then, in these white Western households has various discernible modes of significance—on the political and the social levels—all of which relate to contemporary Western society. These modes surely intersect with each other, and with the particular circumstances of individual residents, in various complex ways that no single study could cover, still less a study that lacks psychoanalytic data to complement the sociological findings. The following case study illustrates some of the particular meanings that can derive from this symbolic matrix.

The suburban Manhasset household (fig. 66) that contained the largest number of images of "primitive" persons—all African—was markedly to the left politically. The husband had been investigated by the United States Senate during the McCarthy period. This household had once contained, but eventually ejected, an African American as resident. He was a handyman, who had for a long time lived in the household of the wife's parents. When the parents died, their daughter invited the handyman, who had no close relatives in the region, to come and live in her household, where he stayed for fifteen years. However, when he developed Alzheimer's disease, it was decided that he could not stay, so he was sent to live with a distant relative of his. It is plausible to see condensed, in this politically and socially liberal household's displays of images of tribal Africans, the complex feelings associated not only with the housing and eventual eviction of the black workman, but also with residence in an all-white suburb and with residence in a society in which the issue of race is rarely absent from national politics.

CONCLUSION

In making the transition from the societies which produce them to the Western households that display them, "tribal" artifacts have acquired new symbolic meanings. These meanings relate, in a complex way, to the modern Western context. But what is clear is that they are by no means confined to the promptings of cultural elites—museum directors, artists, critics, and others. They derive also from the interaction between residents in the context of their homes and neighborhoods. Further, these new meanings themselves arguably affect the elite artistic and cultural scene via the demand, by sections of the well-to-do, for kinds of "primitive" art that can easily symbolize these new meanings and via the interest, on the part of museum goers, in certain kinds of shows and exhibitions.

This suggests, for the case of "primitive" art, the limitations of the approach that sees the audience as of minor importance in the construction of meanings, or that tries to "patrol" these meanings. An example of the latter is Sally Price's recent study, which complains about the discrepancy between the way Western audiences see "primitive" art and the way it is perceived in its societies of origin, and which criticizes Western audiences for thus "misunderstanding" the art/artifacts.[39] Yet as "tribal" art becomes recontextualized in the West, such discrepancies are inevitable, and while it is important to point them out, it is just as important to study them, and to treat as "legitimate" in their own terms the new meanings that Western audiences attribute to the works. Here the audience for "tribal" art is no different from that for any other artistic genre. Why, for example, would we expect modern audiences who view Impressionism in museums or in reproductions in their homes to attribute the same meanings to the works as did nineteenth-century viewers? Price's perspective implies that the meaning of "tribal" art should be frozen in time and space (the time and space of its societies of origin)—a perspective that Price rightly criticizes when it is applied by others to "tribal" art in its societies of origin. Indeed, it would be difficult, if not impossible, for the contemporary Western audience to recover the art's meaning in its original geographical context.

Rather than berate Western audiences for failing to attribute the same meanings to "tribal" objects as are attributed to them in their societies of origin, it may be time to acknowledge that such a discrepancy is inevitable. Rather than see Western audiences as capable of little more than dutifully following where Western artists and critics·lead, or as mere fodder for the

ideological machinations of Western élites, it may be time to see them as intrinsic to a process whereby new meanings may emerge.

One qualification is in order. This discussion has been based on a study in a particular region, albeit one critical for the history of the reception of "primitive" art in the United States. Surely regional differences will assign a different combination of meanings to the art. In other parts of the United States, for example the mid-West, depictions of native Americans may be of greater importance than they were here, and may take on some of the symbolic connotations described here. For example, they may be a litmus test of political attitudes towards minorities, just as images of Africans are in these New York houses.

In drawing attention to the social and political meaning that residents find in the artifacts, I do not want to deny that they also relate to them on an aesthetic level. Still, the traditional stress on aesthetics can explain little about the particular shape taken by the taste for "primitive" art in the twentieth-century West, except in a circular manner. For example, those wedded to aesthetic explanations of developments in taste have a ready made answer to all questions. Each form is chosen for display because it is aesthetically superior. Thus African sculpture (figures, masks) predominates over other types of African art (jewelry, basketry and so on) because it is aesthetically superior; the mask finally gained acceptance because in the end its aesthetic qualities could not be denied. And so on. Considered alone each of these explanations may suffice. Put together, their circularity and Hegelian implications of an aesthetic spirit advancing towards world-historical perfection are apparent.

The idea of fundamental differences between the social classes, on which so many stereotypical images of the audience are based, obtains only limited support here. Thus what at first sight appears to be a deep difference between a section of the upper-middle class that likes "primitive" art for its aesthetic qualities and the working class that cannot appreciate the objects becomes murky on examination. All, in fact, that is clear is that a section of the upper-middle class displays "primitive" art, whereas such displays are unusual among the working class. Everything else is unclear. Instead of a basic difference in taste, instead of a symbol that evokes a particular aesthetic meaning for a particular social class, there is a symbol that evokes a range of meanings for upper-middle-class residents, many of which meanings have little to do with "aesthetics." Further, the attitudes that underpin these

meanings—views about blacks, about Hispanics, about residence in the house of persons who are not part of the nuclear family, and so on—are not confined to one social class at all, but are commonly found throughout the white class structure, even though they are not, for these other social classes, usually triggered by "primitive" art.

Also, the set of meanings that "primitive" masks evoke for the white working class, in particular fear and distaste, is not unlike the meanings that such masks evoke in their societies of origin.

The complexity of this situation is not well captured by the simple idea that "primitive" art is an example of the profound difference in taste between the upper-middle class and the working class.

If class differences are not clear-cut here, neither are the sources of the ability of the upper-middle class to "read" these meanings in the artifacts. Certainly the idea of "cultural capital" theory, that the upper-middle class interprets "primitive" art through a set of carefully learned capacities, is too rigid. Partly that is because many of the meanings conveyed (concerning African Americans, family, and sex) are not especially complex. Partly it is because many of the meanings conveyed are not especially transparent to residents (or observers); as a result, it is hard to see how they could have been packaged and taught as constituting the "appreciation" of primitive art.

6

The Truncated Madonna and Other Modern Catholic Iconography

INTRODUCTION

Mass-produced items of religious devotion—statuettes, inexpensive pictures, crucifixes, and so on—surely place near the bottom of any ranking, by status, of the artistic and cultural motifs in the home. Typically designated as religious "iconography" rather than as "art," they are shunned by most art historians as debased versions of the glorious works of Christianity. Even the hierarchy of the Catholic Church, at least those influenced as young priests by Vatican II and now in positions of authority, are often unenthusiastic. The East Side priest whose rectory appeared in the Manhattan sample and who heads the Catholic missionary effort abroad believed that religious figurines were "fine for the twelfth century," or for simple people groping towards Christianity (the main point made in his own collection of "primitive" art), but that, as used nowadays in places such as Greenpoint, they indicated the regrettable need of some parishioners for simpleminded visual crutches to support religious faith. For his equally progressive rectory colleague, whose own

171

bedroom contained a mixture of classic Christian art (in reproduction) and modern abstract art, commercial religious depictions recalled the shameful days when the church oppressed its own followers and exploited their ignorance. "They're mass produced, and just fulfill the superstitions of the people rather than a need they find in themselves. A thousand years of the Church's emphasizing depictions of Jesus crucified on the cross helped keep the people down—if you're downtrodden yourself, it's easier to relate to someone suffering on the cross."

Yet, though despised by the art establishment and sections of the Church itself, mass-produced religious iconography is of central interest in this study, for the image of the audience implied by these previous comments is the now familiar stereotype that audiences are more or less passive recipients of prepackaged messages contained in visual imagery. In this case the audience is seen as dupes of the propaganda of the Catholic Church. Thus mass-produced iconography raises, in a new form and for the Catholic working class above all, the same questions as have occurred throughout. What meanings do residents attribute to the items, what is their ontological status, from where do these meanings come, and how do they overlap with the "official" meanings purveyed by external institutions (in this case, less the art world than the established Catholic Church)? Above all, are these items simple mechanical aids to which the uneducated relate in a way that is fundamentally different from the way the upper-middle class relates to art?

I will focus, in this chapter, on three striking features of the Catholic iconography in the houses studied. These features include a popular version of Mary depicted as cut at or around the waist; the decline of reproductions of *The Last Supper;* and the decline of images of saints (other than Mary).

OVERVIEW

Religious iconography is confined, in the houses sampled, primarily to Catholics. White Protestant and Jewish households are mostly barren terrain for the study of religious images, although an occasional item of religious iconography is found in some of these homes, for example, "praying hands" or a cross without Jesus among Protestants and a Menorah (branched candlestick) in some Jewish households.[1]

Every white Protestant couple in the sample asserted their dislike for religious depictions. Consider these examples. A Manhattan man: "Religious art? We have none. Protestants don't have religious art." A Greenpoint woman: "We don't believe in having religious items in the house. We're both

Protestants." [2] Some Protestants and Jews are caustic about Catholic iconography. A Jewish man in Manhattan: "I'm very hostile to religious art. Nothing depresses me more than a painting of Christ crucified. Maybe because I was born in a Catholic country (Colombia), and saw a lot of that stuff." A Protestant woman in Manhattan: "Religious art? I don't have any. I can't stand Christ on the cross! It's horrible—nails dripping blood. . . . That's one reason I like Japanese art."

Black Protestants, however, are different, as was evident in the previous discussion of "primitive" art. Many such households in the sample do contain religious iconography.[3] However, since the sample of black Protestant households is small, I will not add here to what was said about them in the account of "primitive" art (for example, the tendency of some black Protestant households to "Africanize" Jesus and other religious personages).

RELIGIOUS ICONOGRAPHY AND SOCIAL STATUS

Among Catholics, religious iconography is more important for the working class than for the upper-middle class, in two main ways. First, Greenpoint and Medford Catholics are more likely to have religious images than those in Manhattan and Manhasset. Eighty-four percent of Catholic or Catholic/Protestant households in Greenpoint display at least one religious item, as do 71% of such households in Medford, compared with only one household in Manhattan—the rectory—and 50% of the households in Manhasset (see table 17).[4]

Further, Catholics in the working-class neighborhoods display their religious images more prominently than do Catholics in upper-middle-class neighborhoods. Every Greenpoint home with Catholic iconography has at least one item in a public area—living room, dining room, hall, or garden—as do 60% of the Medford houses with Catholic iconography.[5] In Manhasset, by contrast, only 23% of the households with Catholic religious items display any publicly; religious items here are usually confined to the private areas, mostly the bedrooms. And those religious items that are present in public rooms in Manhasset are often muted in some way. For instance, a Madonna and child, in the entrance hallway of one house, is a framed Italian lithograph, presented as "art" as much as religion. A small image of Mary in the living room of another house is half hidden by drapes (see fig. 79). In the living room of a third house is a two-inch-square reproduction of a fifteenth-century Madonna, by Filippo Lippi—the religious impact muted because the image is tiny as well as because it is also "artistic." All of these

houses contain religious items that are more explicitly presented as such, but these are upstairs.

This is no accident. Many Manhasset Catholics believe that, in a well-to-do area with Protestant neighbors, the public display of religious artifacts lowers the status of the household. Like sitting on the front stoop, it evokes images of humbler, inner-city, working-class Catholic neighborhoods. A number of Manhasset Catholics explained, in more or less such terms, the reluctance of Catholics there to give prominence to religious items. One woman commented, "I would never put religious items in the living room, only in bedrooms. Religion is a private thing. And I wouldn't want to offend a Protestant who might come to visit." One man thought that "people are embarrassed about religion nowadays." Another said: "I pray in bed. I don't go in for showmanship. I have religion inside [points to his heart]." The woman with the two-inch-square Madonna in her living room also displayed a large painting of Jesus, but in her bedroom; to put the latter in the living room would, she thought, be "like wearing religion on your sleeve." The almost total absence, from Manhattan Catholic households, of religious iconography probably derives, in part, from similar considerations, compounded there by the fact that the neighbors are as likely to be Jewish as well as Protestant (see table 18). By contrast, none of the Catholics in Greenpoint, and only one in Medford, ever expressed the idea that religious iconography in the public rooms of the house was socially inappropriate.

TABLE 17 Religious iconography in Catholic households

	Neighborhood			
	Upper-Class Urban (Manhattan) (%)	Upper-Middle-Class Suburban (Manhasset) (%)	Working-Class Urban (Greenpoint) (%)	Working-Class Suburban (Medford) (%)
Catholic[a] homes displaying religious[b] iconography	11 (N = 9)[c]	50 (N = 26)	84 (N = 31)	71 (N = 28)

[a]"Catholic" households are defined as the sum of "pure" Catholic households (where both heads of household or the only head of household is Catholic) and mixed Catholic/Protestant households.

[b]This table includes only items that respondents see as having at least some religious meaning for themselves. Thus it includes items that respondents see as having both artistic and religious meaning for themselves, but excludes those (upper-middle-class) households that have religious depictions (e.g. icons) that residents view exclusively as art. There are, in any case, only five such households in the whole sample.

[c]These figures refer to the total number of "Catholic" households in the sample in each neighborhood.

FIG. 79. Manhasset living room, Madonna, partially hidden by drapes. Middle-class households that display Catholic religious iconography often shield it from public view, in many cases in bedrooms or on upstairs landings. By contrast, the working class who display Catholic iconography are not, usually, thus inhibited.

TABLE 18 Religious orientation of household members

	Neighborhood			
Religious Orientation	Upper-Class Urban (Manhattan) (%)	Upper-Middle-Class Suburban (Manhasset) (%)	Working-Class Urban (Greenpoint) (%)	Working-Class Suburban (Medford) (%)
Protestant	30[a]	20	20	20
Catholic	15	40	65	30
Catholic/Protestant	8	25	12	40
Jewish[b]	45	5	3	
Other[c]	3	10		10
Total	101	100	100	100
	(N = 40)	(N = 40)	(N = 40)	(N = 40)

[a]The percentages refer to the head(s) of household. Thus of the forty households sampled in Manhattan, 30% were headed only by Protestant(s), 15% were headed only by Catholic(s), 8% were headed by a Protestant and a Catholic, and 45% had at least one Jewish household head.

[b]Includes Jewish/Catholic and Jewish/Protestant households.

[c]Includes a Buddhist household and households where no information on religious affiliation is available.

Notice, however, that even among the working-class notions of "privacy" have affected the display of religious artifacts. Thus it is now rare for working-class Catholics, in Greenpoint or Medford, to place religious artifacts in front of the house on a permanent basis, where they are visible to passersby. Only one house in the sample, in Greenpoint, did so (a Madonna in the front yard). Two other Greenpoint houses had religious statues outside, but in the private backyard. For the rest, the working-class Catholics sampled now place all religious artifacts within the house, albeit often in "public" rooms. This move to within the house reflects the weakening of publicly oriented street sociability that has occurred even among the urban working class studied.[6]

MARY: THE TRUNCATED MADONNA

Jesus and Mary are the most common religious images in Catholic households. Each occur in over 85% of the Greenpoint and Manhasset Catholic households that display religious art (table 19). In Medford, Jesus and Mary also predominate. Saints other than Mary scarcely compare in popularity. They are in less than a third of the Manhasset and Medford households with religious iconography, though in 50% of the Greenpoint houses.

The iconography of Mary is striking. She is often truncated, lacking the lower half of her body. Images of head and shoulders, or half-length from the waist up, are common. This truncated version accounts for every Mary displayed in Medford households, occurs in twice as many Manhasset households as does the full-length version, and in Greenpoint occurs in slightly more houses than the full version. In the sample as a whole, Mary is complete, standing or seated, in only a minority of cases.

Consider examples of this truncated Madonna. Paintings and reproductions include the Black Madonna—Poland's national saint and therefore popular in the Polish section of Greenpoint (figs. 80–81)—and various reproductions of Madonnas by Filippo Lippi (fig. 82). Sculpted versions of Mary's head and shoulders abound in glass, porcelain, and plaster (figs. 79, 83, and 91); a popular version in Greenpoint and Medford doubles as a flower receptacle (a "planter"), with the vase section acting as a base and replacing the torso. Notice that instances of the truncated Madonna occur across media (for example, in paintings as well as in sculpture) and in high-status as well as low-status genres (for example, in reproductions of artistic masterpieces as well as in mass-produced figurines).

The full version of Mary certainly exists. Examples include numerous

statues, ranging from a few inches to three feet in height (figs. 84 and 91), picture versions, and reproductions of works of art such as Van Dyck's *Holy Family with Angels* (which depicts Mary seated with the Infant Christ on her knee). But the truncated version dominates numerically.

This popularity of the truncated Madonna is new in the history of Christian art. The type occurs in the past, but not as the predominant form. For example, historically it is full-length depictions of the Black Madonna that have been the main type (in statue or painting), with the truncated form as just one version.[7] Yet all the Black Madonnas in the Greenpoint houses

TABLE 19 Content of religious iconography in households that display Catholic iconography

Iconographic Image	Neighborhood		
	Upper-Middle-Class Suburban (Manhasset) (%)	Working-Class Urban (Greenpoint) (%)	Working-Class Suburban (Medford) (%)
	Percentage of the houses in each neighborhood with Catholic iconography that contain this image		
Mary	85	88	40
Truncated (head, shoulders, waist)	62	62	40
Full-length	31	50	
Jesus	85	88	75
As a Man	62	69	60
Crucified	46	62	20
Sacred Heart		58	15
Last Supper		31	15
Just as a man, alone	15	19	40
As a Boy	31	50	35
Infant Jesus of Prague	31	50	35
Other			
As a Baby[a]	54	65	15
Saints (other than Mary)[b]	31	50	20
Pope		12	

Note: This table includes only items that respondents see as having at least some religious meaning for themselves. Thus it includes items that respondents see as having both artistic and religious meaning for themselves, but it excludes those households that have religious depictions (e.g. icons) that residents view exclusively as art (such cases are only found among the upper-middle class).

These figures for households that display Catholic iconography include households where one of the heads is Catholic and the other Protestant.

[a]In most of these cases, baby Jesus is carried by Mary alone, but in a few cases by St. Anthony and occasionally by Joseph and Mary.

[b]In Greenpoint, after Mary the most common saint is Anthony, present in just under a quarter of the houses with Catholic iconography. Other saints sometimes present include Anne, Joseph, Theresa, Jude, and Francis. I lack complete data on this for Manhasset and Medford.

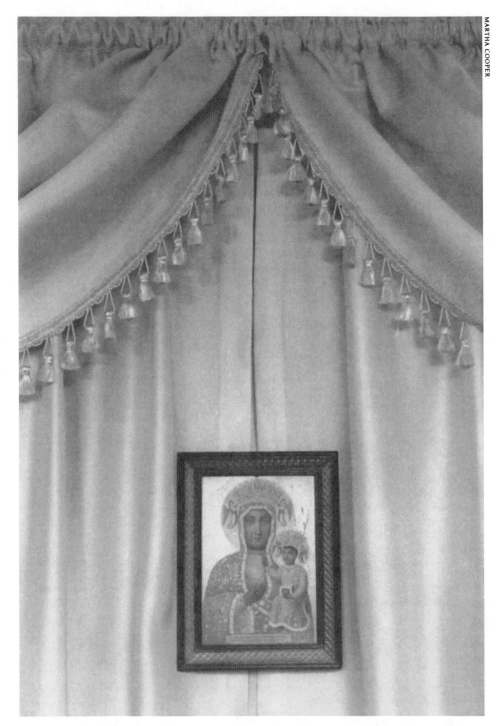

FIG. 80. Greenpoint bedroom, Black (or "Burned") Madonna. A version of the Madonna that is truncated near the waist is popular among residents who display religious iconography. See figs. 79–83.

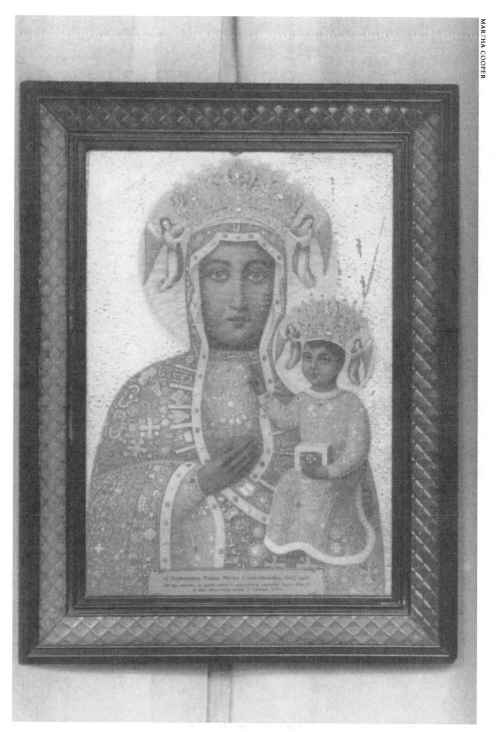

FIG. 81. Close-up of the "Black Madonna" in figure 80.

FIG. 82. Filippo Lippi (1406–69), Madonna (in reproduction), Greenpoint bedroom.

FIG. 83. Greenpoint kitchen, Madonna (on windowsill) and Sacred Heart of Jesus (on refrigerator).

MARTHA COOPER

FIG. 84. Greenpoint bedroom.

sampled are truncated. The fifteenth-century Florentine artist Filippo Lippi painted many Madonnas, most full length, some "truncated." Yet it is only reproductions of the truncated version that modern residents in the sample care to display (a truncated Lippi Madonna occurs in four upper-middle-class households and in two working-class households).[8]

This popularity of the truncated Madonna also appears to be new in the family histories of the Catholic households sampled. Most of the Catholics who display truncated Madonnas say that their parents and grandparents were more likely to display the full-length version. Like so many of the other aesthetic choices encountered in this study, few residents could explain why they themselves now prefer the truncated version. Typical comments were: "It seems nicer," "I prefer it, I don't know why." One Medford resident explained how he and his siblings came to choose "the bust version" of Mary for their mother's gravestone. They knew that she would want Mary on her tombstone, for she had always treasured various full-length versions in her house. But the siblings chose the truncated version because "for some reason it looked better, I don't know why."

Further, this truncation is concentrated on Mary. No other religious fig-

ure is typically presented in this way. The other saints are always full length. With one exception, the various versions of Jesus routinely depict him full length too—on the cross, at the Last Supper, as an infant, as a young child, and so on. The exception in which truncation does occur as a standard feature of the version is the Sacred Heart (figs. 59, 85).[9] Yet here the reason for truncating Jesus is clear. The heart is the spiritual and theological focus of this particular image. "In the devotion to the Sacred Heart," says the *Catholic Encyclopaedia,* "the special object is Jesus's physical heart of flesh as the true natural symbol of His threefold love."[10] Thus if the heart, which comes two-thirds of the way up the human body, is to be the center of the picture, then Jesus cannot be full length. The iconographic solution is to cut the lower third of Jesus.

But why the attraction of the truncated Madonna? The most plausible explanation concerns new attitudes towards virginity. Throughout Christian history, Mary has had thousands of variant forms. Some have stood for the sites of her shrine images (for instance, the Virgin of the Valley), some have stood for devotions sponsored by various orders (for instance Our Lady of the Rosary), others for significant moments in her life (as in Our Lady of the Purification), others for specific attributes. Among the latter, one has been stressed above all—virginity. Indeed, the "Virgin" has been perhaps the most common epithet for Mary in Christian history.

Yet nowadays few of the Catholics in this study who display religious iconography call Mary the "Virgin" as a matter of course. Most refer to her as "Mary," "The Blessed Mother," "The Black Madonna," more naturally than as "the Virgin." Only two persons referred to Mary as "the Virgin" routinely, by first choice, and without prompting.[11] When asked about the epithet, most Catholics who display religious iconography divide into two groups. Some will say that "the Virgin" is an appropriate epithet, though not one they personally are prone to employ. Others, however, will explain that the term has dropped deliberately from their discourse. An eighty-year-old Greenpoint woman explained that she used to call Mary "the Virgin," as did most Catholics. But at some point people started switching to "Mary" and the "Blessed Mother." This change had official sanction; several religious societies sent out notification that Mary should be referred to as the "Blessed Mother" rather than as the "Virgin."

This shift in Mary's nomenclature parallels new attitudes toward virginity among Catholic women. Only two Catholics, of all those sampled, are convinced that a woman should be chaste before marriage. The Greenpoint woman in her eighties, as religious a Catholic as any sampled, is agnostic on

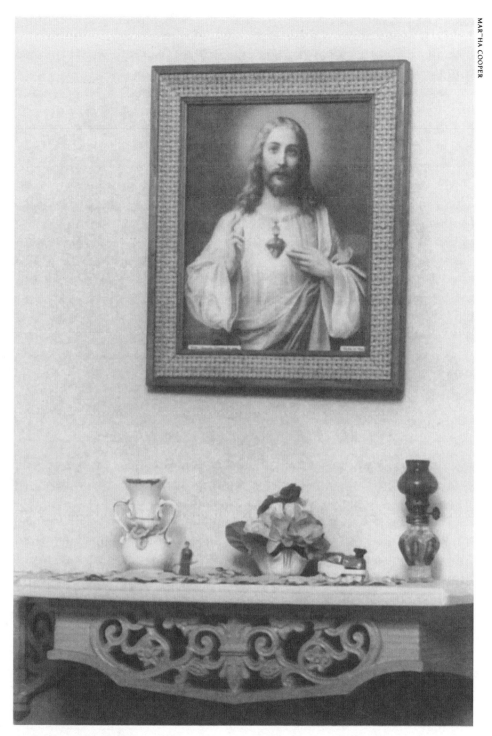

FIG. 85. Greenpoint bedroom, Sacred Heart of Jesus. This is a close-up of figure 59.

the topic: "Women used to be virgins, but now it's changed. They're all living with their men. ["Is virginity important?"] I don't know."

The truncated Madonna is a visual depiction that suits the new sensibilities, for it removes from view the womb and genitals—the body parts central to the issue of a Virgin birth. In so doing, the whole topic of virginity also fades from the agenda. The visual focus shifts just as, on the verbal level, the epithet "Virgin" is fading from discourse.

The linking of the genitals of Christian personages with theological debates is not new in the history of Catholic art and iconography. For example, Leo Steinberg has shown that during the Renaissance Jesus was depicted, in much devotional imagery, with genitals exposed. The theological point, Steinberg argues, was to stress Jesus's human over his divine persona. Notice how, in this Renaissance case, it was by being exposed to view that the genitals of Jesus "signified" within Christian doctrine, while in the case of the modern Madonna it is by disappearing from view that Mary's genital and reproductive organs signify.[12]

So, in the waning years of the twentieth century, does one of the fiercest issues of the Counter Reformation—the topic of the Virgin birth—quietly slip from view on the popular level.

JESUS AND THE DECLINE OF *THE LAST SUPPER*

The Last Supper was once common in the main eating place—dining room or kitchen—in Catholic households. Most of the older Catholics sampled grew up with this picture in the room where they ate.

Nowadays the *Last Supper* is less common. It is in only 15% of the "Catholic" homes in Medford that display religious iconography, and is entirely absent from Manhasset (see table 19). (This absence in Manhasset is probably in part due to upper-middle-class Catholics tending to confine religious iconography to private areas; a *Last Supper* would have to go in the "public" kitchen or dining room.) *The Last Supper* is more common in Greenpoint, but still present in only 31% of the houses with Catholic iconography, a major decline as compared with the past. Further, when displayed the image is nowadays usually small—a bronze or porcelain relief or plate a few inches wide (figs. 86–87). And the image is typically placed on the periphery, not in central view. For example, in many houses it is high up, above a kitchen or dining-room door (fig. 88). (It is usually a reproduction—very much reduced—of Leonardo da Vinci's *Last Supper,* though no one in Greenpoint and only one woman in Medford interviewed knew this.)

FIG. 86. Greenpoint kitchen, *The Last Supper* (plate).

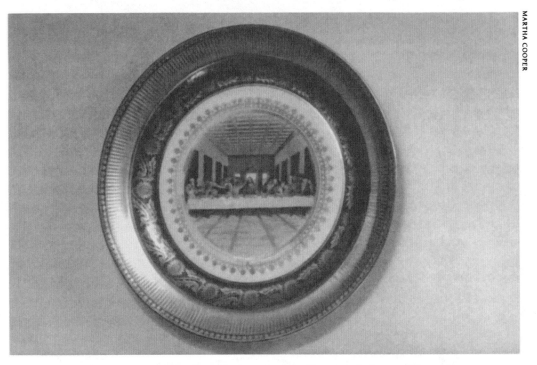

FIG. 87. Greenpoint kitchen, *The Last Supper*. Close-up of plate in figure 86.

FIG. 88. Greenpoint dining room, *The Last Supper* (above door).

The tales that people tell document the *Last Supper*'s decline: "We used to have it in the dining room; but it fell and broke. I didn't replace it. I don't know why; it didn't seem urgent." "I have it, but I don't put it up. I'm not sure why. My parents had it in the dining room."

The fading attraction of the *Last Supper* illustrates the social basis of art. Consider the image's social content—several men, some related but most not, eating together. And recall that the *Last Supper* was common on the refectory walls of medieval and Renaissance monasteries where large numbers of men ate together. Leonardo's painting was for just such a setting.

Various ideas once combined to make this a fitting image for the room where people ate, in Catholic homes two or more generations ago. The idea that relatives and nonrelatives such as boarders and lodgers could live in the same household as the nuclear family; the idea that those in the household, or at least the men, should have an evening meal together each day; the idea

MARTHA COOPER

FIG. 89. Manhattan rectory dining room, *The Last Supper*. This is the only household sampled with a *Last Supper* that is large and prominently displayed. It is also the only household where the eating patterns depicted in the *Last Supper* mirror those in the household, i.e. where each evening several men who are mostly not related by kin eat a meal together.

that men are more important than women; and the idea that woman should cook for, and wait at table upon, the men of the house. All these notions together produced a sensibility for which the *Last Supper*—men eating together without a woman in view—was well suited.

The Last Supper ceased to be a suitable image as these notions, and the practices associated with them, became less acceptable and in some cases totally unacceptable. For example, none of the households sampled takes in boarders who eat meals cooked by the wife. Only one Catholic household in the entire study still contains a large representation of the *Last Supper* displayed prominently in the room where residents eat. And this case supports the preceding analysis. It is the rectory on the East Side of Manhattan, where four priests live—the only household in the sample where a group of men, not related by kin, come together every evening to eat a meal cooked and served by someone else (a woman paid by the rectory) who is not important

MARTHA COOPER

FIG. 90. Scene depicted in fig. 89 from a different angle, and including one of the four resident priests.

enough to eat with them. On a dining-room wall is a colorful *Last Supper,* about 3 feet by 1.5 feet (figs. 89–90), entirely appropriate for such a dining room.

THE SAINTS GO MARCHING OUT

Saints have been, in certain periods, the main topic of Christian art. For instance, Emile Mâle commented that "the art of the Middle Ages . . . is almost entirely a representation of the saints."[13] Even two or three generations ago, many working-class Catholic households featured a variety of saints. The following gives the flavor of these households. It is the bedroom table of a Greenpoint woman, long since dead, preserved by her son, himself now in his sixties, exactly as she used to arrange it (fig. 91). Along with figures such as Mary, Jesus, and Joseph are such non-nuclear-family personages as St. Anthony, St. Patrick, and St. John the Baptist. Such a panoply of saints is nowadays rare.

The decline of the saints is surely overdetermined. In part it results from the victory of modern medicine, for a large part of the responsibilities of saints in these households two or three generations ago concerned the healing of the sick. Each saint had his or her special area of competence. Where this belief remains strong, images of various saints are still likely to be present in the house. For example, an older Catholic woman in Greenpoint displays images of St. Mary, St. Anthony, St. Anne, St. Theresa, St. Michael, and St. Joseph. Believing each saint has a speciality, she prays to St. Theresa in cases of general sickness, to St. Michael in cases of cancer, to St. Anthony in hopeless cases, and so on. But this view is not dominant. The specialities of the saints have been superseded by human specialists (various kinds of doctors, pharmacists).[14]

In part the decline of saints results from the growth of impersonal, bureaucratized organizations and the resulting diminution of the need for personal intermediaries between supplicant and power. The system of standard rules that governs most modern organizations obviates the necessity of having a special "patron" to negotiate on one's behalf. This is not to deny that in some circumstances such a "patron" may help, but it is to say that in many situations it is unnecessary. This contrasts with the unbureaucratized and highly personalized relations that once dominated organizational life, in negotiating with which the help of one or more personal intermediaries was often essential. Thus Catholics in Greenpoint often say, when explaining the

MARTHA COOPER

FIG. 91. Greenpoint bedroom, religious figures. From left: Madonna, St. Anthony and baby Jesus, St. Patrick (with cloverleaf backdrop), Madonna, St. John the Baptist, Joseph, and the Infant Jesus of Prague. This display, in a sixty-year-old bachelor's room, is preserved exactly as it used to be in his mother's bedroom. Large groupings of religious personages, here including several (such as St. Patrick, St. John the Baptist, and St. Anthony) who do not fit easily into roles consonant with the nuclear family, are now rare in the houses sampled.

declining significance of the saints, that saints have little clout with Jesus and God. Consider a Puerto Rican doorman: "Saints don't have authority if God doesn't give it them. When you ask a saint for something, it's like me asking one of my co-workers to go to the boss [with a request]. [Instead] You have to ask Jesus. He goes right through the big door [to the source of power]." The only intercessionary figure that some believe is now of much help is Mary. Otherwise, most people prefer a direct appeal to God (or Jesus). Thus a Polish woman, explaining the absence of saints from her house: "I pray to Jesus and Mary. You wouldn't go to the other saints or the angels, because they're not in charge. It's (going to Jesus and Mary) like you ask your mother and father. I pray through Mary to Jesus. If I pray straight to Jesus, maybe he'll hear me, and maybe not. But sometimes I pray to Jesus. If Mother can't help, maybe Father can."

In part the decline of saints in the house reflects the focus on the nuclear family. While Mary, as the mother, and Jesus—as the child or, in adult form, as the father—offer images consonant with the nuclear family, there is now little place for the cacophony of other personages, unrelated (except for St. Anne) to the holy (nuclear) family, that once crowded into working-class Catholic homes. Images of nonrelatives such as St. Anthony holding the family baby no longer fit the sensibilities of younger Catholics. Here popular taste and Church ideology are in step, for the Western Church too has relegated saints and stressed the nuclear family. As a classic study of religion in rural Spain in the late 1960s put it:

> In the past 100 years, the Church has turned away from the feudal, monarchic, and other political images because of their lack of universal applicability . . . and has focused on the family as an inductive model . . . for understanding divine relations. . . . Since the one intercessor of importance in the family is the mother, this has made irrelevant, by and large, the vast array of saints—hence a relative decline of devotion to the saints, as evidenced by . . . the collapse of saints' chapels, etc.[15]

CONCLUSION

The idea that the audience for religious iconography passively absorbs the messages of religious propaganda that are somehow attached to the objects is scarcely borne out by the data. On the contrary, the relation between audience and religious iconography is strikingly similar to that found already to exist in this study between audiences and other "artistic" genres. In general, the audience selects (consciously or not) those images, and attributes to them those meanings that resonate with their current lives and beliefs, especially as these relate to house, neighborhood, and domestic social relations.

To suggest any overlap between religious iconography, found mainly in the homes of the Catholic working class, and "primitive" art, found mainly in the homes of the upper-middle class, may appear scandalous. Yet once "religious iconography" is seen as being about more than Christianity, and once "primitive" art is seen as being about more than aesthetics, certain similarities emerge. Both convey symbolic meaning through the medium of figurines or quasi-figurines. Both have levels of meaning that are bound up in residents' own lives in and around the nuclear family and neighborhood.

Certainly they do not cover identical subject matter. For example, "primitive" art, in referring to the composition of the household and neighborhood, also stresses the racial question, while religious iconography, in the case of the truncated Madonna, seeks to shed outmoded ideals of virginity. Moreover, some of the meanings of religious iconography are connected to meanings that filter through the Catholic hierarchy, while some of the meanings of "primitive" art are connected to meanings that filter through the art establishment. But both religious iconography and "primitive" art also have a life of their own, supported by the interpersonal nexus of the household context. Further, many of the meanings of religious iconography, like those of "primitive" art (or abstract art), exist outside of the consciousness of residents, in the sense that they are often unnoticed by residents, and, when noticed, are outside the ability of residents to explain. Few Catholic residents can say, for instance, why they no longer find *The Last Supper* an appropriate scene for display any more than upper-middle class residents with "primitive" art can say why it is depictions of the "primitive" person that attract them.

Thus religious iconography, like all the artistic genres discussed in this study, illustrates the complexities involved in accounting for artistic and cultural choices.

Conclusion

Materialist approaches to the study of art and culture have drifted in and out of favor. A nineteenth-century version which saw art as rooted in technology (for instance, in the kinds of tools available to the artists) played itself out by the turn of the century.[1] Marxism, its main successor, has scarcely explained such central twentieth-century developments as abstract art, "primitive" art, and the decline of the portrait.

I have argued here that analysts of culture may have rejected materialism too soon, for they have overlooked the house and its surroundings.[2] To understand the meaning of twentieth-century art and culture for its audience, this material setting—the mode of dwelling—is just as important as the mode of production or the public world of museums, galleries, and critics.

Moreover, the limitations of the standard model for understanding the reception of twentieth-century art become clear when the meanings that the audiences assigns to its art are taken into account. This standard model basically holds that artists, critics, and other cultural gatekeepers (albeit influenced by their social context) create artistic meaning which they then pass along to, or even impose upon, the audience. It implies

that the meanings that the audience assigns to the works are, more or less, those that artists, critics, and others have already assigned. Of course, the audience may "misunderstand" or "fail to appreciate" the works, but then such audience attitudes as do prevail are seen as scarcely worth considering at all, and certainly as without salience for the history of the reception of art in the twentieth century.

Ignoring the meanings that the audience assigns to its "art" leaves many central developments in twentieth-century artistic and cultural taste inadequately explained. When residents in racially diverse urban regions display "primitive" art it appears, from the New York case, that these images symbolize in part attitudes toward contemporary minority groups. The startling decline of the portrait tradition—of the tendency for the well-to-do to commission portraits of themselves for display at home—cannot be understood unless the incompatibility of this tradition with the fragility of the relationship of the modern, nuclear couple is also understood. The tendency of people to prefer that landscape pictures that depict the modern world should be depopulated is related to widespread new preferences for a leisure life that can be privately enjoyed out of the sight of strangers.

Indeed, this study suggests that tastes in art result from a complex and continual interaction between artists, critics, and the purchasing ("demanding") audience. The process is more complex, uncentered, and beyond the ability of any group to fully monitor, let alone control, than is often thought. Such central movements as abstract art, "primitive" art, and the vogue for depopulated landscapes of the modern world were clearly not initiated by the public; but the fact that they went on to become more than footnotes in the history of art has to do with their adoption by sections of the public that often adapted them into their own systems of meaning.

This is not to suggest an idealized "democracy of the market," for the market is skewed in favor of those who can afford to pay. This is why abstract art, which mostly appeals to a limited section of the upper-middle class, has made fortunes for its major artists while religious iconography, which appeals to a numerically larger section of the Catholic working class, has not allowed the flourishing of a comparable group of religious artists.

But it is to say that it is members of "the public," each endowed with "influence" in proportion to their income and wealth and linked to the production of art and culture via the market, who have supported (even demanded) the flourishing of the central genres in twentieth-century art and culture discussed in this study. In documenting the history of twentieth-century culture, the causal influence of this "public," whose artistic interests

are often embedded in the context of residential life—house, neighborhood, leisure life—cannot be overlooked.

I am not proposing an individualistic model according to which people "create" meaning in their private homes. For many of the meanings uncovered in this study are patterned, limited in number, and repetitive (just like the material layout and uses of space in the modern home). Nor am I suggesting that these meanings are themselves without causes external to the individuals. Rather, I am arguing that these causes derive as much from the interaction of residents with social forces such as suburbanization, modern family life, and racial segregation as from the impact of such external forces as artists, critics, and large corporations.

CLASS, CULTURE, AND POWER

These findings, then, raise questions about the entire approach, popular in sociology, that sees art and culture as primarily about domination and power. Such theories typically hold that one group, which understands high culture, exercises "cultural domination" and "symbolic mastery" over another group, which does not understand high culture.

Such a dichotomy, implicit or explicit, in much writing on culture may need to be rethought. It is unclear whether there is one particular group, or even one particular combination of groups, that can be said to hold cultural and ideological dominance in the West.

For one thing, it is no longer plausible to hold that meanings are imposed on "the public" in a one-way process by a dominant elite (corporations, "advertising") or by a mostly impersonal network ("the marketplace"). On the contrary, there is an entire alternate, or parallel, set of meanings— those identified in this study—that exist at the level of art displayed in the home, and in many respects originate in, and are sustained by, this context.[3]

While it is true that in capitalist societies much art and culture is owned and marketed by corporations, neither they, nor the artists and critics, can control the meanings assigned to the works by those who display them. The artistic and cultural elite can surely, by ratifying or failing to ratify, particular works, affect the careers of individual artists and even perhaps of schools of artists working within a given genre. Their judgments can propel to the forefront some artists while keeping others in oblivion.[4] What is less clear is whether they can alone determine the success of a genre ("abstract" art, "primitive" art, landscape art) unless the genre also appeals to audiences because it has an affinity with their lives.

Further, the artistic and cultural elite may offer products, but these products are unlikely to be widely accepted unless they offer at least the raw material for meeting the interests and desires of the purchasers. Anyway, the "meaning" attached to the product is likely to be modified and even reshaped as it is passed from artist/producer/marketer to the purchaser (which is why the "consumption" of cultural products is such an unfortunate term).

Moreover, cases such as those of "primitive" art, the decline of the painted portrait, and abstract art suggest the fundamental point that the highly educated upper-middle class (and even that subsection which specializes in producing and analyzing culture, who are often seen as the purveyors of ideology for the dominant class, or as themselves a new dominant class) is typically unaware of many of the major meanings art forms have for others, and even for themselves. If, in this basic sense, they do not control culture because they are not necessarily aware of all its major meanings and ramifications, then it is hard to argue that cultural and ideological meaning, and hence domination, is concentrated in the hands of one social class or one group.[5]

These are the various problems with most versions of the "Frankfurt school" of sociology's approach to modern culture.

The second major type of theory that sees art and culture as basically about power and domination is Bourdieu's theory of "cultural capital," which views high culture as a device by which the dominant class excludes the dominated classes in capitalism. This theory has three central weaknesses. The whole question of cultural (here artistic) "differences" is less clear-cut than is often thought. For one thing, cultural differences are not neatly aligned with class differences. In the realm of artistic choices, the most apparent differences are not between what can be called a dominant and a dominated class, but between one section of the dominant class and everyone else. In this study, for example, the taste for abstract art, the taste for "primitive" art, the taste for portraits of family members painted by artists of distinction and the practice of regular museum and art gallery attendance are all concentrated primarily among a minority of the upper-middle class. Survey data suggest this is also true of most other components of "high culture." Moreover, there is no evidence that the section of the dominant class which is most involved in high culture has a greater hold on political or economic power than do other sections of the dominant class. This undermines one central axiom of cultural-capital theory.

These statistical doubts are compounded by analysis of the experiential

process involved in looking at high art—the term "appreciate," applied to this process, always did beg the central question of the precise nature of the relation between cultural artifact and viewer. The idea that the typical viewer brings to bear on the works complex skills, received in the family or in the education system, which are used to "decode" the works is too simple. Indeed, close study of those major differences in artistic preference and behavior that do appear suggest many questions about their depth, permanency, and origin. The liking for abstract art distinguishes one group of residents from the rest, but the urge to decorate plain white walls, a central factor underlying the liking for abstract art, is widespread. Displaying "primitive" art distinguishes one group of residents from most of the rest, but many of the attitudes toward African Americans and Hispanics, which are related to such displays, cut across groups. Even seemingly unassailable differences, such as that between sections of the Catholic working class who display (low-status) "religious" iconography and sections of the upper-middle class, who display (high-status) "primitive" art, become less certain when it is understood that religious iconography is not just about religion and that "primitive" art is not just about aesthetics; in both cases symbolic meaning is conveyed via statuettes and other figurative symbols in the living rooms and bedrooms of residents; in both cases much of the symbolic meaning pertains to the social and residential world of residents.

Of course there is a visible difference between those who display abstract art and those who display religious iconography. But at issue is the extent to which such differences constitute cultural barriers. Cultural-capital theorists sometimes imply that the formative experiences of family upbringing and education launch into the world two classes of individuals whose destinies are from that time fixed. One class is endowed with a capacity to clothe themselves in the success-bringing symbolic apparatus of the dominant culture; the other class is doomed to the stigmatizing symbols of a dominated culture. This is a fatalism that rivals that of the Calvinist theory of predestination. It implies what has been called the "oversocialized" concept of the person, according to which major behavioral patterns have been "internalized" at some early stage, so that a person's ongoing social relations have only minor effects on behavior.[6] But culture is more flexible than that. If there is a dominant culture that is used to filter out candidates for entry into elite positions, then certain parts of it are easily adopted by those of humble origins who wish to move upward. How hard is it to take down the reproduction of the *Last Supper* in the dining room and replace it with a reproduction of a Picasso, Matisse, or Mondrian? Moreover, there are certain

striking similarities in the tastes of all social classes. In this study, everyone likes landscapes, and if a few wealthy residents display a somewhat smaller number of landscape pictures than do other people, that is probably not because they have less taste for landscapes but because their taste is also satisfied by the imaginary landscapes they envisage in their abstract art or, as with a minority of Hamptons residents, by the spectacular actual landscape outside their windows. Points such as these undermine a second axiom of cultural-capital theory—that a liking for high art always requires specialized knowledge that is hard to acquire and which can therefore serve to limit entry into the social circles of the dominant class.

Above all, the link between involvement in high culture and access to dominant class circles—the third and pivotal axiom of cultural-capital theory—is undemonstrated. It is unclear how important any of this art and culture is for entry into and continued membership in the occupational and social world of the dominant classes. The answer seems to be that it very much depends on the kind of occupation and social milieu at issue. It is hard to see why "high culture" should be of much importance for individual advancement in many areas of business. Indeed, it is well known that in large American companies the question of culture is typically delegated to a few persons (including, not uncommonly, wives of the top officers) who become the corporation's experts on questions of arts sponsorship and certain aspects of the company itself—which paintings will be bought for the offices of the top executives, and so on. A recent study of how U.S. corporations select the art for their offices reveals that this is often done by a committee of those executives who happen to be interested in such questions. In many cases the committee is then "educated" by an outside expert, who has been hired to guide the committee in the aesthetic and artistic, as well as economic, aspects of its choices. This suggests that culture is often a subspeciality within the corporation rather than a general requirement for advancement. Perhaps individuals need enough knowledge to avoid gross gaffes, but little more. Indeed, it is possible that a deep and passionate commitment to high culture (as opposed to a smattering of knowledge) might be a handicap in the mainstream culture of American business, implying as it could either less than total commitment to the goals of the corporation or a cultural superiority that might make others feel uncomfortable and inadequate. These doubts are strengthened by case studies of the still heavily male-dominated upper echelons of the corporate structure. For instance, in the United States knowledge of sports, which is scarcely difficult to acquire or unevenly distributed in the class structure, seems at least as important as

knowledge of the high arts for individual success in the corporate hierarchy.[7] Doubtless in some sectors of middle- and upper-middle-class life, especially those that deal with the production of culture, a deep knowledge of and commitment to high culture is more important. But persons involved in these spheres constitute only a segment of the "dominant classes."

It will be said that cultural-capital theory is more applicable to a centralized and elitist society such as France. Surely this is true. Still, many of the objections I have cited for the United States case are also valid for France. For example, as I have pointed out in the Introduction, French survey data do not indicate that the correlation between social class and culture is nearly as strong as cultural-capital theorists imply.

Of course, cultural-capital theory can surely be modified, as I have suggested it should, to allow that while in some sectors (to be empirically determined) "engaging" in high culture may facilitate upward mobility, in others it does not; and it can surely be modified to allow that "engaging" in aspects of high culture is a multifaceted activity only certain aspects of which require lengthy training. The ability to read the operatic score requires much cultural training, the ability to purchase the tickets requires almost none, but if attendance at the opera helps social mobility only the latter ability is definitely necessary. And cultural-capital theory can surely be modified to allow that facility with some aspects of high culture can be acquired in the process of upward mobility (on the job, as it were!), as perhaps in the decision to display abstract art.

Nor is there any objection to more cautiously stated theories of the relation between culture and power. The simple idea that for some people artistic choices also reflect status aspirations is surely correct, although the findings of this study suggest that we will often misunderstand their interest if we see status as the only, or even the driving, force behind their choices. Status considerations may explain why the Catholic upper-middle class in suburban Manhasset confine religious iconography to the private rooms of their house, but not why they select the iconographic images they do. Status considerations may inhibit a few upper-middle-class residents of Manhattan from displaying family photographs, but do not explain why, on the whole, they are also inhibited from displaying portraits of themselves.

There is no doubt that America is a society in which economic power is highly stratified, and in which whatever share of political influence "the people" have is constantly threatened by numerous special interests, above all by the corporate/financial sector, and by the executive branch of government which is driven by its own voracious appetite for power. The question

is how significant a role culture (here "art") plays in maintaining such structures of economic power and political domination. To deny that it plays some part would be to overlook the obvious. To exaggerate its role would be to overlook the less obvious but, as this study has shown, widespread, ways in which artistic meanings and choices are located in the particular lives and experiences of people, at every level in the class structure. It would also suggest undue pessimism about the possibilities for radical social change (implying the need first for major cultural education, or worse "re-education," to release "the people" from their lengthy experience of cultural dominance).

MATERIALISM AND SYMBOLISM

The approach presented in this study is not a mechanical reductionism, in which the form and meaning of art can be deduced from a knowledge of the material base. On the contrary, only by studying the art in its context can its meaning for an audience, and the nature of its links with material and social life, be discerned.

The full range of symbolic meaning associated with modern art and culture has not been noticed in part because we have focused on such domains as the museum or public spaces, where those who arrange the art (the potential symbols) and those who view it (the receptors or audience) diverge. The audience that passes through a museum did not decide what items should be displayed or how they should be arranged. To seek the symbolic meaning of such art for an audience is hard, a little like asking what one person's dream "says" about the unconscious of another person to whom it has been recounted. Why should the dream signify anything about the unconscious of someone who did not put the dream together? By contrast, in the house the main audience—the residents—are also the ones responsible for the presence and arrangement of the art and cultural items. This is why the mode of dwelling provides a locus for understanding new, and unexpected, ways in which art signifies in the modern world.

Moreover, for the unhelpful notion that art "reflects" society, which has so often hampered other "material" approaches to art and culture, can be substituted an empirical account of the various ways in which art relates to the material context of society. Does art idealize society, pseudo-idealize society, compensate for it, constitute a metaphor for it, or even simply reflect it?[8] The empirical answer is that it is an empirical question, for art relates to

society in all of these ways, and more, depending on the content of the art and on the nature of the audience.

For example, family photographs are complex signs that, just in their mode of display alone, depict both the *ideal* of family closeness (in their clustered mode of display) and its *opposite,* family fragility, (in their movable mode of display). Landscape depictions pursue another pervasive modern *ideal.* In their portrayal of a contemporary nature as both calm and devoid of other people, they signify—in the material context of houses featuring private backyards as a locus of leisure—the *imaginary achievement* of a private leisure on a scale far grander than the backyard, for they are unfettered by the requirement of legally owning the leisure space depicted. Landscape depictions also, for many respondents, *compensate* for society—for a long, noisy commute to work, for the bustle and pressure of the world of work and so on. Abstract art, for many residents, *decorates* society (a basic and perennial sign). "Primitive" art, as found here in the homes of white liberals in segregated residential settings, is a sign that both *gestures toward* African American culture and residents and, at the same time, *distances from* actual contemporary African Americans, via the very unlikeliness of the Africans depicted in image. Thus "primitive" art is also an example of an imaginary achievement. It plays out a perceived social and political obligation to integrate nonwhites—African Americans, Latinos, and others—into white households and neighborhoods. In its ability to represent the presence of these groups in the house, and therefore also in the neighborhood, it depicts some of the dilemmas of segregation for white liberals. Finally, art can signify by its absence, indicating that the image it depicts is now seen by viewers as *incompatible* with contemporary social life. An example is the decline of depictions of the *Last Supper* in the kitchens and dining rooms of the Catholic working class. This is related to the decline in working-class households of the practice of several males, including boarders, eating together a meal that has doubtless been cooked by a female who is not important enough to be present.

In these and in other ways can emerge a semiotics of art that is properly grounded in data. The interpretations so generated will take into account both the material context of the art and the viewers' sense of the meaning art has for them, while not necessarily accepting the latter at face value.[9]

The approach presented in this study throws light on some of the intellectual dilemmas that have plagued Marxism. For if materialist approaches to the study of art and culture have been under a cloud, this is especially

true of the historical materialism associated with Marxism. As one commentator put it, "Perhaps the sole characteristic common to virtually all contemporary varieties of Western Marxism is their concern to defend themselves against the accusation of materialism. Gramscian or Togliattian Marxists, Hegelian-Existentialist Marxists, Neo-Positivizing Marxists, Freudian or Structuralist Marxists, despite the profound dissensions which otherwise divide them, are at one in rejecting all suspicion of collusion with 'vulgar' or 'mechanical' materialism." [10] Yet if "vulgar" Marxist theories of the influence of the mode of production on culture are out, the new "sophisticated" Marxism has had difficulties too. For example, in a number of his later writings, Raymond Williams rejected the "naive reductionism" of many Marxist accounts of the link between culture and material base. But he ran into problems, which he acknowledged he could not solve, when thinking about a more sophisticated model of the relation between base and superstructure, between ideas and material production. As he said, many of these models are unclear or are posed at such a level of generality as to be unhelpful, or are without meaning.[11] The metaphor, beloved of vulgar materialists, that art "reflects" the material world may be too simple, but it is a dubious advance to substitute the more complex and less clear metaphor that art "mediates" the world. To stress the "complexity and autonomy" of the superstructure in relation to the base may be to replace a simple theory with an empty one.[12]

My argument is that the proper application of the materialist perspective to twentieth-century art demands that we view this art in more than one material context. We do, of course, need to see it in the context of the political and economic structure of modern society—the mode of production. For example, the decline of traditional imperialism in the 1950s and 1960s, triggering growing doubts about Western superiority, was important in the growing attraction of "primitive" art.[13] The Cold War probably played a part in the attraction of abstract expressionism for a section of the American ruling class, because it enabled the latter to contrast Western cultural freedom and individuality with Soviet cultural rigidity.[14] And the policies of museums and galleries have an important impact on cultural dissemination. But we also need to view art in the context for which much of it was purchased and displayed: the modern house. Without the latter perspective, the former is often thin and incomplete.

Some qualifications about this study are in order. The data I have presented are from a particular region of the United States, albeit a pivotal one given New York's role in post–World War II art. We need more information

on differences between countries, as well as on regional differences within the United States. My study is about the meaning of twentieth-century art— "originals" and copies, expensive and inexpensive items—for the audience who purchase and view it, not for the artists who produced it.[15] Within the realm of art, I covered a limited number of topics; but I chose those that seemed most pertinent to the theories under consideration. For example, a detailed analysis of such "critical" cases as abstract art, "primitive" art, and religious iconography was a way to explore the extent to which surface differences between social classes also reflect fundamental and deep-seated differences in taste. I did not discuss Pop Art or Minimalism or *Western* "primitive" artists because these genres were far less common, even in the houses of the well-to-do, than abstract art or non-Western "primitive" art. I carefully considered gender as a variable in my analysis. But, other than the propensity of women to take a lead in the display of family photographs and religious iconography, I did not discern a gender impact on the artistic preferences I examined. Within the households I studied, I concentrated on adults rather than teenagers. This was partly because it is practically impossible to interview most teenagers when their parents are around, and more importantly because teenagers seem to have had a negligible influence on the direction taken by the taste for art in the twentieth century. (Here is a clear difference from music. Indeed, if there is a distinct teenage artistic preference it consists in the liking for visual depictions of musical [rock] stars, with which they often cover the walls of their bedrooms. This underlines the greater salience of music for teenagers.) People who disagree with my conclusions may point to these and other topics that I did not cover, and say that there lies the potential counterevidence. I can only respond that I urge them to go out and gather it.

Finally, this is a study of only one element of modern culture, art (albeit broadly defined). Many of those who study culture typically specialize in one element—film, music, literature, television, art—and then argue that the basic dynamics of the other elements are similar. About this I am unsure. (Note, for example, the salience of music, but not art, for teenagers). But what is clear is that a theory of twentieth-century culture that fails to also fit the case of art is inadequate.

In his now classic essay "The Power of the Powerless," Václav Havel points out that even when East European societies were dominated by the Soviet Union and by local Communist parties, the relation between the ideas of the populace and the power structure was too complex to fit a model of a

dictatorial elite imposing its attitudes on the rest.[16] My findings similarly suggest that the model of one group exercising power over another in the cultural sphere belies the complexity of the relationship between people and power. Thus in the West, too, these models are problematic. Decentering the cultural elite that supposedly controls art and culture makes room for a broader notion of art, as a locus for understanding modern, lived experience via the meanings that people ascribe to the works. The relation between meaning on this level and dominant classes and artistic elites cannot be ignored; but this study suggests that the relationship is by no means unidirectional and is poorly understood if viewed exclusively through the lens of domination and power. Indeed, attempts to assimilate culture primarily to the model of economic and political power may be a mistake. Above all this is because meaning, so central to culture, is so hard to control. It is easier to set the money wages that people earn than the meaning they attribute to their work or to the art they display. Culture is more fluid and complex than theories of cultural domination imply.

Appendix

TABLE A-1 Occupations of the male residents sampled

	Neighborhood			
	Upper-Class Urban (Manhattan) (%)	Upper-Middle-Class Urban (Manhasset) (%)	Working-Class Urban (Greenpoint) (%)	Working-Class Suburban (Medford) (%)
Occupation				
Own business[a]	53	41	19	16
Upper-white collar	47	47	11	12
Blue-collar[b]		12	58	47
Lower-white collar			11	25
Other				
Total	100	100	99	100
	(N = 34)	(N = 34)	(N = 36)	(N = 32)

Note: The data are for current paid occupations, or, if the person has retired, for last paid occupation.

[a]This category is divided into two groups—those who own a business that employs at least 5 people (capitalists) and those who employ less than 5 (owners of small businesses). In Manhattan 18% of the men were capitalists and 35% owned small businesses. In Greenpoint and Medford only one of those men who owned a business (a Medford resident) was a capitalist.

[b]The majority of persons in this category are skilled crafts workers, semi-skilled factory workers, and transportation workers; also included are doormen (several in the Greenpoint sample) and first-line supervisors.

TABLE A-2 Occupations of the female residents sampled

	Neighborhood			
Occupation	Upper-Class Urban (Manhattan) (%)	Upper-Middle-Class Urban (Manhasset) (%)	Working-Class Urban (Greenpoint) (%)	Working-Class Suburban (Medford) (%)
Own business	15		3	3
Upper-white collar	35	33	12	17
Blue-collar			9	11
Lower-white collar	15	31	45	54
Homemakers	29	36	30	14
Other[a]	6			
Total	100	100	99[b]	99
	(N = 34)	(N = 36)	(N = 33)	(N = 35)

Note: The data are for current paid occupations, or, if the person has retired, for last paid occupation.
[a]For Manhattan this category consists of women whose main occupation is volunteer/charity work.
[b]The figures don't add up to 100% because of rounding.

TABLE A-3 Age of the residents sampled

	Neighborhood			
Age[a]	Upper-Class Urban (Manhattan) (%)	Upper-Middle Class Urban (Manhasset) (%)	Working-Class Urban (Greenpoint) (%)	Working-Class Suburban (Medford) (%)
Under 40	27	40	23	45
40–60	40	30	25	15
Over 60	33	30	52	40
Total	100	100	100	100
	(N = 40)[b]	(N = 40)	(N = 40)	(N = 40)

[a]"Age" is the mean age of the head(s) of household.
[b]These numbers refer to the total number of households sampled.

TABLE A-4 Gender of the household head(s)

Gender of the Household head(s)	Neighborhood			
	Upper-Class Urban (Manhattan) (%)	Upper-Middle-Class Urban (Manhasset) (%)	Working-Class Urban (Greenpoint) (%)	Working-Class Suburban (Medford) (%)
Household headed by a man and a woman	80	80	85	82.5
Household headed by a woman alone	10	15	5	15
Household headed by a man alone	10	5	10	2.5
Total	100	100	100	100
	(N = 40)	(N = 40)	(N = 40)	(N = 40)

TABLE A-5 Ownership status of the household head(s)

Ownership status[a]	Neighborhood			
	Upper-Class Urban (Manhattan)	Upper-Middle-Class Urban (Manhasset)	Working-Class Urban (Greenpoint)	Working-Class Suburban (Medford)
Owner	90	98	92	100
Renter	10	2	8	
Total	100	100	100	100
	(N = 40)	(N = 40)	(N = 40)	(N = 40)

[a]In preparing the list of houses in each area from which the samples were drawn an effort was made to exclude houses clearly occupied primarily by renters. Thus in Manhattan and Greenpoint, houses whose mailboxes indicated that they were subdivided into various apartments were excluded. This focus on homeowners was done for ease of comparison between the four neighborhoods. Still, a few renters did turn up on the sample, and they were interviewed anyway.

NOTE: For data on the religious composition of the households see chap. 6, table 18.

TABLE A-6 The subject matter of paintings and photographs prominently displayed on walls in houses: means and standard deviations

Subject Matter	Neighborhood			
	Upper-Class Urban (Manhattan)	Upper-Middle-Class Suburban (Manhasset)	Working-Class Urban (Greenpoint)	Working-Class Suburban (Medford)
Landscape[a]	2.9	2.7	2.2	2.0
	(2.4)	(1.9)	(1.6)	(1.0)
Cityscape	0.4	0.1	0.3	
	(0.7)	(0.4)	(0.6)	
People				
Religious persons	0.2	0.4	1.0	0.5
	(0.8)	(0.7)	(0.8)	(0.7)
Family members	1.0	1.1	1.6	1.8
(photos and	(1.5)	(1.2)	(1.0)	(1.0)
portraits)				
Friends and	0.1			
acquaintances	(0.3)			
Others	1.1	1.4	0.3	0.5
	(0.9)	(1.2)	(0.4)	(1.3)
Abstracts	1.2	0.4		0.1
	(1.3)	(0.7)		(0.3)
Flowers	0.3	2.0	0.8	0.7
	(0.6)	(1.7)	(1.0)	(0.7)
Animals, birds, or fish	0.5	0.2	0.2	0.8
	(0.6)	(0.4)	(0.4)	(1.2)
Still life	0.2	0.2	0.2	0.2
(fruit, vegetables,	(0.6)	(0.5)	(0.6)	(0.4)
or drinks)				
Other	0.2	0.1		0.1
	(0.3)	(0.2)		(0.3)
	(N = 322)[b]	(N = 311)	(N = 243)	(N = 230)

Note: Numbers outside parentheses indicate mean number per house of each type of subject matter. Parenthetical numbers indicate standard deviations. This table complements table 2 in chapter 2.

The data in this table and table 2 include only topics that are prominently displayed on a wall. A topic is defined as "prominently displayed" if pictures depicting that topic constitute all (scored as one point), or at least three-quarters (scored as half a point), of the topics of the pictures on a particular wall. For example, a picture of a landscape that occupies a wall by itself or only with pictures of other landscapes scores one point; a landscape picture or a group of landscape pictures that constitute at least three-quarters of the pictures on a wall scores half a point.

Some topics are also displayed elsewhere than on walls, for instance on the flat surfaces of tables, dressers, and shelves. Family photographs, African, Oceanic, and pre-Columbian figures ("primitive" art), and religious statues are examples. Their presence in the home will therefore be underestimated by the data in tables A-6 and 2. These topics are discussed in later chapters. In particular the fact that family photographs are often displayed, in movable fashion, on flat surfaces is of great significance, and is discussed in chapter 3. Table A-10 (appendix) recomputes the data of table 2 so as to include family photos displayed on flat surfaces.

The data include original pictures, reproductions, and photographs. They include items by anonymous or obscure artists as well as items by recognized artists.

The data in table 2 include pictures in the following rooms and areas of the house: the hallway, foyer, living room, dining room, kitchen, library, den, sitting room, family room, master bedroom, and guest room. They exclude pictures in bathroom(s), children's bedroom, and basement.

^aFor the purposes of the data in tables 2 and A-6, a "landscape" is defined as a picture over half of whose content is land, water, or sky.

^bThese numbers refer to picture-topics (defined in general note), not households. For example, the total number of picture-topics prominently displayed in the Manhattan houses analyzed was 322. In a few cases, the data for a house are not complete enough to include in tables 2, A-6, and A-10. The data in these tables are based on no less than 36 of the 40 houses sampled in each neighborhood.

GENERAL DISCUSSION OF TABLES A-7-I AND A-7-II

Figure 34 (chap. 2) is based on the statistical technique of logistic regression, using maximum likelihood estimates. The probabilities in the chart were calcualted from the results of a logit model that is presented in tables A-7-i and A-7-ii. In model 1, the log odds of a landscape picture being peopled were considered as a function of the type of society depicted in the landscape (a dichotomous variable) and of the type of neighborhood of the house where the landscape is hung. Table A-7-i (analysis of variance) assesses the fit of the overall model and the significance of each independent variable. It reveals that the "type of society depicted" is highly significant (at the .001 level). By contrast, the type of neighborhood of the house where the landscape is hung is not significant at even the .05 level. In other words, whether a landscape picture is peopled is affected by the type of society the landscape depicts but not by the social class of the owners of the picture. The model was also run with additional independent variables, to enable controls to be made for the age of residents, their religion, and their gender (model 2). None of these control variables was significant, which underlines the importance of the type of society depicted as a determinant of whether a landscape will be peopled. Since the control variables included in model 2 were not significant, the parameter estimates of model 1 were used for calculating figure 34.

At the bottom of Table A-7-i is the "likelihood ratio," which permits an assessment of the fit of the model to the underlying data. This statistic is distributed as chi-square. If the chi-square is *small* (relative to the degrees of freedom) then the model exhibits a close fit to the original data. The likelihood ratio probability for model 1 suggests that the model, which yields an associated probability greater than 0.05, fits the data reasonably well.

Note that the computer was programmed to choose at random one of the prominently displayed landscapes from each house and that the logistic regression was performed on this subset of landscape pictures. This was done because the number of landscape pictures prominently displayed varies from house to house, while a valid statistical analysis could be based on no more than one landscape from each house.

Note also that the coefficients were coded on an effect-coded design matrix. For more on these techniques see Michael Swafford, "Three Parametric Techniques for Contingency Table Analysis: A Nontechnical Commentary," *American Sociological Review* 45 (August 1980), pp. 664–90.

TABLE A-7-i Analysis of variance for logistic regression of whether a landscape picture is peopled, on the kind of society depicted, controlling for other variables

Independent Variable	Model 1 Probability (chi-square)	Model 2 Probability (chi-square)
Intercept	0.007	0.98
Type of society depicted by the landscape	0.0001	0.0001
Neighborhood of house	0.84	0.838
Age of residents		0.856
Religion of residents		0.696
Gender of household head(s)		0.191
Likelihood ratio statistic	0.1	0.02

TABLE A-7-ii Coefficients for logistic regression of whether a landscape picture is peopled, on the kind of society depicted, controlling for other variables

Independent Variable[a]	Model 1	Model 2
Type of society depicted by the landscape		
Contemporary	− 2.7***	− 1.71***
America[b]	(0.62)	(0.75)
Neighborhood of house		
Working- and lower-		
middle-class urban	0.11	− 0.47
(Greenpoint)	(0.57)	(0.70)
Upper-class urban	− 0.06	− 0.21
(Manhattan)	(0.55)	(0.75)
Upper-middle-class		
suburban	0.47	− 0.48
(Manhasset)	(0.53)	(0.76)
Age of residents[c]		
Under 40		0.21
		(0.56)
40–60		− 0.34
		(0.61)
Religion of residents		
Catholic		0.63
		(0.74)
Jewish		− 0.23
		(0.79)
Gender of household head(s)[d]		
A man and a woman		0.67
		(0.39)
A woman only		0.61
		(0.7)
Intercept	1.45	6.96

Note: Significance levels denoted by *p<.05 **p<.01 ***p<.001.

Numbers in parentheses are standard errors.

[a]Comparison categories are: Type of society depicted by the landscape—nonindustrial society or an industrial society in the past; neighborhood of house—Medford (working/lower-middle-class suburban); religion—Protestant, mixed Protestant and Catholic, and other; age—over 60; gender of household head(s)—a man only.

[b]This category actually refers to all advanced industrial societies depicted in the present; however, almost all the cases in this category depict contemporary America (an exception is the beach scene of contemporary France, in figure 38).

[c]Where there are two household heads (e.g. husband and wife), "age" is their mean age.

[d]See table A-9, note d.

GENERAL DISCUSSION OF TABLE A-8

Table A-8 deals with the same issues as tables A-7-i and A-7-ii, but using a somewhat different approach. In table A-8 the dependent variable in an OLS regression analysis is the proportion of landscape pictures in each house that are peopled. Again, the most important determinant, by far, is the kind of society depicted in the landscape. It is highly significant in all four models. In fact, in models 1 and 4 residents' social class does appear to also make some difference. Residents of upper-middle-class neighborhoods are somewhat more likely than working-class residents to have peopled pictures. Still, table A-8 bears out the basic point that the taste for unpeopled pictures of contemporary America cuts across social class.

TABLE A-8. OLS regression of the proportion of the landscape pictures that are peopled in a house, on the kind of society depicted, controlling for neighborhood in which houses are located and other variables (unstandardized coefficients)

Independent Variable[a]	Dependent Variable—Proportion of Landscape Pictures that are Peopled in Each House			
	Model 1	Model 2	Model 3	Model 4
The proportion of the landscapes in the house that depict contemporary America	−0.52***	−0.55***	−0.51***	−0.51***
	(0.08)	(0.08)	(0.08)	(0.08)
Neighborhood of house				
Working- and lower-middle-class urban (Greenpoint)	0.05	0.04	0.10	0.12
	(0.08)	(0.09)	(0.09)	(0.09)
Upper-class urban (Manhattan)	0.19*	0.12	0.21	0.26*
	(0.09)	(0.09)	(0.12)	(0.12)
Upper-middle-class suburban (Manhasset)	0.15	(0.11)	0.19*	0.23*
	(0.09)	(0.08)	(0.09)	(0.09)
Age of residents[b]				
Under 40		0.02	−0.04	−0.02
		(0.07)	(0.07)	(0.08)
40–60		0.17*	0.14	0.14
		(0.07)	(0.08)	(0.08)
Religion of residents				
Catholic			−0.13	−0.16
			(0.09)	(0.09)
Jewish			−0.16	−0.22
			(0.11)	(0.13)
Mixed-religion marriages and other religions			−0.22*	−0.24*
			(0.09)	(0.10)
Number of landscape pictures in the house				−0.02
				(0.02)
Intercept	0.55	0.55	0.63	0.67
	(0.09)	(0.08)	(0.09)	(0.11)
R^2	0.45	0.48	0.50	0.51

Note: Significance levels denoted by *$p < .05$ **$p < .01$ ***$p < .001$.
Numbers in parentheses are standard errors.
[a]Omitted categories for dummy variables are: Neighborhood of house—Medford (working-/lower-middle-class suburban); religion—Protestant; age—over 60.
[b]Where there are two household heads (e.g. husband and wife), "age" is their mean age.

TABLE A-9. OLS regression of status-raising characteristics of landscape pictures, on neighborhood in which houses are located, controlling for age, religion, and gender of residents (unstandardized coefficients)

Independent Variables[a]	Dependent Variables			
	Proportion of the Landscape Pictures in the House Painted by a Professional Artist Whose Name the Resident Knows[b]	Proportion of the Landscape Pictures in the House That Depict a Foreign Society	Proportion of the Landscape Pictures in the House That Depict Britain, France, or Japan	Proportion of the Landscape Pictures in the House That Depict the Past
Neighborhood of house				
Working- and lower-middle class urban (Greenpoint)	0.12 (0.10)	0.06 (0.10)	0.05 (0.10)	0.14 (0.12)
Upper-class urban (Manhattan)	0.38** (0.12)	0.74*** (0.12)	0.60*** (0.11)	0.53*** (0.14)
Upper-middle-class suburban (Manhasset)	0.54*** (0.09)	0.30** (0.10)	0.28** (0.09)	0.46*** (0.11)
Age[c] of residents				
Under 40	0.06 (0.07)	−0.22** (0.08)	−0.14 (0.07)	−0.27** (0.09)
40–60	0.08 (0.08)	−0.09 (0.08)	−0.13 (0.08)	−0.26* (0.09)
Religion of residents				
Catholic	−0.11 (0.1)	0.14 (0.10)	0.02 (0.09)	0.02 (0.12)
Jewish	.03 (0.13)	0.16 (0.14)	−0.21 (0.13)	−0.23 (0.16)
Mixed-religion marriages and other religions	−0.01 (0.10)	−0.01 (0.10)	−0.05 (0.10)	−0.31* (0.12)
Gender[d] of household head(s)				
A man and a woman	−0.08 (0.18)	−0.17 (0.18)	0.17 (0.17)	−0.02 (0.20)
A woman only	−0.09 (0.19)	−0.10 (0.20)	0.17 (0.19)	0.04 (0.23)
Number of landscape pictures in the house	0.02 (0.02)	0.01 (0.02)	−0.03 (0.02)	−0.01 (0.02)
Intercept	0.09 (0.18)	0.17 (0.18)	−0.02 (0.18)	0.34 (0.22)
R^2	.47	.59	.32	.30

Note: Significance levels denoted by $*p < .05$, $**p < .01$, $***p < .001$.

Numbers in parentheses are standard errors.

[a]Omitted categories for dummy variables are: Neighborhood of house—Medford (working-/lower-middle-class suburban); religion—Protestant; age—over 60; gender of household head(s)—a man only.

[b]This variable is slightly more restrictive than that in table 4, in that it refers to "professional artists" rather than any artist. It thus excludes art work painted by residents' friends and relatives who are not professional artists.

[c]Where there are two household heads (e.g. husband and wife), "age" is their mean age.

[d]Comparing this trichotomy—households jointly headed by a man and a woman (almost all married couples), households headed by a woman (but not widows), and households headed by a man (but not widowers)—is a better way of exploring gender differences in artistic selections than trying to determine, within married couples, which one selects each type of art. This is because among married couples even where one person takes the lead in artistic selections, the other person is usually given a veto right over what is displayed (unless the marital relationship is markedly poor). In this sense most of the art displayed in the homes of married couples is a product of their joint taste.

Still, for what it is worth it should be noted that for two (but only two) of the artistic genres displayed by married couples in this study, one gender tends to take the lead in making the selection. These genres are family photographs and religious iconography, in the display of which the wife usually takes the lead.

It will be noted that households headed by a widow or widower are excluded from the analysis in table A-9. This is because a widow or widower often deliberately preserves the art in the house more or less as it was when the other spouse was alive, so that the art in such houses cannot be seen as the choice of one gender alone.

TABLE A-10 The subject matter of the paintings and photographs prominently displayed on walls, tables, and shelves in the houses

	Neighborhood			
Subject Matter	Upper-Class Urban (Manhattan) (N = 370)[a] (%)	Upper-Middle-Class Suburban (Manhasset) (N = 365) (%)	Working-class Urban (Greenpoint) (N = 288) (%)	Working-Class Suburban (Medford) (N = 269) (%)
Landscape	30.4	26.8	26.7	27.6
Cityscape	4.0	1.4	4.4	
People				
Religious persons	2.4	3.8	12.2	7.4
Family members				
(photos and portraits)	25.1	25.8	36.1	30.6
Friends and acquaintances	.8			
Others	11.2	14.0	3.9	7.4
Abstracts	12.1	3.8		1.5
Flowers	3.6	19.7	10.0	8.9
Animals, birds, or fish	4.9	1.9	3.3	10.4
Still-life				
(fruits, vegetables, or				
drinks)	2.4	1.6	3.3	3.0
Other	2.8	1.0		3.0
Total	99.7	99.8	99.9	99.8

Note: The data include topics that are prominently displayed on a wall, table, or shelf (by contrast with table 2, chapter 2, which only includes topics that are prominently displayed on a wall). A topic is defined as "prominently displayed" on a wall if pictures depicting that topic constitute all (scored as one point), or at least three-quarters (scored as half a point), of the topics of the pictures on a particular wall (see table 2, note). A topic is defined as "prominently displayed on a table or shelf" if photos depicting that topic are the only artistic/visual items on that surface. (For example, photos displayed on a table with a lamp or a telephone are counted here, but photos displayed on a table with figurines are not.)

The data include original pictures and reproductions, and photographs. They include items by anonymous or obscure artists as well as items by recognized artists.

The data in table A-10 include pictures in the following rooms and areas of the house: the hallway, foyer, living room, dining room, kitchen, library, den, sitting room, family room, master bedroom, and guest room. They exclude pictures in bathroom(s), children's bedroom, and basement.

Note that religious figures and stand-alone items of "primitive" art are still excluded from this analysis. See chapters 5 and 6.

[a] These numbers refer to pictures, not households.

TABLE A-11. OLS regression of the number of photographs displayed, on selected characteristics of head(s) of household, controlling for neighborhood in which houses are located (unstandardized coefficients)

Independent Variables[a]	Dependent Variable—Number of Photographs Displayed in House
Children/grandchildren Situation	
Head(s) of household have children but no grandchildren	12.8**
	(5.0)
Head(s) of household have grandchildren	17.5**
	(5.6)
Occupation of head(s) of household	
The male's occupation involves the production of visual art[b]	−16.9*
	(7.4)
The female's occupation involves the production of visual art	5.6
	(7.1)
Neighborhood of house	
Upper-class urban (Manhattan)	−1.4
	(6.2)
Upper-middle-class suburban (Manhasset)	3.4
	(5.1)
Intercept	12.5*
	(5.2)
R^2	0.25

Note: Significance levels denoted by *$p < .05$, **$p < .01$.

Numbers in parentheses are standard errors.

[a]Omitted categories for the dummy variables are: children/grandchildren situation—no children; occupation of head(s) of household—all occupations not involved in the production of visual art/artifacts; neighborhood of house—working-class urban (Greenpoint).

[b]Occupations involving the production of visual art include photographer, filmmaker, art dealer, architect, advertising executive.

GENERAL DISCUSSION OF TABLES A-12-i and A-12-ii

In the model, the log odds of a household containing any abstract art was considered as a function of the social class of the residents (measured by the type of neighborhood in which the house is located) and other variables (the age, religion, and gender of residents). Social class is the only variable significantly related to the displaying of abstract art (tableA-12-i) in a model that is, however, on the margin of a reasonable statistical fit with the data (likelihood ratio = .05). How far such class differences in the displaying of abstract art as are revealed here can be said to reflect a basic and deep-seated taste divide between the social classes is a main topic of chapter 4.

TABLE A-12-i Analysis of variance for logistic regression of whether a house contains any abstract art

Independent Variable	Probability (chi-square)
Intercept	0.98
Neighborhood of house	0.002
Age of residents	0.95
Religion of residents	0.84
Gender of household head(s)	0.33
Likelihood ratio statistic	0.05

TABLE A-12-ii Coefficients for logistic regression of whether a house contains any abstract art

Independent Variable[a]	Coefficients
Neighborhood of house	
Working- and lower-middle-class urban (Greenpoint)	−14.0
Upper-class urban (Manhattan)	7.0
Upper-middle-class suburban (Manhasset)	4.7
Age of residents	
Under 40	0.06
40–60	−0.15
Religion of residents	
Catholic	0.10
Jewish	−0.5
Gender of household head(s)	
A man and a woman	0.5
A woman only	0.7
Intercept	−5.6

Note: Significance levels denoted by *$p < .05$ **$p < .01$ ***$p < .001$. In fact none of these coefficients was statistically significant, although note that "Neighborhood of House" is highly significant in table A-12-i.

[a]Comparison categories are: neighborhood of house—Medford (working/lower-middle-class suburban); age—over 60; religion—Protestant, mixed Protestant and Catholic, and other; gender of household head(s)—a man only.

Notes

Introduction

1. Although there are few systematic studies of the subject, there are numerous suggestions of the importance of the house in understanding art and cultural items. For example, in a study of the emergence of Impressionism, Harrison and Cynthia White pointed to the fact that most paintings in France in the 1830s and 1840s were being purchased for the homes of the bourgeoisie rather than for those of the aristocracy. This affected both the form of the art (huge ceiling paintings were too large for most bourgeois homes) and its content (panoramic battle scenes were unsuitable for bourgeois homes; genre paintings and landscapes were more suitable). See Harrison and Cynthia White, *Canvases and Careers: Institutional Change in the French Painting World* (New York: John Wiley, 1965).

The link between twentieth-century art and the house is, in fact, implicit in many studies. For example, a preface to a biography of Piet Mondrian comments: "A Mondrian painting hung in a house and room designed entirely in the spirit of Mondrian . . . is a most sublime expression of a spiritual idea." See George Schmidt, "Piet Mondrian Today," preface to Michel Seuphor, *Piet Mondrian: Life and Work* pp. 11–12. Picasso, in a famous outburst in 1945, protested: "Painting is not done to decorate apartments. It is an instrument of war for attack and defence against the enemy." But this protest implies what Picasso knew—that regardless of the artist's intention, most of his paintings and those of his artist friends are purchased to hang in homes. Anyway, that is where Picasso too hung his prized works, in his apartment and in several houses. As one account put it: "When a residence

filled up with paintings, sculptures, furniture . . . Picasso left and bought a new one" *Art News* (December 1986), p. 85. (Picasso's outburst is recorded in an interview conducted by Simone Téry published in *Lettres Françaises,* March 1945.)

2. The terms "primitive" and "tribal" art are controversial. For a discussion of my reason for using the terms, though in quotes, see the beginning of chapter 5.

3. Wassily Kandinsky, "Reminiscences," in Robert Herbert, *Modern Artists on Art* (1913; rept. Englewood Cliffs, N.J.: Prentice-Hall, 1964). On the prevalence of religious images in working-class Italian homes in inner-city Boston in the late 1950s see Herbert Gans, *The Urban Villagers* (New York: Free Press, 1962).

4. Recently, a number of writers have stressed (and critically examined) the role the public museum has played, since its relatively recent origin, in deciding what will count as Art. See Michel Foucault, "Fantasia of the Library," in *Language, Counter-Memory, Practice,* trans. D. F. Bouchard and S. Simon (Ithaca, N.Y.: Cornell University Press, 1977), pp. 87–109; Jean-Claude Lebensztejn, *Zigzag* (Paris: Flammarion, 1981); Rosalind Krauss, "Photography's Discursive Spaces: Landscape/View," *Art Journal* 42 (Winter 1982); P. DiMaggio, "Cultural Entrepreneurship in Nineteenth-Century Boston: the Classification and Framing of American Art," *Media, Cuture and Society* 4 (1982), 303–22; the various essays in George Stocking, ed., *Objects and Others* (Madison: University of Wisconsin Press, 1985); and James Clifford, *The Predicament of Culture* (Cambridge: Harvard University Press, 1988), pp. 189–251; Aldona Jonaitis, "Franz Boas, John Swanton, and the New Haida Sculpture at the American Museum of Natural History," in J. Berlo, ed., *The Early Years of Native American Art History* (Seattle: University of Washington Press, 1992).

5. The French state museums rarely bought works by living artists. See *Art News* (December 1986), p. 85.

6. For example, Nelson Rockefeller's famous collection of "primitive" art, which formed the nucleus of the Museum of Primitive Art, began as his private home collection. On the tendency even today for works to find their way into a museum only after a long period in the private house see Charles Simpson, *Soho: The Artist in the City* (Chicago: University of Chicago Press, 1981), chap. 2.

7. See Schapiro, "The Nature of Abstract Art" (1937), reprinted in Meyer Schapiro, *Modern Art* (New York: Brazilier, 1978), 2 vols. Schapiro is here criticizing Alfred Barr's *Cubism and Modern Art.* Schapiro goes on to point out that this history based on great artists, already limited in scope, is further limited in its explanation of the emergence of new styles. New styles, according to this view, emerge because the old style has exhausted itself. For example, according to Barr, artists turned to abstract art because "representational art had been exhausted."

8. For studies that locate modern/abstract artists in their social context see Irvin Sandler, *The Triumph of American Painting: A History of Abstract Expressionism* (New York: Praeger, 1970); Dore Ashton, *The New York School: A Cultural Reckoning* (New York: Viking Press, 1973); Diana Crane, *The Transformation of the Avant-Garde* (Chicago: University of Chicago Press, 1987); Stephen Polcari, *Abstract Expressionism and the Modern Experience* (New York: Cambridge University Press, 1991); Sharon Zukin, *Loft Living* (Baltimore: Johns Hopkins, 1982); and Charles Simpson, *Soho: The Artist in the City* (Chicago: University of Chicago Press, 1981). An interesting (and controversial) study that argues that abstract expressionism was heavily promoted in the United States in the few years after World War II

because it fitted the ideological interests of sections of the ruling class during the Cold War is Serge Guilbaut, *How New York Stole the Idea of Modern Art* (Chicago: University of Chicago Press, 1983).

Still, as recently as 1988, Robert Herbert complained: "Much writing about art now strikes me as history-less. Because the social matrix for art is not examined . . . art seems to beget art without the intercession of society." *Impressionism: Art, Leisure and Parisian Society* (New Haven: Yale University Press, 1988), p. xiii.

9. For example Rubin writes: "Most of the formal qualities shared by modern and tribal art may be traced to the widespread twentieth-century commitment to conceptual modes of imagining." William Rubin, ed., *Primitivism in 20th Century Art: Affinity of the Tribal and the Modern*, vol. 1 (New York: The Museum of Modern Art, 1984), p. 15.

10. This point is discussed in chapter 5.

11. Leo Steinberg, "Contemporary Art and its Public," in Leo Steinberg, *Other Criteria: Confrontations with Twentieth-Century Art* (New York: Oxford University Press, 1972). In opposing the dichotomy between creative artists on the one hand and a passive public on the other Steinberg writes of a general rule of twentieth-century art that "whenever there appears an art that is truly new and original, the men who denounce it first and loudest are artists."

12. T. J. Clark, *The Painting of the Modern World: Paris in the Art of Manet and his Followers* (New York: Knopf, 1985) and Robert L. Herbert, *Impressionism: Art, Leisure and Parisian Society* (New Haven: Yale University Press, 1988).

13. For a recent collection of essays that applies semiotics to explore a range of topics in art history see Norman Bryson, ed., *Calligram: Essays in New Art History from France* (Cambridge: Cambridge University Press, 1988). For a discussion of various ways of combining materialist and semiotic approaches see Jeffrey Alexander, pp. 2–27, in Jeffrey Alexander and Steven Seidman, eds., *Culture and Society: Contemporary Debates* (New York: Cambridge University Press, 1990).

14. There are a few well-known "living-room" studies by sociologists. Such studies make an inventory of items in the living room—furniture, drapes, type of floor, ornaments, and so on—and then attempt to predict a person's social class from these items. But these studies seldom ask people about the meaning of their art and cultural items, nor do they analyze the content of these items. For example, they rarely consider a picture's subject matter or ask what it means to people. Further, they confine the study to the living room (or "parlor"), often one of the least used rooms in the house. For these studies see F. Stuart Chapin, *Contemporary American Institutions: A Sociological Analysis* (New York: Harper and Bros., 1935), chap. 19; and Edward O. Laumann and James S. House, "Living Room Styles and Social Attributes: The Patterning of Material Artifacts in a Modern Urban Community," *Sociology and Social Research* 54 (1970), pp. 321–42.

For an excellent study of the responses of a sample of residents in a Chicago suburb to the question "What are the things in your home which are special to you?" see Mihaly Csikszentmihalyi and Eugene Rochberg-Halton, *The Meaning of Things* (Cambridge: Cambridge University Press, 1981). The authors discuss the meaning that people attach to items such as furniture, visual art, photographs, books, and stereo sets.

15. For example, Pierre Bourdieu's *La Distinction: Critique sociale du jugement* (Paris: Les Editions de Minuit, 1979), translated as *Distinction: A Social Critique of the Judgement of Taste* (Cambridge: Harvard University Press, 1984).

16. Herbert Gans, "American Popular Culture and High Culture in a Changing Class Structure," in *Prospects: An Annual of American Cultural Studies,* vol. 10 (New York: Cambridge University Press, 1986), pp. 17–38.

17. For an excellent account of many of these theories see Michèle Lamont, "The Power-Culture Link in a Comparative Perspective," *Comparative Social Research* 11 (1989), pp. 131–50.

18. For this view, see Thorstein Veblen's 1899 *The Theory of the Leisure Class* (New York: Viking Press, 1965); Quentin Bell, *On Human Finery* (New York: Schocken Books, 1978). In this view, the differences between high art and popular art may, in fact, be either trivial or profound. What is important is that those who display high art present it as different from other forms and claim that it is therefore capable of conferring social status on themselves and others who own it. Also important is that such claims are accepted as valid by others.

19. For Leavis see F. R. Leavis and Denys Thompson, *Culture and Environment* (London: Chatto and Windus, 1937). For the formulations of theorists of "mass culture," see the essays in Bernard Rosenberg and David M. White, eds., *Mass Culture: The Popular Arts in America* (Glencoe, Ill.: The Free Press, 1957); and Norman Jacobs, ed., *Culture for the Millions* (Princeton, N.J.: Van Nostrand, 1961). For some of the original Frankfurt-school formulations see Max Horkheimer and Theodor Adorno, "The Culture Industry: Enlightenment as Mass Deception," in *Dialectic of Enlightenment* (1944), trans. by John Cummings (New York: Herder and Herder, 1972); Theodor Adorno, "Perennial Fashion: Jazz" in *Prisms,* trans. by Samuel and Shierry Weber (Cambridge: M.I.T. Press, 1983). For more recent Western theorists in the same tradition see Jean Baudrillard, "The System of Objects" and "The Ecstasy of Communication," in Baudrillard, *Selected Writings,* ed. Mark Poster (Stanford: Stanford University Press, 1988); and Frederick Jameson, "Reification and Utopia in Mass Culture," *Social Text* 1 (1979), pp. 130–48. For statements by Central European intellectuals see, for example, Václav Havel, "The Power of the Powerless" (1979), in John Keane, ed., *The Power of the Powerless* (London: Hutchinson, 1985), p. 91. Havel's essay deals mostly with the workings of ideology in Soviet-dominated societies, but toward the end he discusses Western societies ("the traditional parliamentary democracies") in Frankfurt-type ways. Thus he writes that "the traditional parliamentary democracies can offer no fundamental opposition to the automatism of technological civilization and the industrial-consumer society, for they, too, are being dragged helplessly along by it. People are manipulated in ways that are infinitely more subtle and refined than the brutal methods used in the post-totalitarian societies . . . [for example by] the omnipresent dictatorship of consumption, production, advertising, commerce, consumer culture, and all that flood [sic!] of information."

20. See, for example, Raymond Bauer and Alice Bauer, "America, 'Mass Society' and Mass Media," *Journal of Social Issues* 16, no. 3 (1960); pp. 3–66; Herbert Gans, *Popular Culture and High Culture: An Analysis and Evaluation of Taste* (New York: Basic Books, 1974); Simon Frith, *Sound Effects: Youth, Leisure and the Politics of Rock'n Roll* (New York: Pantheon, 1981), chap. 3; and Daniel Miller, *Material Culture and Mass Consumption* (Oxford: Basil Blackwell, 1987). For a subtle interpretation of the relation between working-class culture and the mass media see Stanley Aronowitz, *The Politics of Identity* (New York: Routledge, 1992), chap. 5.

21. Their versions are somewhat different. For Bourdieu, see *Distinction* (cited in note

15); and "Outline of a Sociological Theory of Art Perception," *International Social Science Journal* 20, no. 4 (1968). For DiMaggio see (with Michael Useem) "Social Class and Arts Consumption: The Origins and Consequences of Class Differences in Exposure to the Arts in America," *Theory and Society* 5, no. 2 (March 1978), pp. 141–61; (with Michael Useem) "The Arts in Class Reproduction," in Michael Apple, ed., *Cultural and Economic Reproduction in Education* (Boston: Routledge and Kegan Paul, 1981); "Classification in Art," *American Sociological Review* 52 (August 1987), pp. 440–55; and (with Francie Ostrower) "Participation in the Arts by Black and White Americans," *Social Forces* 68 (March 1990), pp. 753–78. A central difference between Bourdieu and DiMaggio is that Bourdieu holds that separate tastes tend to be associated with each social class (or section of a social class). DiMaggio, at least in his recent work, holds that the taste for popular culture is common among *all* social classes, but that only members of the higher social classes also have a taste for high culture. DiMaggio also believes that the exclusionary function of high culture in the United States has been diminishing for some time, as the institutional world of culture is less and less willing to insist on sharp boundaries between high and popular culture. Some of the differences between Bourdieu and DiMaggio surely reflect actual differences in the role of high culture in France and the United States. But Bourdieu's theory does not easily fit survey data from France, which is a problem.

Some of Bourdieu's work is extremely difficult to read. This is true of his classic *Distinction*, which I use here as the main source for his theory of culture and taste. Indeed, *Distinction* moves between a somewhat extreme statement of differences between social classes (especially in the opening and concluding chapters) and a less extreme statement which recognizes overlaps to the extent that the basic distinction between a dominant and dominated culture becomes problematic. In characterizing Bourdieu's theory I have tended to rely on the more extreme statement, partly because, presented at the start and conclusion of his study, it can reasonably be taken as a summary of his view and partly because if the more nuanced statements are foregrounded it becomes less clear what the theory is. For a presentation of Bourdieu's overall (enormous) body of writings see Pierre Bourdieu and Loïc Wacquant, *An Invitation to Reflexive Sociology* (Chicago: University of Chicago Press, 1992). In "Bourdieu in America: Notes on the Transatlantic Importation of Social Theory" (in Craig Calhoun et al., eds., *Pierre Bourdieu: Critical Readings* [Cambridge, Engl.: Cambridge University Press, 1993]), Loïc Wacquant argues that Bourdieu's writings should be considered as a whole, rather than piecemeal.

22. In Bourdieu's words, "A work of art has meaning and interest only for someone who possesses the cultural competence, i.e., the code, into which it is encoded . . . a beholder who lacks the specific code feels lost in a chaos of sounds and rhythms, colours and lines." (*Distinction*, pp. 2–3).

23. In this argument, "dominant class(es)" or "upper and upper-middle classes" tends to refer to capitalists, managers, and professionals; "dominated class(es)" or "working class" or "popular classes" tends to refer to blue-collar workers and lower white-collar workers (the latter composed mainly of clerical, secretarial, and retail-sales employees).

24. See Kandinsky, *Concerning the Spiritual in Art*, trans. Michael Sadler (New York: Margin Press, 1972), first publ. as *Uber das Geistige in der Kunst* (1912); Ortega y Gasset, *The Dehumanization of Art* (1925), reprinted in *Velasquez, Goya and the Dehumanization of Art*, trans. Alexis Brown (New York: Norton, 1972); Clement Greenberg, "Avant-Garde and

Kitsch," (1939), reprinted in *Art and Culture: Critical Essays* (Boston: Beacon Press, 1961); Leo Steinberg, "Contemporary Art and its Public," (1962), reprinted in *Other Criteria* (New York: Oxford University Press, 1972).

25. For the figures cited see Ford Foundation, *The Finances of the Performing Arts: A Survey of the Characteristics and Attitudes of Audiences for Theater, Opera, Symphony, and Ballet in 12 U.S. Cities,* 2 vols. (New York, 1974). The same pattern emerges from other surveys of involvement in culture and high culture in the United States. Involvement with high culture does vary with socioeconomic level, above all with level of education. Those with college degrees are more likely than those without to have *some* interest in high culture. Yet only a minority of even the college-educated population spend much of their leisure time in these ways. For example a study of men in a variety of occupations in Detroit found that, though only 1% of blue-collar workers read a "quality" newspaper every day, only 11% of engineers did so either. Even among professors and lawyers, a highly educated group, only a minority read a "quality" newspaper (42% of all professors and 36% of all lawyers). See Harold Wilensky, "Mass Society and Mass Culture," *American Sociological Review* 29 (April 1964), pp. 173–97. See also John Robinson, *How Americans Use Time* (New York: Praeger, 1979), p. 159. Likewise, a review of the data collected in the 1982 (U.S.) Survey of Public Participation in the Arts (S.P.P.A.) reported: "Participation in most activities was low. [During the last 12 months] fewer than 5 percent of all respondents attended an opera or ballet performance or performed in public; fewer than 10 percent attended a jazz concert, practiced creative writing, or confessed to enjoying opera." See Paul DiMaggio and Francie Ostrower, "Participation in the Arts by Black and White Americans," *Social Forces* 68 (March 1990), pp. 753–78. Richard Peterson and Albert Simkus, also using the S.P.P.A., show that there are certain associations between occupational groupings and musical tastes. But these associations are much looser than cultural-capital theory implies. For example, no more than 29% of any occupational group named classical music—the paradigm of high musical culture—as their favorite music. See Richard Peterson and Albert Simkus, "How Musical Tastes Mark Occupational Status Groups," in Michèle Lamont and Marcel Fournier, eds., *Cultivating Differences* (Chicago: University of Chicago Press, 1992) chap. 7.

26. See, for example, *Distinction,* chap. 5. For a careful, multivariate analysis of data collected by the French census bureau (Institut National de la Statistique et des Etudes Economiques) that finds that parental (actually father's) education, when used to measure the cultural milieu in which an individual grew up, is less important in determining access to positions of ownership and management (especially ownership) than Bourdieu's theories imply, see Robert Robinson and Maurice Garnier, "Class Reproduction among Men and Women in France: Reproduction Theory on Its Home Ground," *American Journal of Sociology* 91 (1985), pp. 250–280. For critical discussions of the dubious fit between Bourdieu's theory and his data see Stanley Lieberson, "Einstein, Renoir, and Greeley: Evidence in Sociology," *American Sociological Review* 57 (February 1992), p. 1–15, and John Hall, "The Capital(s) of Cultures," in Lamont and Fournier, *Cultivating Differences* (cited in note 25). See also Michèle Lamont and Annette Lareau, "Cultural Capital: Allusions, Gaps and Glissandos in Recent Theoretical Developments," *Sociological Theory* 6 (Fall 1988), pp. 153–68.

For a broadening of Bourdieu's argument involving the claim that, in addition to familiarity with high culture, other cultural traits, especially moral traits (such as honesty and respect for others) and social traits (such as power and membership in certain social clubs),

are important for gaining access to dominant-class circles, and for an interesting attempt to specify which such traits are most valued in the United States and France see Michèle Lamont, *Money, Morals, and Manners* (Chicago: University of Chicago Press, 1992).

27. Paul Goldberger described the Hamptons as "perhaps the wealthiest second-home communities in the world . . . towns full of city folk who earned their money elsewhere and chose to display it here." See *The Houses of the Hamptons* (New York: Knopf, 1983). Several of the houses in the section where I interviewed were badly damaged during storms in the winter of 1992–93.

28. The head(s) of household of five of the twenty households sampled in Spinney Hill were born in the Caribbean, and in one other case were an interracial couple. The head(s) of the other households sampled were blacks born in the United States.

29. For example, a company director's first wife knew many of the major figures on the French art scene (her grandmother had been Raoul Dufy's mistress). Braque, a family friend, painted a wedding portrait for them, and the husband had bought the works of pop artists such as Warhol and Lichtenstein before they became famous. Another respondent, a female lawyer, heads the committee at work that purchases art for her firm's offices.

30. Many of the houses were built during the real-estate boom that began in New York in the late 1870s and ran into the 1890s.

31. When, after the 1900s, town-house living became unfashionable by comparison with a house in the suburbs or an apartment in a modern, high-rise building, many of these houses were divided into several small apartments.

32. Early industrial development in Greenpoint, from the 1830s on, was based on ship-building, glass, and pottery. The factories were located along the water—the East River and Newtown Creek. Residential areas grew up a little inland, along a rim within the northern and western part of the land. The houses were varied: substantial row houses for the owners and managers of the factories and businesses, smaller row houses and walk-up apartment houses for the factory workers. The ethnicity of the residents at this time was mainly English, Irish, Scotch, German, and Scandinavian.

Later, in the 1880s and 1890s and first quarter of the twentieth century, heavier industry, including several oil refineries, entered. More houses were built inland, including many inexpensive wood frame houses for the factory workers, and new nationalities came in, from southern and eastern Europe, especially Poland and Italy. Most of the houses from which the sample for this study was selected were built in this period.

For much of this history see Henry R. Stiles, *The History of the County of Kings and the City of Brooklyn, New-York* (New York: W. W. Munsell and Co., 1884); William L. Felter, *Historic Greenpoint* (Brooklyn: Green Point Savings Bank, 1919); and New York City Landmarks Preservation Commission, *Greenpoint Historic District Designation Report* (New York: Designation List 159, LP 1248), September 14, 1982.

33. Since this study focuses on adult homeowners, it deals with the somewhat well-to-do sections of the working and lower-middle class. For a study that concentrates on poorer residents of Greenpoint see Ida Susser, *Norman Street: Poverty and Politics in an Urban Neighborhood* (New York: Oxford University Press, 1982). For a study of Greenpoint teenagers from mostly poorer families see William Kornblum and Terry Williams, *Growing Up Poor* (Lexington, Mass.: Lexington Books, 1985).

34. The entire area studied is bounded by Greenpoint Avenue to the north, Kingsland

Avenue to the east, Grand Street to the south, and Manhattan Avenue and the Brooklyn-Queens Expressway to the west.

35. For an example of this erroneous view that Greenpoint is synonymous with the small section of brownstones being gentrified north of Greenpoint Avenue see *The New York Times,* August 1, 1986, p. A14.

36. Thus the Landmarks Preservation Commission complained in the document justifying the designation of this section of Greenpoint as a "Historic District": "A cause for concern today is the 'modernization' of houses by the application of spurious veneers. . . . Such changes and 'improvements' create jarring notes in otherwise harmonious rows of houses. Ill-conceived improvements almost always result in an erosion of architectural quality. Historic district designation of Greenpoint will help to insure the protection of the area's distinctive architectural quality." *Greenpoint Historic Designation Report,* p. 15. The judgments implied here are breathtaking for their ignorance not only of the dynamics of life in these neighborhoods, but also for their lack of appreciation of the changing history of tastes.

To the casual observer and to experts such as those involved in historic preservation, the colorful external facades with which most working-class residents in Greenpoint encased their wood frame homes from the 1940s to the 1970s exemplified a basic difference in taste between the social classes. According to this view, working-class taste, either because it is uneducated and therefore ignorant of the value of history or because it is uninhibited by middle-class inhibitions (which sort of explanation is preferred depends largely on the observer's politics), led to the covering of the original, somber and uniform, wood facades of these houses with brightly colored siding, creating a blaze of color in the street. Middle-class taste disapproved, which led to the creation of a historic district designed, in part at least, to preserve the rest of the neighborhood from such a fate.

The truth is more complex. I have already mentioned that covering these houses with siding was, for residents, the only practical way to preserve them. Neighboring houses are covered in *different* color siding from one another mainly because residents made individual decisions to renovate, at different times, as opposed to one builder constructing an entire street; and some residents chose colorful siding because they wanted a "modern" look.

For most of this period, the middle class and cultural elite paid little or no attention to these urban houses. City row houses had become increasingly unfashionable from the last quarter of the nineteenth century, as the wealthy and middle class moved outward to new, detached houses in the suburbs, or upward into new and fashionable high-rise apartment buildings in the city. (At this point, the idea of creating a "historic district" to preserve urban row houses was unheard of.) Later, in the 1960s and beyond, interest in row houses revived among the middle class. And together with this came the start of the idea that the "original" look of these houses had aesthetic merit. This perception gained ground as the price of urban row houses rose. Indeed, it is hard to separate the aesthetic perception that original-looking row houses have value from the economic context that increasingly prized such houses. It was in this context that sections of the upper-middle class began to criticize the taste of working-class residents of areas such as Greenpoint who had repaneled the exterior of their wood frame homes in bright aluminum siding. Sections of the cultural avant-garde led the attack on an implied "working-class taste" (actually lack of it) which had "modernized" rather than restored these urban houses. In an ironic footnote, by the late 1980s working-class perceptions in Greenpoint had caught up with the new middle-class views. Above all, working-class residents now saw that "restored" houses had a higher market value than

"transformed" houses. As a result, many of these working-class residents came themselves to regret having "modernized" the exteriors of their homes, and to prize the "original" look. This case study exemplifies many of the pitfalls involved in too easy proclamations of the discovery of taste differences between the social classes, especially if these taste differences are to form the basis for grander theories about the role of cultural differences in class domination. For much of the research on which this discussion is based see Camilo Vergara, David Halle, Kenneth Jackson, and Lisa Vergara, *Transformed Houses* (Washington D.C.: Smithsonian Institution, 1983).

37. From 1890 until the 1930s some of the richest residents of New York City bought land around the North Shore of Long Island and built lavish estates with often fanciful mansions. The most notable of those in or near the areas studied included an Irish stone castle (the Guggenheim estate in Sands Point), a French chateau (the structure built by Louis Sherry in Manhasset, in imitation of the Petit Trianon in Versailles), and a reproduction of a Georgian brick manorial home (the Phipps house in Old Westbury). At the same time developers bought farmland which they subdivided into suburban homes for the upper-middle class and middle class. The Long Island Railroad was extended to Manhasset by 1897; and the Manhasset station was improved for daily commuting to New York City in 1925. Later, the fashion for estates passed, but the appetite among the middle classes for a house in the suburbs grew, so most of the estates were sold, subdivided, and covered with houses. In a few cases a section of an estate was preserved as a country club for the new middle-class residents. Occasionally a developer spared a "historic" home. Levitt, having built middle-class homes on the Onderdonk estate in Manhasset, gave the four-columned Greek revival Onderdonk home (built in 1836) to the owners of his new homes.

38. There was an old black community, around Spinney Hill in Great Neck adjoining the Western border of Manhasset; this remained as the "black section," and parts of it were developed with suburban homes for well-to-do blacks. One black couple did buy a home in the white section of Manhasset in the 1950s; eggs were thrown at the house at night, until they were induced to leave.

The Levitt homes built on the old Onderdonk estate in Manhasset were deeded to exclude Jews, who moved into adjoining Great Neck in large numbers.

The desire to exclude apartment dwellers was actually the origin of Plandome, Plandome Heights, Flower Hill, and other adjacent villages, which were once all part of Manhasset. In the 1920s and 1930s residents of various sections of Manhasset, alarmed by proposals to build blocks of apartments there, voted to incorporate themselves into separate villages—hence the origin of Flower Hill, Plandome Heights, Plandome Manor, Munsey Park, and North Hills. Each village was now too small to support a sewer system, as was the rump of Manhasset, and without a sewer system no apartments could be built. This prevented the construction of apartment buildings until, to many residents' displeasure, a few years ago some were built south of Northern Boulevard. For the history of Manhasset see Frances Bourguet, ed., *Manhasset: The First 300 Years* (Manhasset: Manhasset Chamber of Commerce, 1980).

39. On the winding lane as a feature of the nineteenth-century suburb that was specifically intended to distinguish it from the urban gridiron see Kenneth Jackson, *The Crabgrass Frontier* (New York: Oxford University Press, 1985), chap. 4.

40. Many of the first residents had been commuting long distances from Brooklyn and Queens in New York City to jobs on Long Island.

41. In some cases the welfare department bought houses and moved in welfare families.

In 1992, there was a highly publicized incident in which a two-foot-tall cross, doused in gasoline, was set aflame on the front yard of a black family's house in Medford. See *New York Times* (Metro) September 28, 1992, page B5.

42. In fact, a few rental households appeared in the sample, and I interviewed them anyway. See table A-5.

43. The "response rate" here refers to the percentage of interviews obtained with at least one head of household in each residence drawn on the sample. The response rates for each area sampled are as follows: Medford, 68%; Manhasset, 65%; Greenpoint, 60%; Manhattan, 54%. In Greenpoint the response in the predominantly Polish section was 69% while that in the predominantly Italian section was 39%. For the two smaller samples: Spinney Hill, 47%; the Hamptons, 44%.

44. Camilo Vergara, David Halle, Kenneth Jackson, Lisa Vergara, *Transformed Houses* (cited in note 36). For the *New York Times* review see Paul Goldberger, *On the Rise: Architecture and Design in a Postmodern Age* (New York: Penguin Books, 1983).

45. We developed these techniques in pilot interviews. During the interviews, I wrote down what people said as we talked. The interviews were based on a schedule composed of both open- and closed-ended questions. However, I was flexible about the order in which I introduced the topics in each interview. In particular, when respondents started showing us around their house, I would ask about items and topics as we encountered them. If, for example, we came across an abstract painting, I usually asked about it, and about the respondent's attitudes to abstract art, right then.

46. On a number of occasions, for example, a respondent would tell us early in the interview that he or she had no examples of a particular category of art, yet when the house tour began we would discover (and he or she might remember) that this was not so.

47. This notion of "original" can, of course, be problematic, and collapses almost entirely when photographs are referred to. Great photographs can be mass produced from the negative. On this see Walter Benjamin, "The Work of Art in the Age of Mechanical Reproduction" (1936), in *Illuminations,* trans. Harry Zohn (New York: Schocken Books, 1969); and Rosalind Krauss, "The Originality of the Avant-Garde," in *The Originality of the Avant-Garde and Other Modernist Myths* (Cambridge: MIT Press, 1985). See also Howard Becker, *Art Worlds* (Berkeley: University of California Press, 1982).

Chapter One

1. The historical account that follows is based on study of the original floor plans for houses in and around the area sampled, together with records of any later changes to the houses. (This material is on file in the New York City Department of Buildings.) The account also relies heavily on Charles Lockwood, *Bricks & Brownstone: The New York Row House, 1783–1929, An Architectural and Social History* (New York: McGraw Hill, 1972). I also studied such contemporary magazines as *House and Garden, House Beautiful,* and *Carpentry and Building.* For general histories of American houses in the nineteenth century see Elisabeth Garrett, *At Home* (New York: Harry Abrams, 1990) and David Handlin *The American Home* (Boston: Little, Brown, 1979).

The basic layout of Manhattan town houses of the 1880s had changed little since the 1820s. The main change during this period was the shifting of the dining room from the

basement to the rear first floor, associated with the introduction of the dumbwaiter into large row houses in the 1850s and 60s.

2. On the centrality of the doorway in nineteenth-century New York brownstones see Lockwood, passim. In his classic study of Japanese houses, written in 1883, Edward Morse contrasted the entrances and front doors of ordinary houses in the United States and Japan. As he wrote: "With us [the United States], the commonest house in the city or country will have a definite front-door, and almost always one with some embellishments, in the shape of heavy panels, ornate brackets and braces supporting some sort of covering above, and steps approaching it equally pretentious. . . . In the ordinary Japanese house, on the other hand . . . the entrance is often vaguely defined; one may enter the house by way of the garden . . . or by an ill-defined boundary near the kitchen." See Edward Morse, *Japanese Homes and Their Surroundings* (first publ. 1885), pp.234–35. As late as 1920 *House and Garden* wrote: "A doorstep is a mark of hospitality, a stage in the approach to the house. Consequently, it should be wide and generous and, if space and design permit, afford a bench for guests to sit upon and where the owner can linger on pleasant days." "The Doorstep Makes the House," *House and Garden* (February 1920), p.38.

3. Kenneth Jackson, *Crabgrass Frontier: The Suburbanization of America* (New York: Oxford University Press, 1985), chap. 3. Jackson's comment, though made about pre–Civil War urban backyards, would certainly have applied to the backyards of well-to-do town houses well into the twentieth century.

The lack of interest of residents in the backyard applies to the well-to-do and the rich. On the other hand the middle- and working class sometimes used their backyards for growing food and keeping animals. For more on this see note 28.

4. "According to prescriptive literature, fiction, illustrations etc. . . . the parlor's interior represented the best the family could afford." Sally McMurry, "City Parlor, Country Sitting Room: Rural Vernacular Design and the American Parlor, 1840–1900," *Winterthur Portfolio* 20 (1985), pp. 261–80. By the nineteenth century, the division between a front parlor and a back parlor was standard, at least in New York City row houses. The front parlor, located next to the formal front door and hallway, was for formal activities, for receiving guests. The back parlor was where the informal life of the family took place. Later in the century, with the invention of the dumbwaiter to take food from the basement to the floor above, the dining room was moved upstairs to replace the back parlor. See Lockwood, *Bricks and Brownstone* (cited in note 1).

Althought the parlor, copied from England, was well established as the "best room" in America by the colonial and early national period, it had been a recent development in England, at least for those outside the aristocratic dwelling. Its appearance there had marked the emerging public/private, intimate/formal distinction which was just beginning to reshape the dwelling and the family's social life. See John Demos, *A Little Commonwealth: Family Life in Plymouth Colony* (New York: Oxford University Press, 1970), chap. 2.

5. On the third floor were other family and guest bedrooms.

6. Lockwood, *Bricks and Brownstone* (cited in note 1), p. 182.

7. The front basement room was used variously as a servants' sitting room, an informal dining room, a smoking room, and occasionally an office or nursery.

8. The East Side residents sampled rarely spend time in front of the house, and sitting on the front stoop, where it exists, is almost taboo. In part this is because of notions of

privacy, shared with most residents of the upper-middle class suburbs studied. In part it is because of notions, also shared with many residents of the upper-middle-class suburbs, that such behavior is what characterizes working-class and lower-class people and their neighborhoods. And in part it is because on and around the streets is a continual flow of working- and lower-class people—housekeepers, babysitters who work in the surrounding houses, delivery people, blue-collar workers such as maintenance people and drivers, and panhandlers and homeless people. Few of the East Side residents sampled wish to prolong this contact with people of lower social classes and other strangers by spending time in front of the house. One resident commented: "Here, if someone is sitting on the stoop, it's a bag lady." Another explained why she shunned the front: "There's nowhere to sit, and it's not done here. I don't dress very elegantly and someone might think I'm a day worker."

9. The entry up the front stoop is routinely used in only two kinds of houses. One kind is where the ground floor (now called "first floor") serves as an office, with the residential sections of the house starting on the second floor and above. The other kind is where the upper floors are rented out, so that the stoop provides a separate entrance for the tenant.

10. The stoop was removed in many of these brownstones as early as the first twenty years of the twentieth century (partly as a result of criticisms of the excessive formality of the front parlor). Sometimes this left a single entrance for servants and tradespeople and family/ guests alike on the basement level. Sometimes a second entrance for the family was created on the basement level.

11. Six feet is standard; much higher may be seen as unsociable or unnecessary. One resident explained how his neighbor, the film director Mike Nichols, wanted to raise the six-foot fence to ten feet. The resident thought this was unsociable and persuaded Nichols to leave the existing fence intact.

12. These comments give an idea of the value most residents attach to their contemplative gardens. A man in his late fifties: "A garden gets you out of New York, even when you're there. It's one of the luxuries, to sit in a garden in the city." A woman in her early sixties: "You're nearer God's heart in a garden than anywhere else on earth. It's so peaceful and remote. And it's something you can make so beautiful so easily and quickly."

13. Ten yards are dominated by children. However, a number of these gardens do manage to cultivate some flowers and bushes around the perimeter.

14. Sixty-two percent of these residents have a summer home, and 12% have two. Many of these summer homes are located on the fashionable eastern fork of Long Island in the Hamptons and in nearby areas such as Quogue; others are scattered around in places such as Martha's Vineyard in Massachusetts, Florida, a small island (owned entirely by the family) off the Connecticut coast, and a village in France. Of the residents who own vacation houses, almost half have some kind of vegetable garden there, and many described their vegetable garden as thriving.

15. "Suburbanization" can be defined in various ways. Its spatial and demographic features are well captured by a definition that dates its start from about 1815 and sees suburbanization as involving both the practice of a daily commute from home on the periphery to work in the urban core and the expansion of the periphery at a more rapid rate than the core. See Kenneth Jackson, *Crabgrass Frontier.* There was, of course, nothing new about prizing the countryside for its scenic and aesthetic qualities. What was new was the tendency for this notion to push aside a notion of the countryside as valuable for what it could produce. On

the mushrooming, in the seventeenth and eighteenth centuries, of a nonutilitarian attitude toward the natural world (animals, trees, flowers, and the landscape) see Keith Thomas, *Man and the Natural World: Changing Attitudes in England 1500–1800* (New York: Allen Lane, 1983).

16. The extension of suburban ideals to the city was well under way in the nineteenth century. As early as the 1840s, the rising Romantic appreciation for "natural" countryside affected the design of row houses in New York City. There was, for example, the development of "garden blocks" of houses which, instead of being close to the street, were situated twenty or thirty feet back, to give the front a picturesque, countryside feeling. Around the same time, cast-iron verandahs, which denoted the countryside, appeared on some row houses, especially those facing a park (for example, Gramercy Park). See Lockwood, *Bricks and Brownstones,* chap. 2.

The construction of Central Park in Manhattan in the 1850s was a striking reflection of the impact on the American city of the new image of suburban life and of nature. For Frederick Olmsted, urban parks such as Central Park were a way of bringing the advantages of the suburbs to city dwellers. "We want a park," he wrote, "where people may . . . see nothing of the hustle and bustle and jar of the streets . . . where they shall, in effect, find the city put far away from them." Rejecting the idea of a park with rugged terrain and dramatic hills as too wild, connoting too much effort, Olmsted stressed the need for a calm and tranquil scenery. "The beauty of the park should be the beauty of fields, meadows, prairie, green pastures, still waters. What we want to gain is tranquillity and rest to the mind. Mountains suggest effort." See Frederick Law Olmsted, *Public Parks and the Enlargement of Towns* (Cambridge: Riverside Press, 1970; rept. New York: Arno Press, 1970). See also Roy Rosenzweig and Elizabeth Blackmar, *The Park and the People: A History of Central Park* (Ithaca: Cornell University Press, 1992).

17. Although most of the East Side houses sampled were originally never intended for the well-to-do, but for the middle class or better-off members of the working class, nevertheless in their layout they mostly mirrored the well-to-do houses, on a much smaller scale. In that sense, if their current residents, who are well-to-do, wished to replicate an older layout and its accompanying life-style, they could easily do so.

18. For the classic study of servants during this period see David Katzman, *Seven Days a Week* (New York: Oxford University Press, 1978). See also Ruth Schwartz Cowan, *More Work for Mother* (New York: Basic Books, 1983) and Susan Strasser, *Never Done: A History of American Housework* (New York: Pantheon, 1982).

19. For the classic history of Western attitudes to privacy see Philippe Aries and Georges Duby, *Histoire de la vie privée,* 5 vols., (Paris: Seuil, 1985–87).

20. Le Corbusier, *Towards a New Architecture* (1921) (New York: Dover Publications, 1986), pp. 114–15.

21. The separation between kitchen and dining room was traditionally underpinned not just by the social difference of servants who would cook food which would be formally served to the residents in a dining room, but also by the technological fact that before modern ventilation systems the cooking smells generated in the kitchen were hard to control. These smells were, in fact, typically viewed as highly undesirable. See, for example, Girouard, *Life in the English Country Home,* (New Haven, Yale University Press, 1978). In some well-to-do houses the kitchen and dining room were in separate buildings, and in extreme cases the

two buildings were quite distant from each other. For example, in some southern Colonial homes the cooked food was transported on bicycles to the dining area. A fictional, but revealing, example of the axiom that in well-to-do homes the kitchen personnel operate totally separately from the residents comes in "The Hound of the Baskervilles." Sherlock Holmes and Watson are watching, from outside, a well-to-do house where a dinner party is in progress. They believe that as soon as the hostess leaves the dining room for another location in the house, she is in danger of being murdered. They assume they will know when she leaves the dining room since the lights will go on in another room. However, during all of their surveillance the lights are also on in the kitchen. This is all right, for it is axiomatic that the hostess could not be in the kitchen with the servants, at least not during a dinner party. See A. Conan Doyle, "The Hound of the Baskervilles."

22. On the prevalence of this layout also in the houses of the well-to-do and avant-garde in the Hamptons see Paul Goldberger, The Houses of the Hamptons (New York: Knopf, 1983).

23. Starting in the last quarter of the nineteenth century, the urban parlor came under increasing criticism for its excessive formality, for its emphasis on conspicuous consumption, and for its inappropriately reserving the best furnishings for visitors rather than for the family. These criticisms had already been leveled against the rural parlor from the 1850s. See Sally McMurry, "City Parlor, Country Sitting Room." Thus the formal front parlor, isolated from the other rooms of the house, tended to give way to a somewhat less formal "living room."

24. Where the formal front stoop remains, the grand entrance up a flight of stairs into the formal reception rooms remains an option, for parties and so on.

25. In these houses, the family bedrooms are now usually on the top two floors. Some of the houses have elevators, in which case the master bedroom is generally on the top floor. (Elevators, which had first appeared in luxury apartment buildings in America in the 1870s, began to be introduced into New York town houses from the 1900s.)

26. For young people and teenagers the front stoop was an arena for courting.

27. Elizabeth Smith, Greenpoint: A Study of a Brooklyn Neighborhood (New York: Brooklyn Council for Social Planning, 1940).

This public life is now viewed with nostalgia by many middle-class critics of the dominance of the automobile in post–World War II suburbia. However, two, three, and four generations ago it was the object of much middle-class disapproval; urban street life then was viewed as unhealthily crowded and a breeding ground for "vice and crime." Much of the parks movement, as it developed in America in the second half of the nineteenth century and in the early twentieth century was driven by a critical view of urban street life. Urban parks would provide not only fresh air but also a calm contrast with the unhealthily bustling and egoistic nature of urban life and would draw people away from the "grog shops and worse places." See J. Frederick Law Olmsted, Public Parks and the Enlargement of Towns (cited in note 16).

28. Urban backyards in nineteenth- and early twentieth-century America seem likewise to have been either mostly unused or devoted to production of food. Writers who stress the food-producing function are Susan Strasser, Never Done, chap. 1, and Gwendolyn Wright, Building the Dream, chap. 2. On the other hand Margaret Byington's account (early twentieth century) suggests that many urban working-class yards were too small (especially after backyard structures had been added) to grow anything much. The Lynds' account of Middletown suggests that by the 1920s urban yards were shrinking in size and kitchen gardens were on

the wane. See Margaret Byington, *Homestead* (New York: Charities Publication, 1910), and Robert Lynd and Helen Lynd, *Middletown* (New York: Harcourt, Brace and World, 1929), chap. 9.

29. Although the discussion that follows will focus on the row houses, the points made are relevant, mutatis mutandis, to the detached houses sampled.

30. For this epithet see Kenneth Jackson, *Crabgrass Frontier,* chap. 3. Still, the result of Downing's work and writings was to popularize the suburban cottage to which even working men could aspire.

31. In winter it was usually a cold place, since the fireplace or heating stove was lit only when the room was in use.

32. For a discussion of boarding and lodging as common practice in colonial American families, as well as among the middle and working classes in nineteenth- and early twentieth-century urban America, see John Modell and Tamara Hareven, "Urbanization and the Malleable Household: an Examination of Boarding and Lodging in American Families," in *Family and Kin in Urban Communities, 1700–1930,* ed. Tamara K. Hareven (New York: New Viewpoints, 1977). See also Susan Strasser, *Never Done,* chap. 8.

33. In a feeble gesture toward the old decorated front door, a number of the contractors who installed aluminum siding gave residents a free small awning to go over the door.

34. The recreational backyard is new, dating from after World War II. Thus although in the 1920s and 1930s, as auto traffic grew, being hit by a car was added to the list of the dangers of street life, the proposed cure for the dangerous aspects of street life was another form of public life—parks, especially playgrounds. The backyard was not yet seen as an important arena for recreation. A study of social life in Greenpoint in 1940 stressed the inadequate recreational facilities for children. The suggested solutions were all public or quasi-public: either more playgrounds or more, and more receptive, social clubs for children and teenagers. Not once did the author mention backyards as a solution. See Elizabeth Smith, *Greenpoint.*

Parts of this earlier public street life do remain, so that public street life is distinctly more vigorous than in the upper-middle-class suburbs of Manhasset or in urban Manhattan. Thus, social life is confined to the rear for only half the houses in this sample. In the other half, social life is divided between the front and the rear. One woman in this category commented: "In summer you sit outside in the front and talk to each other [neighbors]. And when you get tired of talking to people in the front, you go to the back and talk with the same people [over low fences]." An Italian man in his mid-sixties has a backyard that provides a shady place to sit, but he also likes to spend time in front of the house, sitting on a chair and walking up and down and talking with friends and neighbors.

Still, whatever social life occurs in the front in Greenpoint is much reduced compared with the past. Nor do the streets teem with children. Children still play stickball on the streets, but these games are occasional, usually involve small groups of three or four (as opposed to entire blocks), and rarely attract much attention from the adult residents.

Further, among children in Greenpoint, certain activities that once took place on the streets have now reemerged, in modified form, confined to special park areas and controlled by adults. Little League is an example of the successful replacement of one form of public life with another that is more controlled. Thus Little League takes place far from the neighborhoods in an isolated field at the eastern end of Greenpoint, near the Creek. The field adjoins the huge gas tanks of the Brooklyn Union Gas Company, who donated the land for Little

League. The teams are organized by age group, not by street or block, and are closely super-
vised by parental volunteers. A ceremonial march of all the teams through central Greenpoint
starts the season, and offers a distant echo of the once dominant block and neighborhood
contests.

The white working class has not abandoned the park entirely. Groups of older Italian
and Polish men cluster during the summer around the southern fringes of the park, playing
cards on benches under the shady trees. And, especially on weekends, parents wheel their
infants and toddlers around the park.

But park life is no longer a major arena for family leisure among the white ethnic work-
ing class. McCarren Park, for example, is now dominated by Hispanic and black youngsters
playing organized team sports, especially baseball and football. Many of these young people
live in rented apartments to the north of the park.

Many white ethnic adults have clearly abandoned the park for their backyards. A turning
point was the demise of the public pool. In the 1970s it was closed because of vandalism and
it remains closed, surrounded by a barbed-wire fence. (It was after the closing of the pool
that many of the residents sampled began to acquire private pools in their backyards.) Some-
how, a few rusting cars have been left inside the pool, where they lie on a blue-painted bed
of cracked concrete. McGolrick Park too suffered from vandalism in the 1970s. The large
wooden pavilion was burned down. A few years ago it was renovated, but the public concerts
were not resumed. McGolrick Park is now used as a play area for young children and as a
place around which parents can wheel their infants.

For a subtle analysis of social and interpersonal ties in another contemporary urban
working- and lower-middle-class neighborhood (East New York, Toronto) see Barry Wellman
et al., "Networks as Personal Communities," in Barry Wellman and S. Berkowitz, *Social
Structures* (Cambridge: Cambridge University Press, 1988).

35. The remaining houses do not fall easily into a single category. For instance, four
houses have gardens that are about half fruit and vegetables and half other uses (usually
flowers and a patio).

36. An excellent sociological study of working-class gardens in France is Françoise Du-
bost, *Côté Jardins* (Paris: Scarabée, 1984). Dubost studied three neighborhoods—two were
in the pre–World War II suburbs of Paris and the third was in a rural area on the outskirts of
Lyons. She found that here too the productive working-class urban kitchen garden was de-
clining. Thus in the two Paris neighborhoods, workers rarely say that they are cultivating
vegetables out of necessity. Instead they insist their motives are "just to have something fresh
to eat," and they use fashionable ecological phrases such as "at least (what we grow) is not
treated with chemical fertilizer." In one of these Paris neighborhoods, as in the rural section
outside Lyons, the pleasure garden and its accoutrements (lawn, pond, flowers, plastic ani-
mals) typically take up as much space or more than the kitchen garden. (The other Paris
neighborhood consists of ninety plots designated by the authorities specifically as kitchen
gardens.) See Dubost, chap. 5.

In fact, the kitchen garden (as an economically productive space rather than as a leisure
pursuit or an exercise in the "appreciation" of nature), in urban and suburban America was
already on the decline by the early 1900s, when this section of Greenpoint was developed, as
a result of the increase in commercially canned goods, the development of refrigeration and
cold storage, and the increasingly rapid transportation of food. One indicator of this in Green-

point was the phenomenon of children's gardens, organized by the Brooklyn Parks Department in the 1910s and 1920s. A section of McCareen Park contained the largest children's garden in Brooklyn. An acre of land was divided into five hundred plots, each assigned to a child. The children were taught the names of various seeds and how to cultivate a garden. "When the first seedlings appear, the little farmers are shown how to cultivate, weed . . . They realize the fact that the vegetable garden can be a thing of beauty if artistically planned and planted. . . . The average value of the products of a plot was $8.95. The inestimable value is the physical, intellectual, spiritual development of the child." *The Annual Report of the Department of Parks, Brooklyn, 1928,* p. 46.

37. Exceptions include one case where an uncle of the married couple has a room in their household and another case where a married son and his family live on the upper floor of a house while his parents live below, with no formal separation between the residential space of the two sets of families.

38. In his study of working-class Italian Americans in Boston in the 1950s, Herbert Gans stresses that there too people prefer that each apartment be inhabited only by the nuclear family, though other relatives often live close by. See Herbert Gans, *Urban Villagers: Group and Class in the Life of Italian-Americans* (New York: Free Press, 1962).

39. Just over half of these consist of adult married (or once married) children living in the same house as one set of parents, and most of the rest consist of adult siblings living in the same house.

40. In only two households sampled do the adults regularly sit in front of their house. When elderly and infirm, the mother of a Manhasset woman came from urban Brooklyn to live with her daughter. The old lady used to sit in front of the house, as she had done in Brooklyn. She would make sarcastic comments when her daughter came home from work, such as "I saw two cars today!" A man in Flower Hill, in his early thirties, discussed the decline of the front:

> My mother [who grew up in Greenpoint] sits in front from time to time, and sometimes my wife and I sit in front with her. But we also sit in the back a lot [where they have a built-in swimming pool]. We're the only people in this section who sit in the front. [Why has this shift to the back occurred?] It's the loss of neighborhood. Each house is an island; here you have to make playdates with kids. I grew up in Queens, and when you'd walk outside the kids would all be there.

41. For a perceptive study that sees this "cordial detachment" as central to modern suburban life see M. P. Baumgartner, *The Moral Order of a Suburb* (New York: Oxford University Press, 1988).

42. Twenty-five percent of the residents grew up in working- or lower-middle-class neighborhoods of New York City; Another 35 percent grew up in small towns. These people typically contrasted the public street life of the areas in which they grew up with the restrained social life of the suburbs. For example, a woman of Italian origin: "People aren't very friendly here. In the Bronx people spent a lot of time outside the house, in front, but here they don't have time to sit in front." A woman in her mid-fifties who grew up in a small mining town commented, "We used to sit on the porch. I miss the porch. You see the people pass by." A woman in her mid-forties who grew up in the small town of Amsterdam, New York: "Growing up I lived in my grandfather's house. They had those big old houses with

beautiful porches in the front. People would sit in the front. But then they didn't have barbecues and swimming pools like they have now."

43. Other reasons include the lack of anything interesting to look at, and the lack of anywhere, such as a stoop or porch, to sit on. A man of Italian origin explained why he spent little time in front of the house: "In Brooklyn [where he lived before] you've got a lot going on—kids on bikes, neighbors, maniacs with race cars. Here it's quiet; you don't see anyone passing by."

44. Sometimes adults are drawn into the children's activities. For example, on one block every Friday the men and boys play softball against each other.

Many residents commented that social relations had been less private in the early days of this suburb. Few fences existed between houses, and neighbors were more friendly. There are several reasons for this. Perhaps the most important is that a brand-new development, where everyone is a new resident, fosters efforts to get to know a range of residents which fade as people settle in and decide with whom they wish to be friendly. Herbert Gans documented some of this, for the new suburb of Levittown. See Herbert Gans, *The Levittowners* (New York: Pantheon, 1967).

45. The notion that white working-class residents are more likely than white upper-middle-class residents to oppose violently the movement of blacks into their neighborhoods may simply reflect the fact that such in-movements of blacks are more likely to occur in the (more affordable) working-class neighborhoods. Certainly there are examples, well-known in the neighborhood, of an occasional black family that has attempted to move into Manhasset and been harassed into leaving.

46. A classic example was the middle-class complaints about the aluminum siding placed on working-class houses in Greenpoint. See the Introduction.

Chapter Two

1. Whereas every house in Manhattan and Medford, and more than 80 percent of those in Greenpoint and Manhasset, prominently displayed at least one.

2. On the connection between country villas and interest in landscape pictures see A. Richard Turner, *The Vision of Landscape in Renaissance Italy* (New Jersey: Princeton, 1966), chap. 10. For a detailed account of the growth of the suburban villa among wealthy Romans from 1420 to 1585 see David Coffin, *The Villa in the Life of Renaissance Rome* (Princeton: Princeton University Press, 1979). On the emergence of landscape painting as a distinct genre see E. H. Gombrich, "The Renaissance Theory of Art and the Rise of Landscape," in *Norm and Form in the Art of the Renaissance* (London: Phaidon Press, 1966); and M. J. Friedlander, *Landscape, Portrait, Still-Life: Their Origin and Development* (1947), trans. from German by R. F. C. Hull (New York: Schocken Books, 1965).

3. See Wayne Craven, *Colonial American Portraiture* (New York: Cambridge University Press, 1986); and Richard Saunders and Ellen Miles, *American Colonial Portraits, 1700–1776* (Washington: Smithsonian Institution Press, 1987).

4. On this nineteenth-century suburbanization see Sam Bass Warner, *Streetcar Suburbs* (Cambridge: Harvard University Press, 1962); and Kenneth Jackson, *Crabgrass Frontier: The Suburbanization of America* (New York, Oxford University Press, 1985).

5. On the growing popularity of landscape paintings in nineteenth-century America see Barbara Novak, *Nature and Culture: American Landscape and Painting, 1825–1875* (New York: Oxford University Press, 1980).

6. On blue-collar workers in post–World War II suburbs see Herbert Gans, *The Levittowners* (New York: Pantheon, 1967); Bennett Berger, *Working-Class Suburb* (Berkeley: University of California Press, 1968); and David Halle, *America's Working Man* (Chicago: University of Chicago Press, 1984).

7. Ernest Gombrich argued that an artistic phenomenon that is widespread is almost always the result of several causes. This is certainly true here. See Gombrich, "Tradition and Expression in Western Still Life," in *Meditations on a Hobby Horse,* (London: Phaidon, 1985).

8. Henri Matisse, "Notes d'un peintre" (1908), reprinted and translated in Jack Flam, ed., *Matisse on Art* (New York: Dutton, 1987). The full Matisse quote is: "What I dream of is an art of balance, of purity and serenity, devoid of troubling or depressing subject matter, an art which could be for every mental worker, for the businessman as well as the man of letters, for example a soothing, calming influence on the mind, something like a good armchair which provides relaxation from physical fatigue."

9. On the connection between religious beliefs and landscape in nineteenth-century America see Barbara Novak, *Nature and Culture.*

10. Turner, *The Vision of Landscape in Renaissance Italy,* chap. 10.

11. On the development in the mid-nineteenth century of the notion of the sea as a pleasurable resort see Linda Nochlin, *Realism* (New York: Penguin Books, 1971), chap. 3.

12. See M. Jean Adhemar, "Les Lithographes de paysage en France à l'époque romantique," in *Archives de l'Art Français: Nouvelle Période* 19 (1938); pp. 230–32. Victor Adam was the best known of the artists who specialized in adding the figures to landscapes. In earlier times the number of figures depicted in the landscape certainly sometimes declined and even vanished. For example, Girouard writes how, in the later part of the eighteenth century in England, an ideal of solitude in the country became fashionable and as a result "pictures of country houses no longer showed them thronged with people. . . . Instead, they appeared in idyllic solitude, with perhaps just a single figure—a horseman or a ploughman with his team—or herds of grazing deer or cattle." See Mark Girouard, *Life in the English Country House* (New York: Penguin, 1978), p. 217. It is, however, the *pervasiveness* of the ideal of *entirely* depopulated landscapes that characterizes the modern period.

13. This is not to say that people in modern society are lonely, and so on (and especially not the married couples with children who form the predominant household type in this sample). But it is to say that a central leisure ideal is aloneness in viewing nature.

14. For a criticism of studies that exaggerate the difference between high and popular culture see Herbert Gans, *Popular Culture and High Culture: An Analysis and Evaluation of Taste* (New York: Basic Books, 1974).

15. Perhaps, when it comes to the works in their own homes, even art historians and critics also engage in the kind of decoding that is involved in the common preferences for depopulated landscapes of the modern world.

16. Meyer Schapiro, *Paul Cézanne* (New York: Harry Abrams, 1962), p. 14.

17. It was Monet's haystacks, for example, that enthused Kandinsky when he saw them

on exhibit as a student in Moscow in the 1880s. See Wassily Kandinsky, "Reminiscences" (1913), in Robert Herbert, *Modern Artists on Art* (New Jersey, Prentice-Hall, 1964).

18. John Rewald, *Paul Gauguin* (New York: Harry Abrams, 1954).

Chapter Three

1. Meyer Schapiro, *Vincent Van Gogh* (New York: Harry Abrams, 1950), pp.16–18. On this aspect of traditional portraiture see also Wilhelm Waetzoldt, *Die Kunst des Porträts* (Leipzig: F. Hirt and Sohn, 1908); Richard Brilliant, *Portraiture* (Cambridge: Harvard University Press, 1991), p. 11; and Wayne Craven, *Colonial American Portraiture* (New York: Cambridge University Press, 1986), esp. pp. 9, 14, 56,77.

2. Greenberg's view is widely cited. See, for example, Frank Goodyear, *Contemporary American Realism since 1960* (Boston: New York Graphic Society, 1981), p. 51.

3. Jean Borgatti and Richard Brilliant, *Likeness and Beyond: Portraits from Africa and the World* (New York: The Center for African Art), p. 17. Brilliant is here writing about Marsden Hartley and his contemporaries such as Marcel Duchamp and Charles Demuth, but his remarks clearly have wider application. The relation between a portrait and personal identity is so fundamental that depictions that cannot be seen to denote a named, or nameable, person are arguably not portraits. For a fascinating exploration of the relationship between portraiture and questions of identity see Richard Brilliant, *Portraiture* (cited in note 1). See also Wendy Steiner, "The Semiotics of a Genre: Portraiture in Literature and Painting," *Semiotics* 21 (1977), pp. 111–19.

4. See, for example, E. P. Richardson, *A Short History of Painting in America* (New York: Harper and Row, 1963), pp. 178–79.

5. Meyer Schapiro, *Vincent Van Gogh,* pp. 16–17.

6. There are several studies of family photos. We have, for example, Julia Hirsch's fine conceptual analysis, another fine account (ethnographic, historical, and conceptual) by Pierre Bourdieu and others, and Christopher Musello's ethnographic discussion. But there is no serious study of family photos in the context in which they are displayed—the home. There is no systematic study of their location, content, and meaning. See Julia Hirsch, *Family Photographs,* (New York: Oxford University Press, 1981); Christopher Musello, "Family Photography," in Jon Wagner, ed., *Images of Information* (Beverly Hills: Sage Publications, 1979); and Pierre Bourdieu (et al.), *Un art moyen: Essai sur les usages sociaux de la photographie* (Paris: Les Editions de Minuit, 1965). See also S. L. Titus, "Family Photographs and the Transition to Parenthood," *Journal of Marriage and the Family* 38 (1976) pp. 525–30, and Philip Pacey, *Family Art* (Cambridge: Polity Press, 1989).

7. I discuss the significance of the movability of family pictures later in this chapter.

The pictures on display, often so numerous themselves, are of course a tiny fraction of those stored in albums and elsewhere.

8. Three categories are thus excluded here: first, portraits of public figures such as an American president (not, anyway, very common) or rock stars (popular, in poster form, among teenagers); second, images of religious figures (a topic discussed separately in chapter 6); and third, works of art (in the original or reproduced). To include these categories would raise complex issues that are not relevant to the main topic.

9. About half of these portraits in Greenpoint and Medford and a third of those in Manhasset are drawings by street artists. There is one such street drawing in the Manhattan sample.

The Greenpoint figures include one house that contains two sculpted portrait busts of the parents of a resident. These busts, made by the resident's uncle, are the only portrait busts of relatives or friends of residents displayed in any of the houses sampled.

10. Thus the portraits in the Manhattan house that contains four are all of the nuclear family.

11. The basis for this statement is comments by older respondents. Also, Bourdieu reports how among French peasants when the camera was first introduced (about 1905–14), almost the only pictures displayed were marriage photos. But after 1945 informal pictures came to dominate. See Pierre Bourdieu, et al. *Un art moyen: Essai sur les usages sociaux de la photographie* (cited in note 6), pp. 40–43. In a study of traditional Spanish villagers in northern Spain William Christian comments on the pervasiveness in the home of the formal wedding photo of the adult residents—photos Christian describes as "solemn, formal pictures, almost lugubrious with dignity" (by contrast with the colorful and fanciful pictures of religious figures that also pervade these houses). See William Christian, *Person and God in a Spanish Valley* (New York: Seminar Press, 1972), chap. 3.

12. "Clearly outnumber" or "predominate" here refers to situations where informal photos constitute 60% or more of those on display.

Also, no house in Manhattan exhibits more than six formal photos, and just over a third of the houses have none at all.

13. For the use of "clearly outnumber" or "predominate" see note 12.

14. See note 11.

15. Wedding photographs of the head(s) of household are displayed in 35% of the Manhasset houses and 25% of the Medford houses.

Other wedding pictures in these houses refer to marriages of the children, parents, or siblings of the owners of the house.

16. These figures include depictions, in moments of occupational success, of grown children of the adult residents as well as the adult residents themselves.

17. All these are in Greenpoint. One is a painting of a Greenpoint man's dead mother (fig. 55). The other two are sculpted busts of a resident's parents (see also note 9).

18. See Meyer Schapiro, *Vincent Van Gogh*.

19. Though there are many exceptions to this tendency.

20. The numbers in this section concerning kin and non-kin in photos are based only on pictures that are individually framed, whether displayed in clusters or not. The analysis excludes cases where several photos are combined, collage fashion, in a common frame. Such collages are too hard to analyze in the detail required here.

21. For example, in Greenpoint there is a class picture of the daughter but on a shelf eclipsed by numerous individual pictures of the same girl. On an upstairs landing wall in Manhasset a daughter has several pictures of herself and the school hockey team.

22. Photos of at least one parent are displayed by 73% of the houses in Greenpoint and Manhasset, 50% of those in Medford, and 45% of those in Manhattan.

23. There are, of course, an enormous number of societies where lineage and ancestry are very serious matters. For just two examples see, on ancient Rome, Polybius, *The Histo-*

ries, VII, 53, 54; and, on the Tallensi in Ghana, Meyer Fortes, *The Web of Kinship among The Tallensi* (Oxford University Press, 1949).

24. This, according to Pope-Hennessy, is the Duke of Urbino's purchase of Titian's painting "La Bella." As the Duke wrote in 1536: "Tell Titian . . . we want him to finish the portrait of a woman with a blue dress." See John Pope-Hennessy, *The Portrait in the Renaissance* (Princeton: Princeton University Press, 1963).

25. Of the houses that contain any family pictures, a grouping of ten or more photos is found in 78% of the houses in Manhasset, 67% of those in Greenpoint, 55% of those in Manhattan, and 37% of those in Medford.

26. Actually 0.4%.

27. It is toward current adult residents that this taboo applies. By contrast, one mode of handling a *dead* person whose loss is still deeply felt is to display a picture of that person alone. Clearly this symbolizes the separation and loss. Such photos occur in four houses in this study. In three of these houses, the photos are of a dead spouse, displayed by an elderly spouse who survives. The fourth case is the Greenpoint man in his sixties who displays a photo of his dead mother (fig. 55).

28. But, as with photographs, portraits of children alone and displayed alone are more acceptable. There are five on the East Side.

29. Some of the respondents have themselves been divorced. Anyway, they all have at least one divorced relative or close friend. A number of historical studies stress the distinctive fragility of the modern Western family. See, for example, Lawrence Stone, *The Family, Sex and Marriage in England, 1500–1800* (New York: Harper and Row, 1977); Philippe Aries, "The Family and the City," in *The Family,* ed. Alice S. Rossi (New York: Norton, 1978); Kenneth Keniston, *All Our Children* (New York: Harcourt Brace Jovanovich, 1977).

30. The phrase is from Richard Brilliant, "Editor's Statement: Portraits: The Limitations of Likeness," *Art Journal* 46, no. 3 (1987), pp. 171–72.

31. For an account of recent adaptations of portraiture see Frank H. Goodyear, Jr., *Contemporary American Realism Since 1960* (Boston: New York Graphic Society, 1981), chap. 2.

Chapter Four

1. Le Corbusier, *Towards a New Architecture* (1921), trans. Frederick Etchells (New York: Dover Publications, 1986).

2. Ortega y Gasset, "The Dehumanization of Art" (1925), in *Velasquez, Goya and the Dehumanization of Art,* trans. Alexis Brown (New York: Norton, 1972).

3. Roman Ingarden, *The Ontology of the Work of Art* (1928) (reprint Columbus, Ohio: Ohio University Press, 1986).

4. Walter Benjamin, "The Work of Art in the Age of Mechanical Reproduction" (1936), in *Illuminations,* trans. Harry Zohn. (New York: Schocken Books, 1969).

5. Clement Greenberg, "Avant-Garde and Kitsch" (1939), reprinted in *Art and Culture* (Boston: Beacon Press, 1961).

6. Bourdieu, *Distinction: A Social Critique of the Judgment of Taste* (Cambridge: Harvard University Press, 1984), p. 4.

7. Bourdieu asked respondents three questions about abstract art. In addition to the question cited in the text, he asked them whether abstract art "interested" them as much as "the classical schools." And he asked what people thought of the view that "modern painting is just slapped on anyhow; a child could do it." The last question does begin to get at some of the experiential issues.

8. It is true of many other areas of modern culture that sociological surveys have often done little more than establish who does and who does not engage in the particular item.

Marxists too have done little detailed analysis of abstract art, as Zollberg has pointed out. See Vera Zollberg, *Constructing a Sociology of the Arts* (Cambridge: Cambridge University Press, 1990), p.56. An interesting study is Serge Guilbaut, *How New York Stole the Idea of Modern Art* (Chicago: University of Chicago Press, 1983).

9. Thus Naum Gabo, the Russian Constructivist, opposed the use of the word "abstraction" in art, considering it a "false terminology." See Naum Gabo, "Russia and Constructivism" (1956), reprinted in *Gabo: Constructions, Sculpture, Paintings, Drawings, Engravings* (London: Lund Humphries, 1957).

10. See Wassily Kandinsky, *Uber das Geistige in der Kunst* (1912), translated as *Concerning the Spiritual in Art* (New York: Wittenborn, 1947), p. 68; Piet Mondrian, "Towards the True Vision of Reality" (1937), reprinted in *Plastic Art and Pure Plastic Art* (New York: Wittenborn, 1945) p. 14; Adolf Loos, "Ornament and Crime" (1908), reprinted in Ludwig Münz and Gustav Künstler, eds., *Adolf Loos* (New York: Praeger, 1966), pp. 226–27; Le Corbusier, *Towards a New Architecture* (1921) (reprinted, New York: Dover Publications, 1986); Frank Lloyd Wright, "The Cardboard House," pp.78–79 in *Modern Architecture: The Kahn Lectures for 1930* (Princeton: Princeton University Press, 1931), p. 78. The full Wright quotation is: "Any house decoration, as such, is an architectural makeshift, however well it may be done, unless the decoration, so called, is part of the architect's design in both concept and execution."

There were, however, exceptions even in the early days. For example Worringer, in his classic account of the spread of abstraction, seems to have seen the "decorative" as central to abstraction. See Wilhelm Worringer, *Abstraction and Empathy* (1919), trans. Michael Bullock (New York: International Universities Press, 1953).

11. See Greenberg, "Milton Avery," *Arts* (December 1957), pp. 40–45. According to Greenberg, modern artists could infuse decoration with art in a number of ways. For example: "Matisse and the later Monet overcame decoration by dint of [adding]the monumental." Milton Avery did it by injecting "nature." "Avery . . . is moved by a . . . naturalism, and it is this that he invokes against the decorative."

12. See Donald Kuspit, *Clement Greenberg* (Madison: University of Wisconsin Press, 1979), pp. 173–81. On the presence of much "merely decorative" art in corporate offices see Rosanne Martorella, *Corporate Art* (New Brunswick: Rutgers University Press, 1990), pp. 126ff.

13. See, for example, Frank Willett, *African Art* (New York: Praeger, 1971).

14. Given that a number of residents "see" landscapes in their abstract art, it is worth recalling that, for several of the main abstract artists too, there was a close connection between landscape art and abstract art. Thus some of the most important specialized in landscapes before moving on to more abstract works.

15. See Brissot de Warville's report of his visit to the United States in *Nouveau voyage*

dans les Etats-Unis de l'Amérique (Paris, 1788), cited in Françoise Teynac et al., *Le Monde du Papier Peint* (Paris: Berger-Levrault, 1981).

16. Downing wrote, "The great advantage of papering the walls lies chiefly in the beauty of effect, and cheerful, cottage-like expression, which may be produced at very little cost." For those who could not afford wallpaper whitewashing would do, but a "mere white wall" was not his first choice. Moreover, he noted that in the last two years there had been introduced inexpensive patterns of wallpaper perfectly suited to the walls of cottages in various styles of architecture, such as Gothic, Italian, and Grecian. See A. J. Downing, *The Architecture of Country Houses* (1850) (reprinted New York: Dover Publications, 1969), pp. 369–70.

17. Machines for making wallpaper were first introduced in the United States in the 1840s. In 1874 wallpaper sold wholesale at prices ranging from six cents a roll to fifty cents a roll. Five years later the wholesale price had fallen by about half, and by 1895 *retail* prices ranged from about three cents a roll upward. See Catherine Lynn, *Wallpaper in America: From the Seventeenth Century to World War I* (New York: Norton and Co., 1980), chap. 16. Much of the other material here on the history of wallpaper in America is also based on Lynn, pp. 310–15 and 463.

On the history of wallpaper in America, see also Brenda Greysmith, *Wallpaper* (New York: Macmillan, 1976). On the history of wallpaper in the West see Heinrich Olligs, *Tapeten: Ihre Geschichte bis zur Gegenwort,* 3 vols. (Braunschweig: Klinkhardt und Biermann, 1970); and Françoise Teynac et al., *Le Monde du Papier Peint.*

18. By 1885 wallpaper was incorporated in many building contracts. The California architects Newsom and Newsom, in the introduction to their book *Picturesque Californian Homes,* commented, "The query 'What shall we do with our walls?' has long since been answered. . . . White walls, unrelieved by any color are relics of barbarism, and are almost a thing of the past. House-papering is now incorporated in building contracts, and a house is considered incomplete without these adornments." Samuel and Joseph Newsom, *Picturesque Californian Homes, no. 2* (San Francisco: S. and J. Newsom, 1885), p. 5.

19. See *The Wall-Paper News and Interior Decorator* for December 1908.

20. Adolf Loos, "Ornament and Crime" (1908), reprinted in Ludwig Münz and Gustav Künstler eds., *Adolf Loos* (New York: Praeger, 1966).

21. Le Corbusier, *Towards a New Architecture* (1921) (reprinted New York: Dover Publications, 1986).

22. Le Corbusier, "A Coat of Whitewash: The Law of Ripolin," in *The Decorative Art of Today* (1925) (reprinted London: The Architectural Press, 1987). Complaining about the way decorative tendencies from the West ruined simpler societies, which already whitewashed their walls, he wrote "Once factory-made brassware arrives, or porcelain decorated with gilt seashells, whitewash cannot last. It is replaced with wallpaper, which is in the spirit of the new arrivals." Modern society must rediscover whitewash. "Imagine the results of the Law of Ripolin. Every citizen is required to replace his hangings, his damasks, his wall-papers, his stencils, with a plain coat of white Ripolin. His home is now clean. There are no more dirty, dark corners. Everything is shown as it is. . . . Once you have put Ripolin on your walls you will be master of yourself."

23. The vogue for white walls was not merely aesthetic. It coincided with a focus on white, in the kitchen at least, for sanitary reasons. See Gwendolyn Wright, *Building the Dream: A Social History of Housing in America* (New York: Pantheon, 1981), chap. 9.

24. Thus Ernest Gombrich wrote: "Only the 20th century has witnessed the final elevation of pattern-making into the autonomous activity of 'abstract art.'" In addition to his comments cited earlier, Clement Greenberg wrote: "Modern painting . . . comes closest of all to decoration—to wallpaper patterns capable of being extended indefinitely." See Ernest Gombrich, *The Sense of Order* (Oxford: Phaidon Press, 1979), p.vii; and Clement Greenberg, "The Crisis of the Easel Picture" *Partisan Review* (April 1948), reprinted in *Clement Greenberg: The Collected Essays and Criticism*, vol. 2, 1945–49 (Chicago: University of Chicago Press, 1986).

My argument is merely sketched here. It needs more evidence, especially the statements of those who purchased abstract art as to why they liked the art. Unfortunately such statements are scarcely available. Most of the major collectors of art have had statements written for them by the art critics, curators, and so on who guided their tastes or to whose museums they may have donated parts or all of their collections. Critics and curators in this context are unlikely to be candid about the motivations of their followers or benefactors. As Vera Zollberg put it, accounts by critics and curators of collectors' motivations "typically stress the spontaneity, intuitiveness, taste and generally ineffable qualities of the collectors . . . they are intended to be flattering, to place the collector into the same category as the disinterested, quasi-aristocratic, spontaneous 'geniuses' whose works they collected." See Vera Zollberg, "New Art—New Patrons: Coincidence or Causality in the Twentieth-Century Avant-Garde," in I.S.A. Research Committee 37, *Contributions to the Sociology of the Arts, Reports from the 10th World Congress of Sociology, Mexico, 1982* (Sofia, Bulgaria: Research Institute for the Arts, 1983). A typical example of such accounts is Douglas Cooper, *Les Grandes Collections Privées* (Paris: Editions du Pont Royal, 1963). Zollberg's article proposes an interesting typology of the early collectors of modern art.

25. The other main solution is to avoid portraits altogether.

26. Of course twentieth-century critics impose many distinctions on the genre of "abstract art," but these distinctions refer to artists and schools. By contrast the distinctions here refer to varieties of meanings for the audience.

27. "A Life Round Table on 'Modern Art,'" *Life* Magazine (October 11, 1948), pp. 56ff.

Chapter Five

1. For general accounts of this history see Robert Goldwater, *Primitivism in Modern Art* (1st ed. 1938) (enlarged ed. Cambridge: Harvard University Press, 1986); W. Rubin, "Modernist Primitivism: An Introduction," in W. Rubin, ed., *Primitivism in 20th-Century Art: Affinity of the Tribal and the Modern*, vol. 1 (New York: The Museum of Modern Art, 1984); the essays in George Stocking, ed., *Objects and Others: Essays on Museums and Material Culture* (Madison: University of Wisconsin Press, 1985); and Michael Ames, *Cannibal Tours and Glass Boxes: The Anthropology of Museums* (Vancouver: UBC Press, 1992).

In a brief, and well-known, interlude, the treasures sent back from Mexico by the Spanish conquistadores in 1519 astounded select Europeans such as Dürer, supposedly for their aesthetic qualities. But the idea that these objects were art soon lapsed; tribal objects continued in the European Renaissance merely as exotica in the "cabinets de curiosités" of princes. For skepticism about whether Dürer et al. really prized the items for their aesthetic value see Christian Feest, who argues that Dürer was simply impressed by the "sheer value of these

things, their sometimes exotic raw materials, and their obvious craftsmanship." See "From North America," in Rubin, *Primitivism in 20th-Century Art,* pp. 85–99.

In fact, a small number of Western travelers before the twentieth century *did* see aesthetic and artistic value in "tribal" objects. See note 16 to this chapter.

2. For this same reason, I use the terms in quotes, and also in order to distance myself from some of the (untenable) implications, about the artifacts and about the societies that produced them, that went along with the use of these terms. For a discussion of the terms "primitive" and "tribal," and of the difficulty of finding better ones for discussing the reception of the artifacts in the twentieth-century West, see Rubin, *Primitivism in 20th-Century Art.*

3. This account is so well-worn that it has been dubbed the "origin story of modernism." See James Clifford, *The Predicament of Culture* (Cambridge: Harvard University Press, 1988), pp. 196 ff. The "tribal" objects that Picasso and others "discovered" were found in European curiosity shops as well as in ethnographic museums such as the Trocadero in Paris.

4. On the history that follows in this paragraph see Douglas Newton, Julie Jones, and Susan Vogel, "The Stuff That Wasn't in the Metropolitan: Notes on Collecting Primitive Art," in Thomas Hoving, ed., *The Chase, the Capture: Collecting at the Metropolitan* (New York: The Metropolitan Museum of Art, 1975); and Douglas Newton, *Masterpieces of Primitive Art* (New York: Alfred Knopf, 1978), including the "Introduction" by Nelson Rockefeller.

5. The Denver Art Museum was the first art museum in the United States to recognize "primitive" art. In 1923 the Department of Ethnology of the Brooklyn Museum mounted "Primitive Negro Art," a large show of almost fifteen hundred Congolese objects of all kinds. In 1930 a show called "Rare African Sculpture," which presented its material almost entirely as aesthetic objects, opened on Fifty-seventh Street in Manhattan.

6. Nelson Rockefeller, Introduction to Douglas Newton, *Masterpieces of Primitive Art,* p. 24.

A more recent landmark in the aesthetic career of "primitive" art in America was the Museum of Modern Art's 1984 exhibition, "'Primitivism' in 20th-Century Art," which documented the supposed affinities between "tribal" and modern art. For critiques of the assumptions made by this exhibition see Arthur Danto, *The State of the Art* (New York: Prentice Hall, 1987), chap. 4, and Clifford, *The Predicament of Culture* chap. 9.

7. For example, writing on North American Indian art, J. C. H. King commented, "To compartmentalize Indian art as 'traditional' and 'nontraditional' is to deny the continuity of Indian society by specifying a particular point at which it breaks from the past. To do this is to idealize precontact societies and to imply that in adopting Euro-American ideas, materials, and markets, Indian societies are absorbed." See J. C. H. King, "Tradition in Native American Art," in Edwin Wade, ed., *The Arts of the North American Indian: Native Traditions in Evolution* (New York, Hudson Hills Press, 1986). Likewise, Aldona Jonaitis has written about the "invention" of traditional American Indian art. As she says, "Most museum collections upon which we typically base our definitions of Native American art were created between 1860 and 1930, a time of severe cultural upheaval among most Indian groups. Regardless of this reality, many museums—and the literature based on their collections—present art acquired and in many cases actually produced during this period as 'authentic and traditional' Indian art, timeless and eternal." See "Franz Boas, John Swanton and the New Haida Sculpture at the American Museum of Natural History," in J. Berlo, ed., *The Early Years of Native American Art History* (Seattle: University of Washington Press, 1992). Also in the vanguard

of this critical movement is Clifford, *The Predicament of Culture.* By contrast, some recent exhibitions of "tribal" art have made an effort to present the current artistic works as of equal value with the earlier ones. See Aldona Jonaitis, ed., *Chiefly Feasts: The Enduring Kwakiutl Potlatch* (New York: American Museum of Natural History [catalogue], 1991).

8. Susan Vogel, *The Art of Collecting African Art* (New York: The Center for African Art 1988), pp. 4–5. Compare Robert Goldwater: "Consideration [by the ethnographic museums] of the aesthetic values of primitive art comes . . . considerably after the beginning of such an appreciation on the part of artists and private collectors" (*Primitivism in Modern Art,* p. 7).

9. Despite the widespread dissatisfaction in art circles nowadays with the term "primitive art" (see note 2), only one resident interviewed demurred at using the term to refer to items from non-Western societies.

10. She writes, "The linking of African, Oceanic, and Native American art . . . represents little more than imaginative musings." Suzanne Preston Blier, "Art Systems and Semiotics: The Question of Art, Craft and Colonial Taxonomies in Africa," *The American Journal of Semiotics* 6 (1988–89), pp. 7–18.

The term "primitive" was not, of course, always used in this way in art. In late-nineteenth-century France, "primitives" were primarily fourteenth and fifteenth century Italian and Flemish painters and sculptors. Later definitions expanded to include Romanesque, Byzantine, and a host of non-Western arts ranging from Peruvian to Javanese. Only in the twentieth century did the "tribal" arts of Africa, Oceania, and Native America enter the definition. After 1906–7 there was a shrinkage in the scope of what was considered "primitive" art, to leave primarily these three regions, with African art as of predominant importance within the trio. On this see Rubin *Primitivism in 20th-Century Art,* and Blier, "Art Systems and Semiotics." On the contemporary preference of collectors for African art see Rubin, p. 17.

11. Of the residences with other kinds of "primitive" art, the most notable and unusual is the rectory apartment of the priest who heads the American Catholic missionary effort abroad (see table 12, note). Although there are about twenty masks, figures, and faces in his collection, there are about twice as many other items—weapons, fabric, musical instruments, ornaments. It is not surprising that the composition of the items in this household in many ways resembles an ethnographic museum, for the main intent of the priest who collected them was to record the progress toward Christianity of the people he studied.

12. "Quality pieces" here are defined as those which residents said had been professionally appraised as valuable. The two "quality" pieces that did not refer to the person were pre-Columbian pots.

13. By 1968, a specialist on African art could write: "On a vast scale in many parts of Africa, but especially in East Africa, mechanized factories are springing up. . . . The object is designed specifically for a popular trade dominated by the requirements of vulgarization." Frank McEwen, "Return to Origins: New Directions for African Arts," *African Arts* 1, no. 2 (Spring 1968), pp. 18–25 and 88. Some recent researchers have started to take "tourist" art seriously for what it tells us about cultural practices, if not for its aesthetic merits. See, for example, N. Graburn, ed., *Ethnic and Tourist Arts* (Berkeley: University of California Press, 1976) and R. Phillips, "Glimpses of Eden," *European Review of Native American Studies* 5 (1991): 19–28.

14. Picasso not only did not care about the aesthetic quality of the figures and masks

that he saw but also did not care about understanding their meaning in their societies of origin. As he said, "Everything I need to know about Africa is in these objects." All this underlines the fact that it was the subject matter—the treatment of the person—that attracted Picasso. See Rubin, "Modernist Primitivism: An Introduction," in W. Rubin, ed., *Primitivism in 20th-Century Art.* On the mediocre aesthetic quality of most of the works that Picasso and his circle first observed, see also Jean Laude, "Lectures des arts 'primitifs,'" in *Arts primitifs dans les ateliers d'artistes* (Paris: Musée de l'Homme, 1967); and F. Willett, *African Art* (New York: Oxford University Press, 1971), p. 36.

15. Roy Sieber, *African Textiles and Decorative Arts* (New York, 1972), p. 10. On the Center for African Art experiment see James Baldwin et al., *Perspectives: Angles on African Art* (New York, Center for African Art, 1987), esp. p. 11.

It is depictions of the person that continue to arouse so much enthusiasm among artists, experts, and the public. Consider, for example, three recent exhibitions. Jean Borgatti and Richard Brilliant, *Likeness and Beyond: Portraits from Africa and Beyond,* (New York: The Center for African Art [catalogue], 1990) compares African portraits (figures, faces, and masks) with portraits from all over the world; Enid Schildkrout and Curtis Keim, *African Reflections: Art from Northeastern Zaire* (New York, Museum of Natural History [catalogue], 1990) focuses on anthropomorphism in the art; Kate Ezra, *Royal Art of Benin: the Perls Collection in the Metropolitan Museum of Art* (New York, Metropolitan Museum [catalogue], 1992) heavily stresses figurative pieces (underlined by the choice of a statue of a court official for the cover of the exhibition brochure).

16. See Willett, *African Art.* The specifically modern focus on the person is underlined by the fact that the occasional Western travelers to Africa before the twentieth century who did see aesthetic merit in the artifacts rarely valued the sculpture. For example, in 1702 the Dutchman Van Nyendael visited the Benin and was struck by the "very well carved" copper snakes, by the "beautifully chequered" cloths, and by such personal ornaments as coral necklaces and copper arm rings. He dismissed the numerous masks and figures as "wretchedly carved." The Scottish surgeon Mungo Park, who traveled through West Africa in 1795–97, commented on the (dyed) blue cloth among the Mandingoes ("equal to the best Indian or European blue"), on their gold personal ornaments, and on the "very beautiful baskets, hats, and other articles" found in Bambarra and Kaarta. He said nothing complimentary about the sculpture. Neither, about twenty years later, did Bowdich, the British envoy to the Ashanti; instead he praised their dyed cloth, commenting on its "fineness, variety, brilliance and size," and he also considered they "excelled in pottery, especially clay pipes." See David Van Nyendael, letter written on September 1, 1702, reprinted in William Bosman, *A New and Accurate Description of the Coast of Guinea* London, 1907; Mungo Park, *Travels in the Interior Districts of Africa* (London, Bulmer and Co., 1799), pp.285–86; T. Edward Bowdich, *Mission from Cape Coast Castle to Ashantee* (London, John Murray, 1819; reprinted London, 1966). On these early observers in Africa see also M. Leiris and J. Delange, *African Art* (London, Thames and Hudson, 1968), chap. 1.

17. For a protest that Western stress on the "fearful" aspects of (undifferentiated) "tribal" objects reflects Western biases and even racism see Sally Price, *Primitive Art in Civilized Places* (Chicago: University of Chicago Press, 1989), pp. 37–55.

18. See Robin Horton, *Kalabari Sculpture* (Lagos: Department of Antiquities, Federal Republic of Nigeria, 1965), pp. 8–15. Compare Willett, who writes that "[African] masks are

usually occupied by the spirit only during the ceremonies; between times they are regarded as so much wood." And: "Not only are many figure sculptures not normally seen, but many African masks are not seen at all even when they are in use." See Willett, *African Art,* pp. 168 and 174.

Likewise for Oceanic art. Thus one expert on Maori art writes: "Many Maori individuals are afraid of 'taonga' (ritual objects including masks and figures) and will not have them near their food or lying by their beds. Some tremble in the presence of such 'taonga', while others stand in awe or weep." See Sidney Moko Mead, ed., *Te Maori: Maori Art from New Zealand Collections* (New York: Abrams, 1984), p. 23.

19. Many upper-middle-class residents dislike abstract art, as we have seen, but then they usually do not display it in their homes.

20. For the comments on the Congo exhibition see Alain Locke, "A Collection of Congo Art," *The Arts* 9 (1927), pp. 61–70. Locke went on to wonder how a people capable of producing such beauty in other areas could lapse into "grotesque starkness and crudity" in their masks. On Locke's importance as a spokesman for black American artists see *Harlem Renaissance: Art of Black America* (New York: Harry Abrams 1987), pp. 38ff. The Steiglitz exhibition in 1914 presented African statuary as art, but probably included no masks. (This statement is based on the absence of any mention of masks in the exhibition review by Charles Caffin, the noted art critic, in *New York American,* reprinted in *Camera Work,* no. 48 [1916] and collected in Jonathen Green, ed., *Camera Work: A Critical Anthology,* [New York: Aperture, 1973.])

21. James Johnson Sweeney, *African Negro Art* (New York: Museum of Modern Art, 1935).

22. Likewise almost all the items in the book *Sculptures nègres,* published in 1917 by the Parisian art dealer Paul Guillaume with a preface by Apollinaire, are sculpted faces and figures that are recognizably human. See *Sculptures nègres* (Paris: Paul Guillaume, 1917. Reprinted New York: Hacker Art Books, 1973). The authority is Rubin. See "Modernist Primitivism," in *Primitivism in 20th-Century Art,* p. 13. It is, in fact, hard to be sure what proportion of the masks that the pioneer artists first collected were basically sculpted faces and what proportion diverged into more fantastic forms. An exhibition by the Musée de l'Homme that aimed to recreate the "primitive" art collections of each of these artists does not, unfortunately, distinguish items collected early (in the first two decades of the twentieth century) from those collected later (when fantastic masks had became more popular in cultural circles). See the Musée de l'Homme's *Arts primitifs dans les ateliers d'artistes.* Still, from inspection of photographs of the "primitive" art in artists' studios and homes in the first two decades it looks as if masks that are sculpted faces predominate. Certainly the well-known collections of "fantastic" masks and images—that is those most unlike a human face, often because they depict animals and fantastic beasts—were made somewhat later, in particular when Oceanic art became popular with the Surrealists. A notable example of the latter is Max Ernst's collection.

23. And of these two households that had "primitive" art and treated it with respect yet were Republican in their political orientation, one was only partly an exception to the tendency for persons with "primitive" art that they viewed with respect to be Democrats. Thus the wife in this household had one item of "primitive" art, a face from South Africa which her niece (a famous designer) had given her as a gift. Although the wife liked *this* item, and

believed it to be equal to some of the best of Western art, she hated "primitive" art in general, believing it to be inferior in quality and to be produced by cultures that were alien to her own (that of the "WASPs," as she put it).

24. For demographic studies that document the degree of separation between whites and blacks in the United States, and its even greater pervasiveness in the suburbs than in the cities, see Reynolds Farley, "The Changing Distribution of Negroes within Metropolitan Areas: the Emergence of Black Suburbs," *American Journal of Sociology* 75 (1970), pp. 512–29, and "Residential Segregation in Urbanized Areas of the United States in 1970: An Analysis of Social Class and Racial Differences," *Demography* 14 (November 1977), pp. 497–518; and M. White, "Segregation and Diversity Measures in Population Distribution," *Population Index* 52 (summer, 1986): 198–221. White argues that segregation declined somewhat in the 1970s, but still remained high.

25. See Paul Abramson, John Aldrich, and David Rohde, *Change and Continuity in the 1988 Elections* (Washington D.C., Congressional Quarterly Press, 1990), p. 122. It took the economic debacle of 1990–92 to induce enough members of these other groups to vote Democratic in order for Clinton to be elected President in 1992. But in 1992 African Americans still voted Democratic in far greater a proportion than did any of these other major social groups.

26. Nelson Rockefeller, a Republican politician who did much to improve the standing of "primitive" art in the West, may be the "exception that proves the rule." For it was the liberal wing of the Republican party that Rockefeller led. Further, the "liberal-Republican" category to which he belonged scarcely exists anymore, for the set of policies associated with it has proven too radical for the Republican Party and has been willingly ceded to the Democrats.

27. See Steven Dubin, "Symbolic Slavery: Black Representations in Popular Culture," *Social Problems* 34, no.2 (April 1987), pp. 122–39.

28. Clifford, *The Predicament of Culture,* 196ff.

29. For a detailed comparison of participation by African Americans and white Americans in a variety of arts (music, ballet, theater, and so on) see Paul DiMaggio and Francie Ostrower, "Participation in the Arts by Black and White Americans," *Social Forces* 68 (March 1990), p. 753–78.

30. However, all of these households also contain other classical religious figures that are white. No household has converted all the religious figures to blacks.

31. On African Americans in domestic service in northern cities in the twentieth century see David Katzman, *Seven Days a Week* (New York: Oxford University Press, 1978). Of course the middle of the nineteenth century had seen the reverse tendency, as whites such as the Irish began to replace blacks as domestic servants in Northern cities.

32. See, for example, *Harlem Renaissance: Art of Black America* (New York: Harry Abrams, 1987).

33. The claim that 1950 was the approximate time when it began to be fashionable among avant-garde residents of New York City to collect pre-Columbian artifacts is based, for example, on the testimony of a Manhattan resident in the sample who was an early collector of pre-Columbian pieces and now owns a famous photographic gallery. This resident described how, in 1950, she began to go, in the company of dealers in Mexico, on clandestine nightly meetings with Indians who had artifacts they had stolen from graves. She and the

dealers, heavily armed, gave cash for the artifacts. She bought her first load of about thirty artifacts, almost all figures, back to her Manhattan apartment, and laid them out on the dining room table. Word got around her friends and their acquaintances that she had strange and unusual figures, and people came to examine, and purchase, her artifacts.

34. Thomas Dunk writes about the prevalence of disparaging attitudes toward the Indian population among the white working class in northwestern Ontario. See Thomas Dunk, *It's a Working Man's Town: Male, Working-Class Culture in Northwestern Ontario* (McGill: Queens University Press, 1991). Here the "Indians" are clearly the repository of many of the negative sentiments that, in New York City and its suburbs, are directed toward African Americans and Hispanics. It is reasonable to suppose, first, that residents of northwestern Ontario who display "primitive" art are likely to display far more Indian art than the New York residents sampled in this study; and, second, that displaying Indian art with an attitude of respect is, in northwestern Ontario, correlated with a liberal, rather than conservative, social and political outlook.

35. Masks may also, as Meyer Schapiro suggested over fifty years ago, seem exotic to residents, both liberals and conservatives, who are affected by the mundane quality of much modern residential life. See Meyer Schapiro, "Abstract Art," in *Modern Art* (New York: Braziller, 1978).

36. The Surrealist claim, that these masks expressed in their societies of origin the fantastic unconscious of "primitive" peoples suggests an alternative explanation for their attraction in the West, one that implies that the Western audience likes the masks because it enjoys looking at the liberated unconscious of another people. This explanation, which is ironic given the Surrealists' general insistence on the priority of the unconscious in social life, excessively intellectualizes the relation between art and the viewer. Why should people wish to gaze at the unconscious of "primitives"? Anyway, Surrealist art is, in fact, not at all popular in the upper-middle-class houses sampled, far less so than "primitive" art.

37. See, for example, Lawrence Stone, *The Family, Sex and Marriage in England, 1500–1800* (New York: Harper and Row, 1977).

38. See Malinowski, *Sex and Repression in Savage Society* (New York: Harcourt, Brace, 1927); and Margaret Mead, *Sex and Temperament in Three Primitive Societies* (New York: W. Morrow, 1935).

39. Sally Price, *Primitive Art in Civilized Places.*

Chapter Six

1. Couples where one is Catholic, the other Protestant may have religious iconography in the house; but the Protestant is almost always aware that the practices are Catholic. For example, one such couple, in Manhasset, have the Infant Jesus of Prague in the kitchen, and a cross in the bedroom. The Infant Jesus of Prague is traditional in the wife's family—Catholics. Her husband put the cross in the bedroom for his wife. "I figured Catholics have a cross in the bedroom. But," he points out, "it's a Protestant cross. There's no Jesus on it. It's just a cross."

2. A Greenpoint man, a Protestant Sunday-school teacher: "Religious art? The only thing I'd go for is a cross [but he doesn't have one]. The cross is the symbol of our faith . . . but it would have to be an empty cross, symbolic of the risen Christ."

3. Even where they do not, no one expressed a distaste for religious art.

4. Also, Catholics in Greenpoint have more images per home. Greenpoint households with religious items have an average of eight; in Manhasset the average is three.

5. In Greenpoint, an average of three religious items per household are in public rooms; four items per household in private rooms. The rest—an average of one per household—are in semi-public rooms such as the kitchen or family room.

6. Elaborate displays of nativity-related scenes, placed on a temporary basis in front of the house in view of passersby, are also on the wane among the working class. For example, in 1990 only five of the Greenpoint houses sampled had such displays.

7. For the history of the iconography of the Black Madonna see Marie Durand-Lefèbvre, *Etude sur L'origine des vierges noires* (Paris: G. Durassié, 1937). Almost all the versions depicted and discussed in Durand-Lefebvre's study are full-length (statues and paintings). Even the few "truncated" versions depicted in the study (see plate 3) look as if the truncation may have been performed by the photographer/editor on full-length originals.

8. On Lippi's work see Giuseppe Marchini, *Filippo Lippi* (Milan: Electra, 1975); Umberto Baldini, *Filippo Lippi* (Florence: Edizioni Arnaud, 1957). Some of the Lippi Madonnas in the Greenpoint houses sampled are probably truncated reproductions of full-length Lippis.

9. Only one household in Medford and one in Manhasset contain a head and shoulders of Jesus that is not the Sacred Heart.

10. *New Catholic Encyclopedia* (New York: McGraw-Hill), vol. 12, p. 818.

11. One of the only two persons who routinely called Mary "the Virgin" was a Puerto Rican male who had a traditional attitude toward women. He valued the way the stress on virginity helped men to control women's sexual behavior: "American women are too independent. . . . And then the man doesn't feel comfortable. Maria [his second and current wife] was a virgin when I married her [a few years ago]. And when I was a young man it was important for me to marry a virgin. My first wife was a virgin. Nowadays people are less concerned about these matters." On this traditional attitude, as expressed by men in a northern Spanish rural region in the 1960s, see William Christian, *Person and God in a Spanish Valley* (New York: Seminar Press, 1972). "Men are roughly aware of the effect of religion in keeping women in line, making them less likely to cuckold their men, etc."

12. Leo Steinberg, *The Sexuality of Christ in Renaissance Art and in Modern Oblivion* (New York: Pantheon, 1983).

13. Emile Mâle, *L'Art religieux du XIIIe siècle en France* (Paris: Librairie Armand Colin, 1919), pp. 315–88.

14. On this system, and its decline in the villages of northern Spain, see William Christian. *Person and God in a Spanish Valley.*

15. William Christian, *Person and God in a Spanish Valley,* chap. 2.

Conclusion

1. The main statement of this nineteenth-century version of materialism was by Semper. Semper saw the work of art as, in fact, a product of three factors: raw material, technics (available technology), and utilitarian purpose. Reactions against this materialist view included Riegl, who insisted on the concept of "absolute artistic volition" (a latent inner force which exists in the artist entirely independent of the object and which is the primary factor

in all artistic creation). Others followed Riegl in rejecting materialism. Thus Lipps explained art works by "the urge to empathy" (the giving of oneself over to the beauty associated with the existence and creation of objects). Worringer followed with the concept of the "urge to abstraction," which, for reasons to do with their harsh climate, was especially pronounced among "Northern peoples." See Gottfried Semper, *Der Stil in den technischen und tekton-ischen Künsten,* 2 vols. (Munichi: F. Bruckmann, 1878); Alois Riegl, *Stilfragen: Grundle-gungen zu einer Geschichte der Ornamentik* (Berlin: Siemens, 1893); Theodor Lipps, *Äs-thetik: Psychologie des Schönen und der Kunst* (Hamburg: L. Voss, 1903); Wilhelm Worringer, *Abstraction and Empathy: A Contribution to the Psychology of Style* (1908), trans. Michael Bullock (New York: International Universities Press 1967). Later attempts to correct the epistemological idealism of these works have focused on understanding the artists and critics in a social context (an undeniably important project) but have virtually ignored the audience, as I have argued throughout.

2. By a "materialist approach" here I mean the view that art and culture should be studied and understood in the material context in which it is located, and that this material context has an important causal impact on the existence and persistence of that culture.

3. Analysts of consumer culture, such as Baudrillard, who argue that the meanings con-veyed by advertising are impoverished—in Baudrillard's formulation, the language of adver-tising purveys a set of expressions ("langue") but not a language—may have a point. Their error, however, is to vastly overestimate the impact of advertising, for they argue that adver-tising obliterates other meanings.

4. On the role of New York galleries and museums in this regard see Diana Crane, *The Transformation of the Avant-Garde: The New York Art World, 1940–1985* (Chicago: Uni-versity of Chicago Press, 1987).

5. The Frankfurt school did believe that a lot of meaning was outside of the conscious-ness of the audience, but they focused on this phenomenon for the supposedly repressed dominated class, not the dominant class. Anyway, although I have argued in this study that much meaning operates outside the consciousness of dominant and dominated classes, I do not argue that this meaning is necessarily repressed (i.e., in the unconscious). It is just not in awareness.

6. For critiques of the "oversocialized" model see Dennis Wrong, "The Oversocialized Conception of Man in Modern Sociology" *American Sociological Review* 26 (1961), pp. 183–93; and Mark Granovetter, "Economic Action and Social Structure: The Problem of Embeddedness," *American Journal of Sociology* 91 (November 1985), pp. 481–510.

7. For a classic study of the male-dominated culture of the executive sector of a large American corporation, see Rosabeth Moss Kanter, *Men and Women of the Corporation* (New York: Basic Books, 1979). See also note 26 to Introduction (last paragraph). For the study of corporations purchasing art for their buildings see Rosanne Martorella, *Corporate Art* (New Brunswick: Rutgers University Press, 1990), chap. 6.

8. For a philosophical critique of simple theories that art "reflects" or "expresses" soci-ety, see Richard Wollheim, "Sociological Explanations of the Arts: Some Distinctions" (1985), reprinted in Milton Albrecht, James Barnett, and Mason Griff, eds., *The Sociology of Art and Literature: A Reader* (New York: Praeger, 1970).

9. On some of the complexities involved in analyzing symbolic meaning see Steven Lukes, "Political Ritual and Social Integration," *Sociology* 9 (May 1975), p. 289–308; and

Jeffrey Alexander, pp. 2–27 in Jeffrey Alexander and Steven Seidman, eds., *Culture and Society* (Cambridge: Cambridge University Press, 1990).

10. Sebastiano Timpanaro, *On Materialism* (London: New Left Books, 1975), p. 29.

11. See Raymond Williams, *Marxism and Literature* (Oxford: Oxford University Press, 1977); and "Problems of Materialism," *New Left Review* 109 (1978), pp. 3–17.

Rather than refine and fine tune the model of the relation between ideas and mode of production, some of the recent Marxist theoreticians of art and culture have rejected materialism altogether. The results are not always encouraging. For example Herbert Marcuse, in *The Aesthetic Dimension: Toward a Critique of Marxist Aesthetics* (Boston: Beacon Press, 1978), denies many of the "materialist" propositions of Marxist aesthetics, including the idea that there is a "definite connection between art and the material base, between art and the totality of the relations of production." Marcuse argues that "authentic art" or "great art," which is his focus, is "largely autonomous vis-à-vis the given social relations," for the defining characteristic of great art is that it is critical of existing social relations, "breaking through the mystified (and petrified) social reality and opening the horizon of change." Thus art is not a reflection of society, but "goes beyond it." This theory has several problems. One consequence of Marcuse's view would appear to be the exclusion from the realm of "authentic art" of a wide range of works including most Christian art, most Impressionist art, and most abstract art of the twentieth century, since little of this art is particularly critical of society and still less suggests an alternative one. (See Janet Wolff, *Aesthetics and the Sociology of Art* [London: George Allen and Unwin, 1983], for similar criticisms.)

Moreover, Marcuse ends by grounding his theory of the critical nature of art in archaic biology, specifically in Freudian drive theory. Thus he argues that great (i.e., critical) art pertains to the domain of eros, the beautiful, representing Freud's pleasure drive, for great art strains toward the liberation from oppression. Uncritical works, by contrast, represent Freud's destructive drive, for they collaborate in domination. Yet given the highly controversial status of Freudian drive theory in modern psychoanalytic thought, and given the various psychoanalytic schools that reject drive theory altogether (of which interpersonal theory and object relations theory are the two foremost) it is untenable to simply assert the truth of drive theory, as Marcuse does. For a critical discussion of Freudian drive theory and of competing schools and perspectives in psychoanalytic theory see Jay Greenberg and Stephen Mitchell, *Object Relations in Psychoanalytic Theory* (Cambridge: Harvard University Press, 1983).

In his theory of what constitutes "great art," Althusser puts forward a similar notion to Marcuse's, minus the psychoanalytic underpinnings (although in his more general approach to ideology Althusser definitely does not reject materialism). See Louis Althusser, "A Letter on Art in Reply to André Daspre," in *Lenin and Philosophy and Other Essays* (London: New Left Books, 1971), pp. 221–28. Both Althusser's and Marcuse's theories of art in many ways constitute what has aptly been referred to as "veiled idealism." For this term see Jeffrey Alexander, "The New Theoretical Movement," in Neil Smelser, ed., *Handbook of Sociology*, (Beverly Hills, Calif.: Sage Press, 1988), p. 93.

12. Compare Engels's famous formulation that the base influences the superstructure only "in the last analysis."

13. The relation between imperialism and "primitive" art is, of course, complex and varies from period to period. For a discussion of the link between modern imperialism and the attraction of "primitive" art in the West in the late nineteenth and early twentieth centu-

ries, see Meyer Schapiro, *Modern Art, 19th and 20th Centuries* (New York: G. Braziller, 1978), pp. 200–202.

14. See Serge Guilbaut, *How New York Stole the Idea of Modern Art* (Chicago: University of Chicago, 1983).

15. At the same time, some of the central meanings of the works uncovered for the audience may be relevant for the artists too. For example, if the fragility of marital life in the twentieth century, underpinning a reluctance on the part of the audience to see a clear and instantly recognizable image of an adult resident depicted alone, is central in the decline of the traditional portrait, then why should it not also be an ingredient in the artists' motivations for producing different portraits, for example, quasi-recognizable "abstract" portraits? Thus Picasso, in the vanguard of producing such portraits, was also notoriously in the vanguard of unstable marital relations. Likewise, if it is the continuation of nineteenth-century suburbanization injected with twentieth-century notions of privacy that underpins the popularity of depopulated landscapes, then perhaps it was an ingredient in motivating the artists too. Many of the dominant landscape and modern artists of the post–World War II period worked in the scenic, yet secluded, setting of the Hamptons.

16. Václav Havel, "The Power of the Powerless" (1979), in John Keane, ed., *The Power of the Powerless* (London: Hutchinson, 1985).

Index